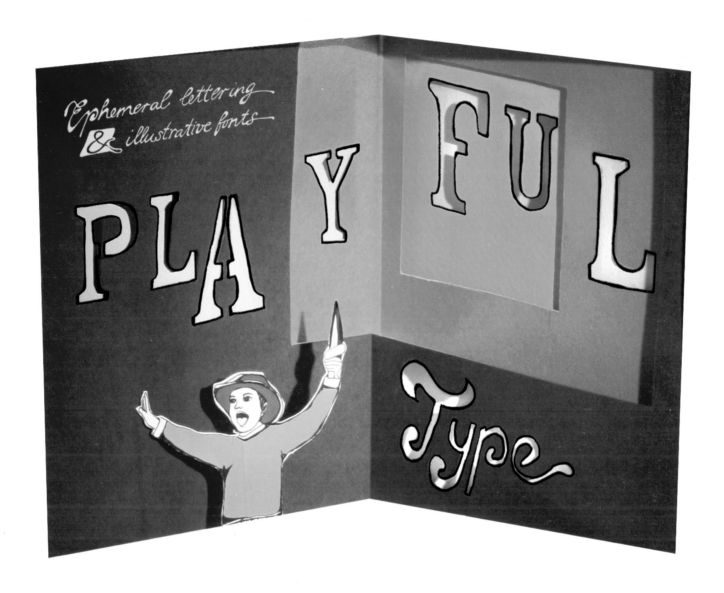

Ephemeral lettering & illustrative fonts

PLAYFUL Type

gestalten

GET YOUR HANDS DIRTY! · · · · · · · · ·

Playful Type reveals unique typographic designs developed through diverse and experimental techniques. There are cases of hand-lettering, calligraphy, carved block prints and old-fashioned collage, along with investigations in liquids shaped into sentences, manipulative photo-techniques along with complex arrangements of elements. Cross-disciplinary experimental techniques with an extra dash of fantasy and play. Indulge in letters made of practically anything from cake dough to scrap wood, cut out paper bits to concrete moulds, candy bars to light installations. This is a book to explore the core of letters and typography in its broadest, most refreshing sense.

Various creators participate. Classic typographers as well as experimental graphic designers go out and share their lesson in „play", which is precisely what grants these works a special touch of originality, uniqueness and individuality.

These are one-off font creations custom made to suit concrete tasks; typography beyond classical rules and compositions made for the challenge of the moment.

The basic motivation here is to not think of designs that can be re-used, but to apply the greatest care to each single letter, craft it with fun and originality, treat it like an individual character standing strong in its bigger composition. These letters actually have something to say. They are curious and carry their personality with pride. Beyond the rigid rules of typography, Playful Type introduces a colourful world of letters and motivates you to grab whatever you can find and improvise yourself.

LETTERING VERSUS TYPE DESIGN · · · · · · · · · · · ·

Because this book contains such a wide range of techniques and applications, it makes us ask the following questions: Where does typography stop? What is lettering? When does a

letter „count" as a letter at all? Former TDC chairman James Montalbano's personal view on lettering describes many of the works gathered in this compilation very well: "Lettering is, in many ways, the opposite of type design. Whereas type design creates letters that must function under the broadest possible circumstances, lettering is created for the most narrow of applications. A word or phrase, be it a logo or a book jacket, is custom tailored to work in that environment alone. Every letter is drawn to fit perfectly within its own small world. Even lettering that looks like typography initially, has been custom tailored letter-by-letter, and space-by-space to work perfectly."

FOLLOW THE PROCESS • • • • • • •

In the everyday realm of a designer's profession, one often forgets that most people out there may appreciate design, although they have very little idea of how it is actually made. Assuming that most processes are automated nowadays, the actual work and care put into a creation by a designer, such as shifting elements on a computer screen for hours, does not only get overlooked, one doesn't even know that a human hand was involved in the process in the first place. The result – often an immaculate design, perfect in alignment – is certainly appropriate in many cases, but the human aspect gets lost entirely.

How refreshing is it then, to make the process as obvious as possible and reconnect with the audience by using those very reliable, non-high-tech tools such as pen and paper, scissors and glue (or countless other techniques shown here) re-introducing the presence of the human hand in visual communication.

Sometimes revealing the making of a letter or typographic composition creates a little narrative within that piece, such as the kitchen settings of Annemarie van den Berg, where the process of creation almost becomes a strategy to humanise the whole project.

At times, it is not so much the creation of a letter as such, but its „reception" – a certain openness commonly experienced when watching children discover shapes in tree holes or looking at clouds in the sky. It is this openness and sense for a typographic objet-trouvée that let designers create alphabets such as the sky letters by Lisa Rienermann: simple sky-shapes are observed, documented and composed to an original and legible alphabet.

CREATING IDENTITY IN A DIGITAL WORLD • • • •

It is both natural and apparent to yearn for experimental non-slick solutions, to jump at the chance to create something that is utterly unique and individual in a world where anonymous digital, non-tangible spaces and services are taking over. The world simply craves a personal voice, something that reminds us of where we came from, how creativity is born, and that the freedom to play leads to stunning results.

Idiosyncratic shapes create typography for the moment, mistakes are welcome, irregular lines inspire, are connected and eventually add passion and a tangible creator's spirit to odd

surfaces. Some of these typographic creations then translate into incomparable alphabets with the possibility of implementation as digital fonts – others don't. At the starting point, however, a „serial production" is certainly not the main priority – rather the contrary. The main motivation seems to be to bring out the maximum in individuality and identity.

It is common knowledge, that designers have always customised computer text fonts for exclusive corporate applications. There are logos, of course, but also posters, movie titles, or in particular magazine and newspaper titles, which demand an extra tweaking and adjustment of letters. It is especially the field of editorial design that acts as a major force in the field of unique typography. A few years ago, magazines had not only put emphasis on their practice to use tailored display fonts for their headlines, but also embraced illustration and collage for the purpose of giving theme-based editions of magazine a slightly different look and feel than the previous one. Here is where a broad variety of alternative, experimental and overall individual solutions is most welcome.

TANGIBLE MATERIALS AS A LAST RESORT • • • • • • • • • • • •

Today's designers have unmistakably learned to embrace the advantages of technology, but also need to think beyond its limitations. How can we still touch people with our works in a world so flooded with impersonal information and fleeting messages? What makes people stop and get involved in a work of art? Isn't it a form of playfulness that still raises sympathy and speaks to us with its unpretentious, refreshing honesty?

Simple, but powerful works such as the „Everything is Illuminated" book cover reveal a composition with an individualistic, entirely handmade design that fills every corner of the page. It underlines the personal, the real, irretrievable identity. The designer's personality plays a crucial part in the creation. In retrospective, the viewer has the chance to follow each wobbly pen stroke of the letters once created. One „e" looks unmistakably like no other, proving that a real person made this. That alone can sometimes be enough.

Playful Type is researched and created in an ongoing quest for identity and genuine design with a special focus on ephemeral solutions. Everything that is created for the moment only, cannot be duplicated. It is utterly unique and stands strong as an individual artwork, a typographic composition with a definite, human creator. It is precisely this quality that is so important today. A human feel achieved by using tangible materials – things the viewer can grasp and identify with, a touch of warmth in a mechanical world – is what gets the viewer engaged and moved. In this sense, materialism is the designer's last resort, a sanctuary that depicts true authenticity.

Mistakes, quirks and imperfections, coincidence and an unstoppable desire for experimental exploration – those are qualities found in the works introduced in Playful Type. This is an inspirational journey, an ode to the liberation of the letter, a celebration of typography in its most creative and open-minded sense. Enjoy and be inspired!

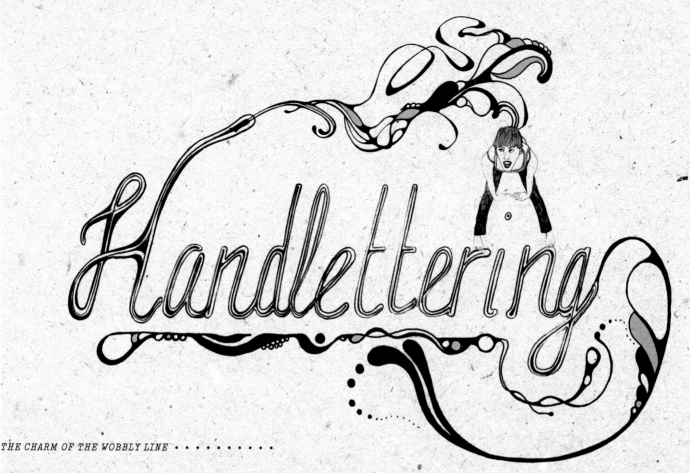

THE CHARM OF THE WOBBLY LINE • • • • • • • • • •

No doubt about it: there is just something special and natural that happens when good designers and typographers create type and words by hand-drawing them. A certain extra dash of charm that brings life to design works. Even today, many of the big masters in typography swear by hand-drawn sketches that serve as a strong base for their digital font creations. The freely swung line, the direct natural scribbling from the brain transported through the hand onto a surface, still brings out the best in creativity. Or think of doodling! How many good shapes and ideas come to life when the pen is allowed to find its own way and create forms that stem from the subconcious? This is where odd lines become the core of a unique and fresh design approach.

Freely created hand-drawn shapes can certainly be a great starter for anything, but this chapter focuses on the qualities of hand-lettering itself. It reveals the joy that lies in the authenticity of the material: creations that are impossible to be taken apart for the later use of individual letters in a similar composition. Watch how every letter sits in its place and is designed for this very purpose, for this moment, precisely for this piece only. At times, whole carpets of words are woven; letter for letter they construct a definite, irretrievable composition. Writing also plays an important role. Tiny words that fill the space on a paper, bit by bit, influencing each other's position and height; sparing no effort, allowing no weariness, resulting in a powerful design that reflects endurance and human impact.

Handwriting brings out more character – it reveals the character of the person creating it and fuels this very character into the actual design. Wobbly lines, imperfect spacing,

and welcome slip-ups are what give these works all their charm. It also brings a certain consciousness back to the design world. While everything „can" be done cleanly, immaculately, we long to see the human aspect in the work, the hand that drew these shapes and the warmth it left while scampering across the page.

Works differ wildly in style and aesthetics; the overall variety achieved by the simple marriage of pen and paper is just stunning. There are certainly nostalgic feelings when looking at some of these colourful type compositions that remind us of 60s advertisements or the hand-lettering in old children's books. Even when seen in a contemporary application, this untroubled charm of swooshy characters and playfulness remains. Others go back even farther and communicate an almost antique feel when creating old-fashioned maps like those of Fiodor Sumkin for Aeroflot. Sticking to sepia-like colour schemes and combining lovely, old swirly elements to an informational typographic structure, he bestows cultural wealth, history and authenticity upon the Russian airline. But then again, hand-lettering can be incredibly new. When observing 44Flavours works for The Tape vs, RQM, there is a fresh mix of Hip Hop styles next to Neo-Folk, Metal, Punk elements as well as classroom desk scribbling aesthetics which fuse to make music graphics with a contemporary flavour. The band's genre mix and their preference for a hands-on approach to making music gets carried all the way through to their hand-drawn typographic identity, which fits these tunes like a glove.

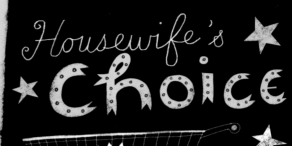

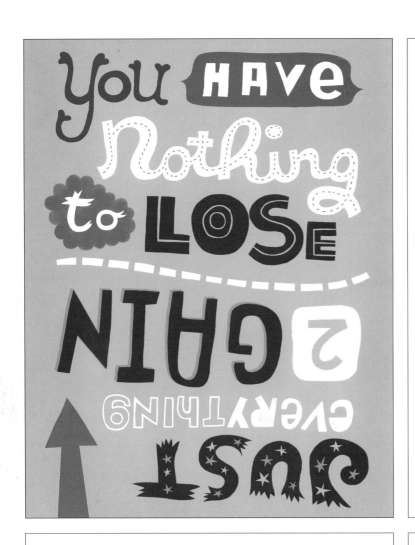

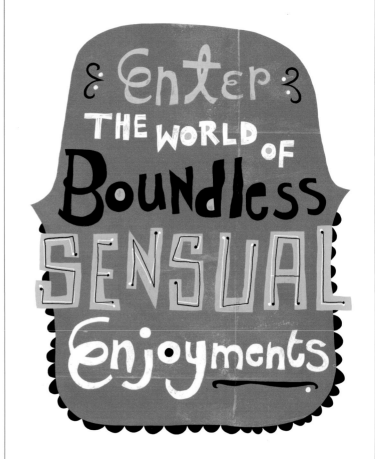

FROM NOW ON YOUR SMALL BREASTS NEED NOT BE THE CAUSE OF YOUR EMBARRASSMENT.

the AIM ♥ OF THIS MESSAGE is ✽ TO HELP you achieve Better HEALTH

7

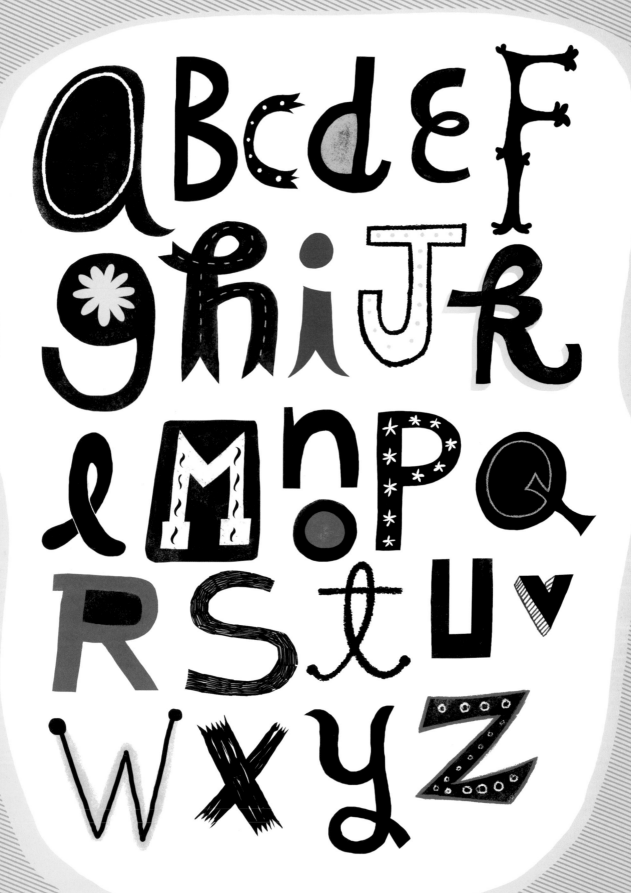

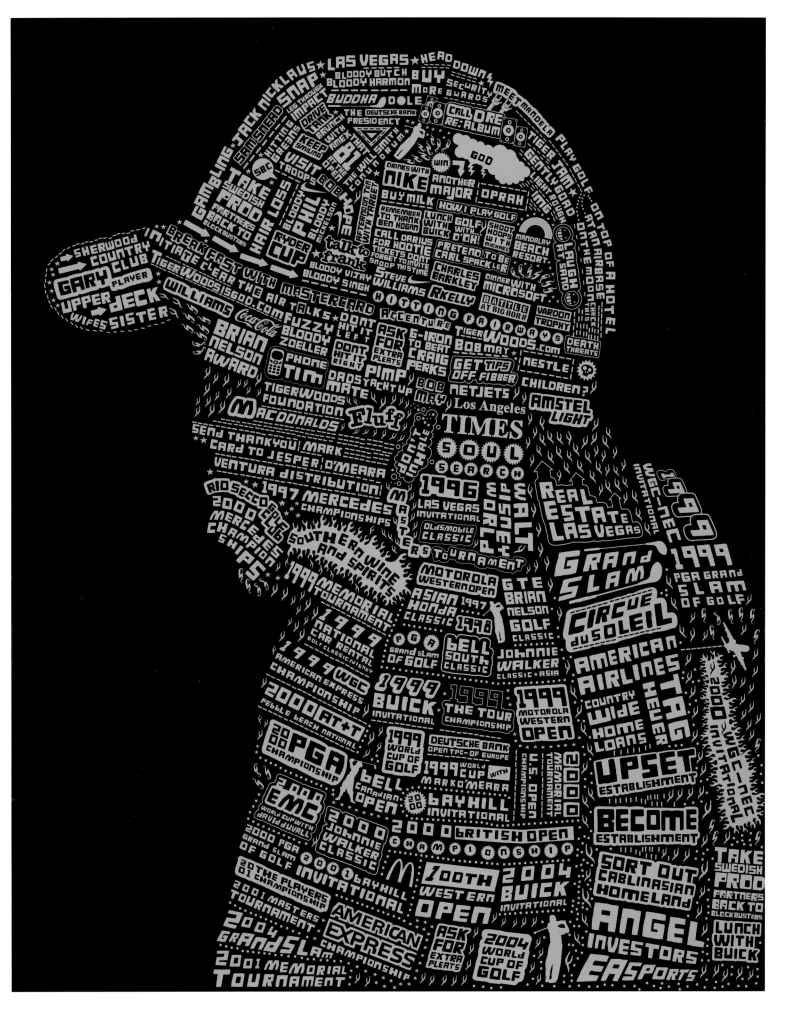

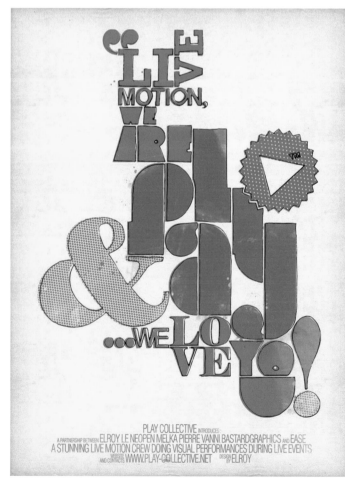

PLAY COLLECTIVE INTRODUCES :
A PARTNERSHIP BETWEEN ELROY LE NEOPEN MELKA PIERRE VANNI BASTARDGRAPHICS and EASE
A STUNNING LIVE MOTION CREW DOING VISUAL PERFORMANCES DURING LIVE EVENTS
WEBSITE AND CONTACTS WWW.PLAY-COLLECTIVE.NET DESIGN BY ELROY

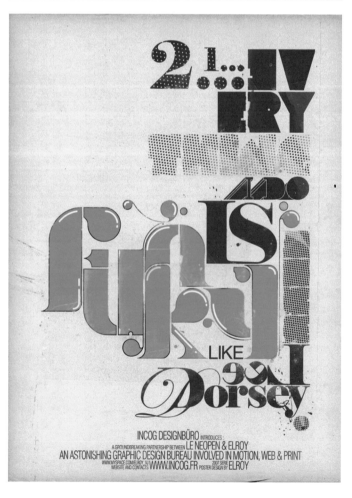

INCOG DESIGNBÜRO INTRODUCES :
A GROUNDBREAKING PARTNERSHIP BETWEEN LE NEOPEN & ELROY
AN ASTONISHING GRAPHIC DESIGN BUREAU INVOLVED IN MOTION, WEB & PRINT
WWW.MYSPACE.COM/ELROY_VJ
WEBSITE AND CONTACTS WWW.INCOG.FR 2007 SERIE POSTER DESIGN BY ELROY

CLUB NOWHERE
MAAK & DOE LEUKE DINGEN!

BREAK VIDEO
DANCE CLIPS
GAMES RAP!
FASHION
MOVIES
RADIO SING!
COMEDY
DIGITAL diary | VANAF 1 APRIL

CLUB NOWHERE KOMT TOT STAND I.S.M. CYBERSOEK

NOW HERE 2008
MADURA STRAAT 90
1094 GS AMSTERDAM
020.4636912
INFO@NOWHERE.NL
WWW.NOWHERE.NL

Amnesty International

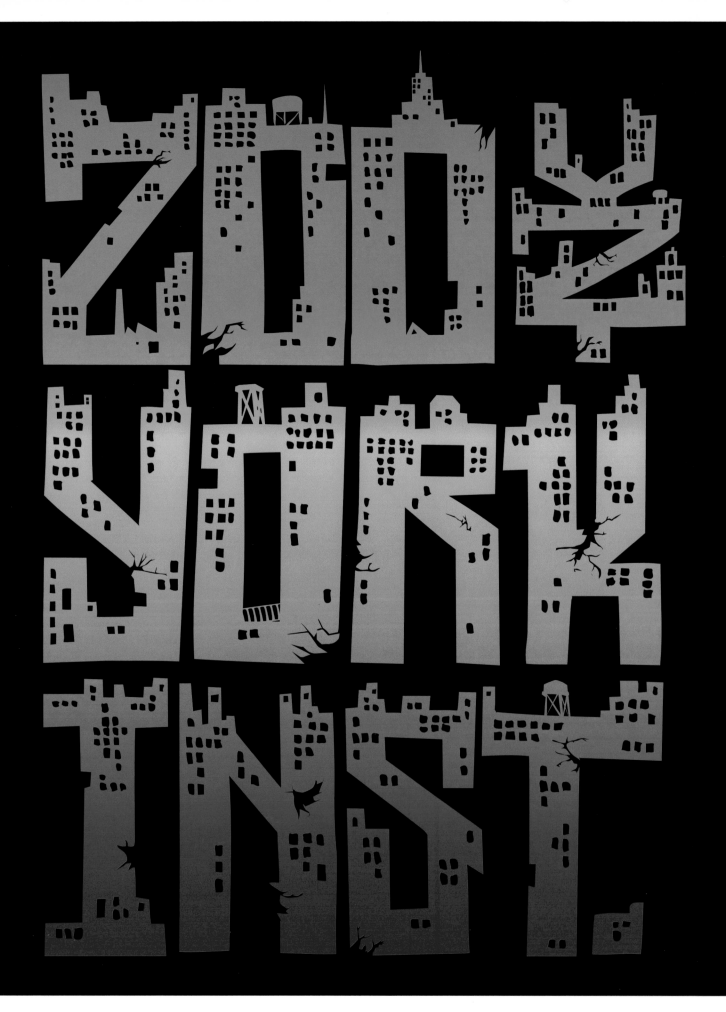

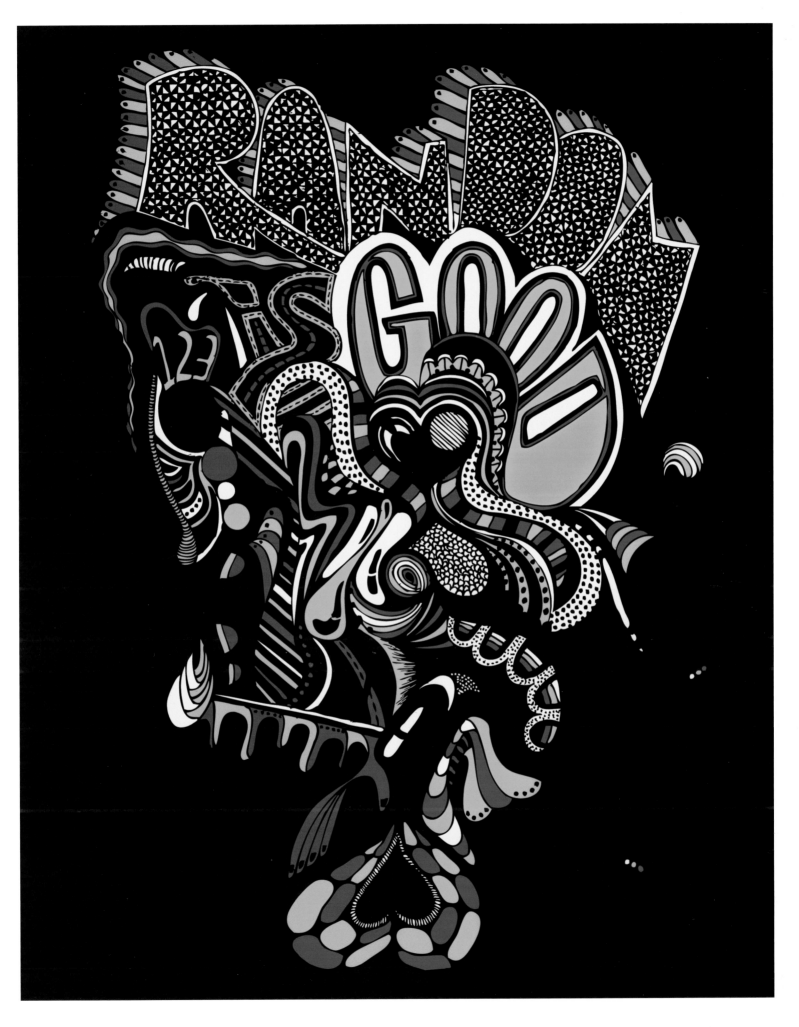

17

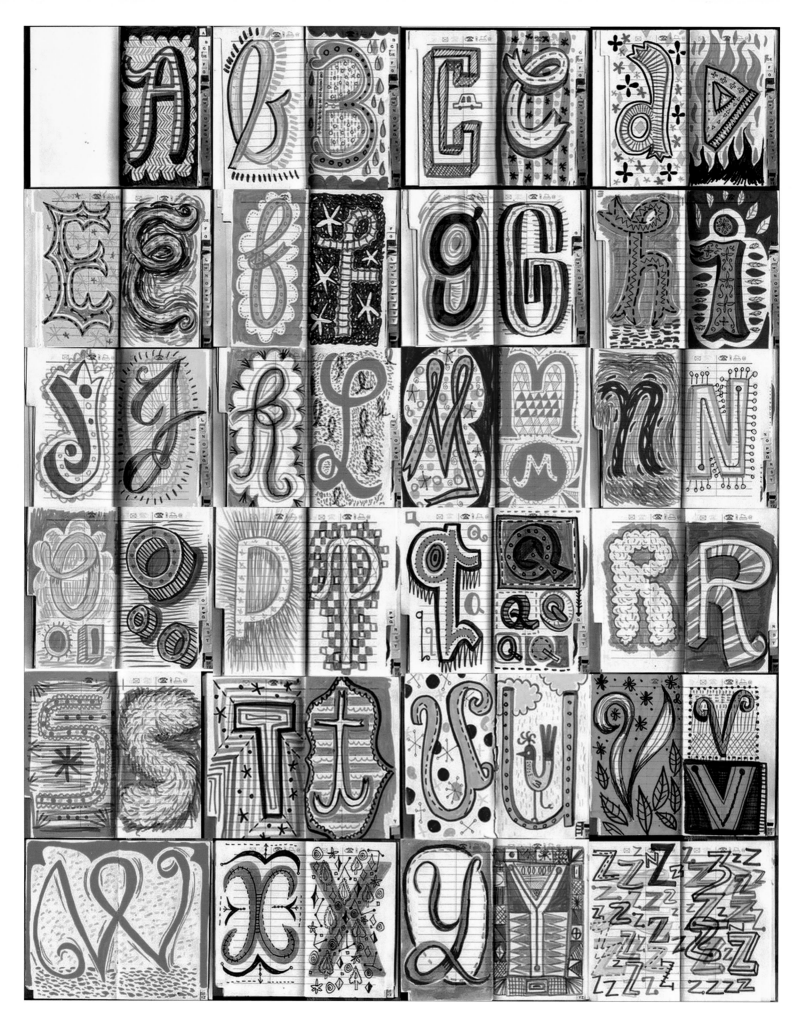

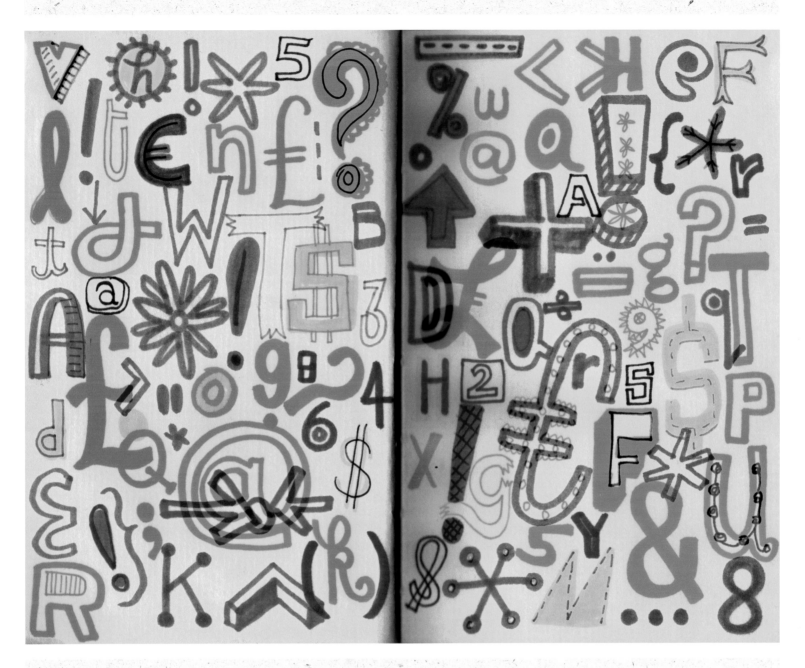

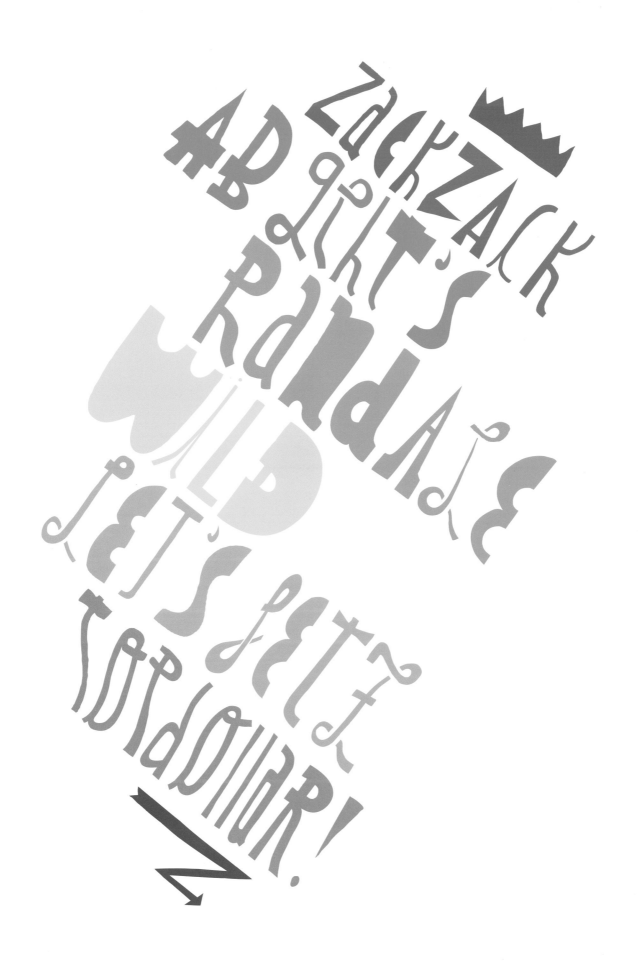

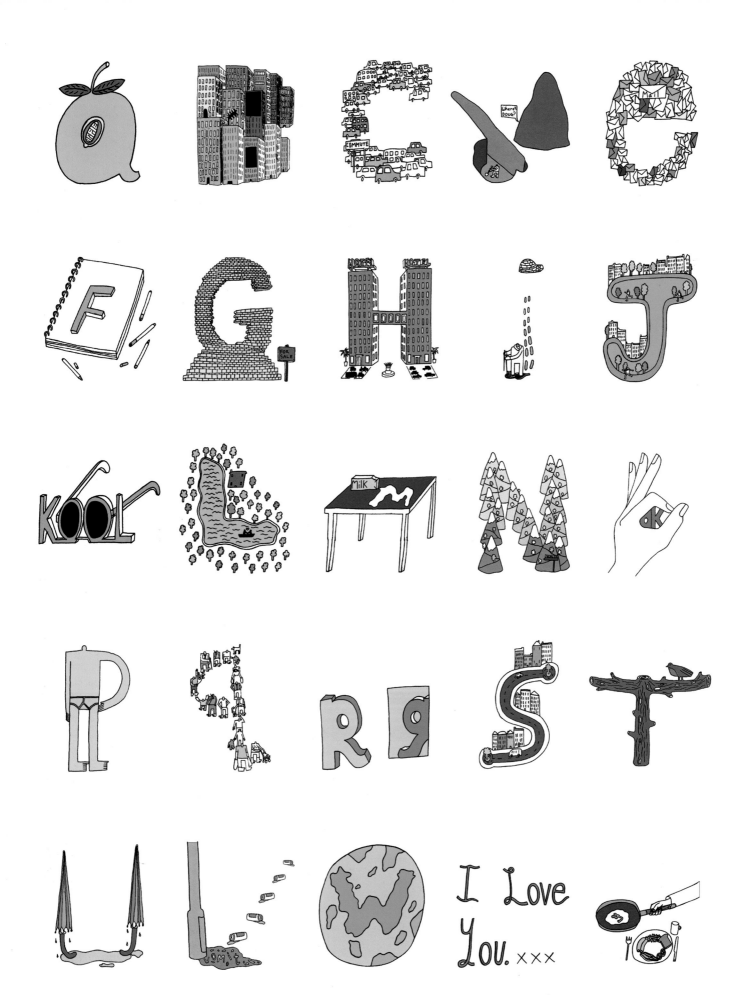

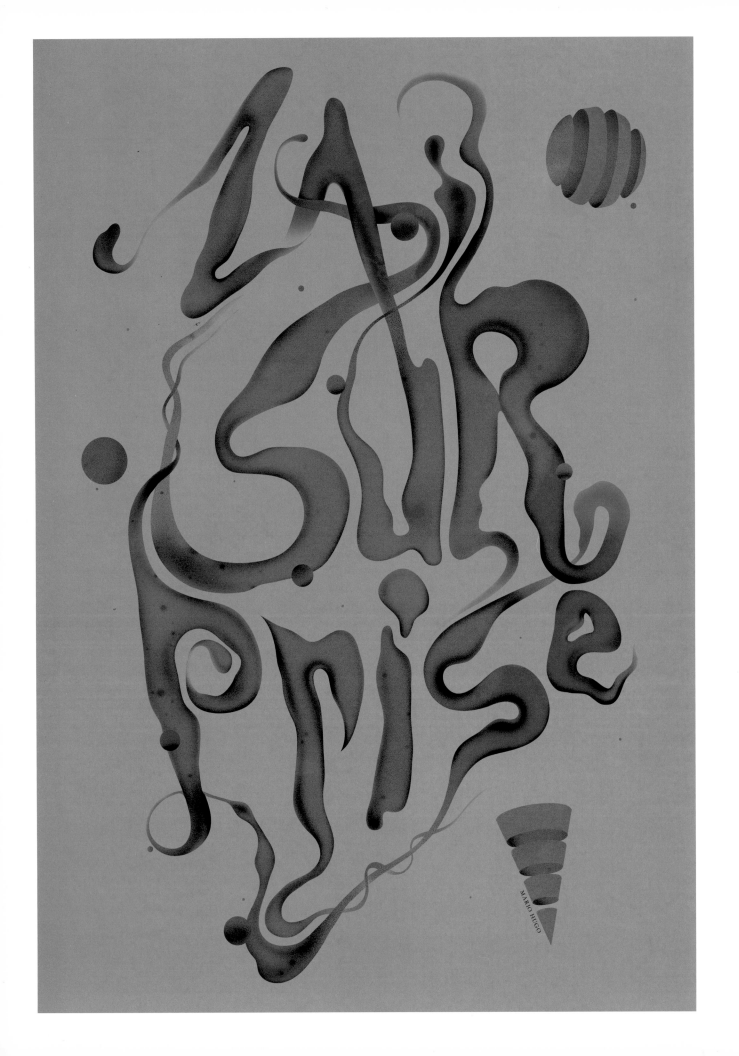

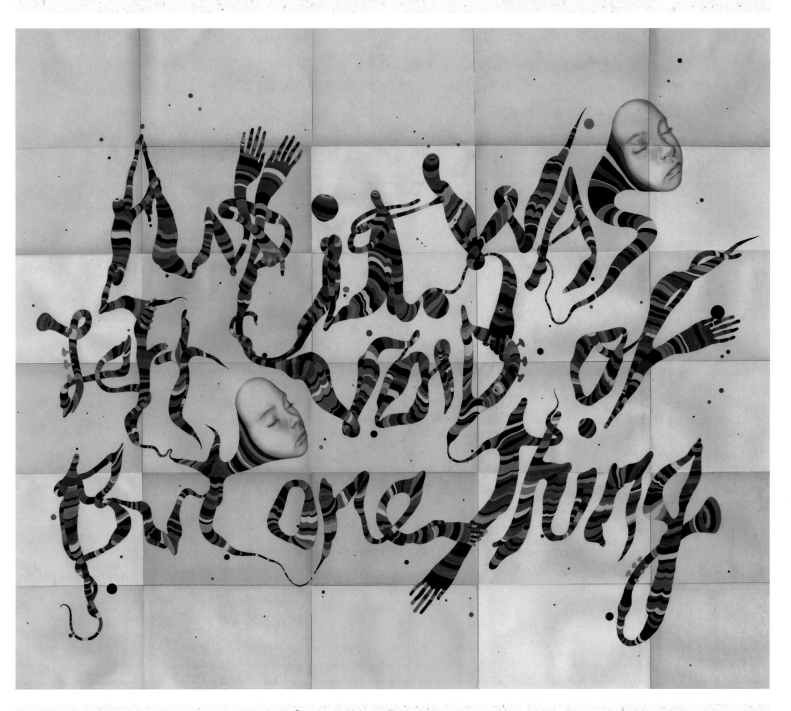

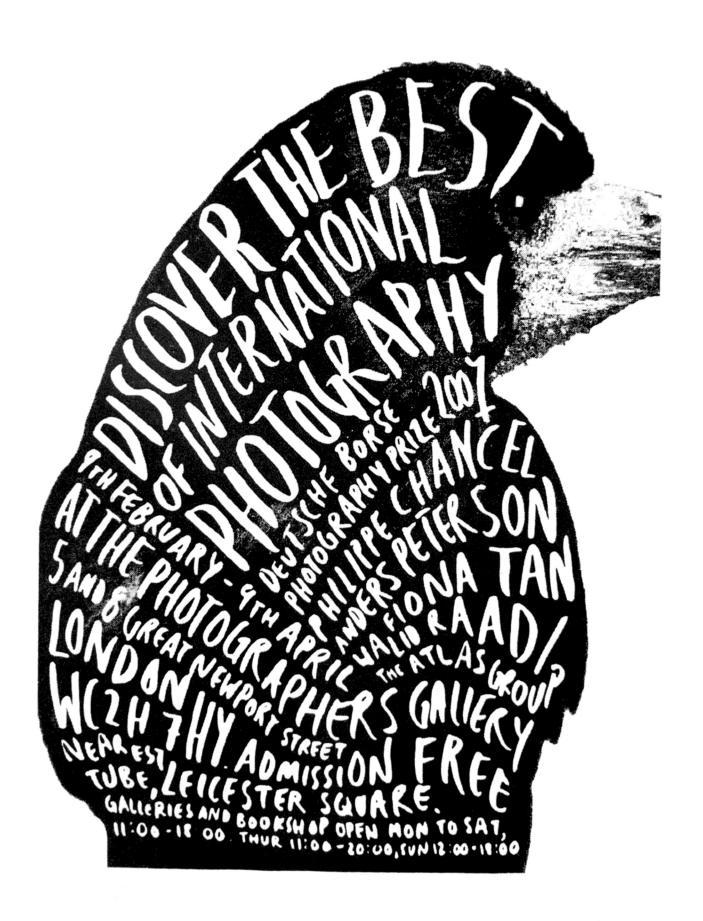

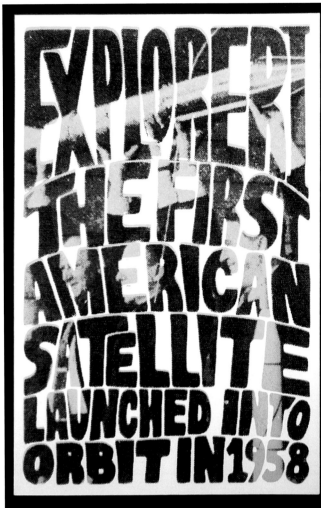

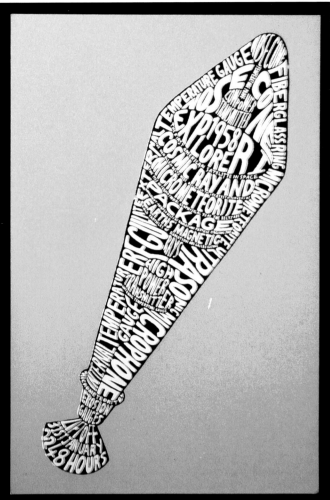

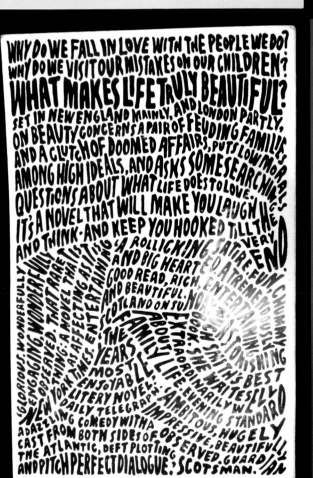

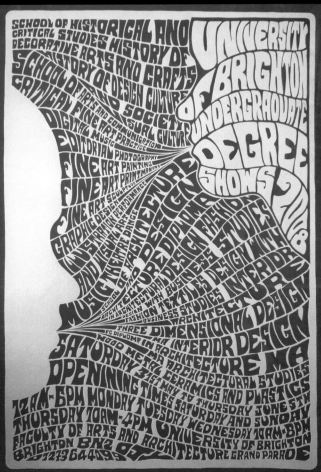

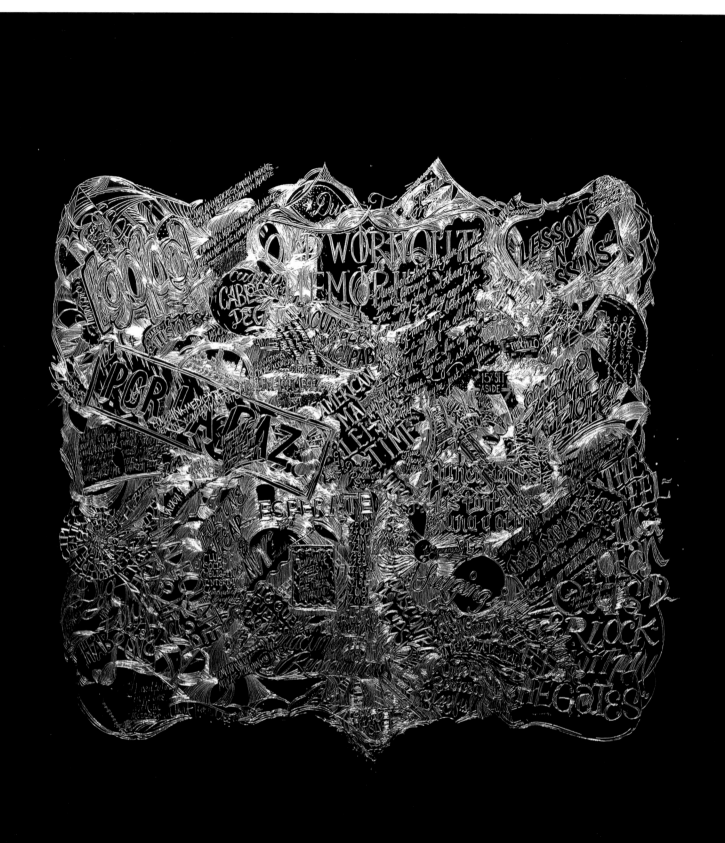

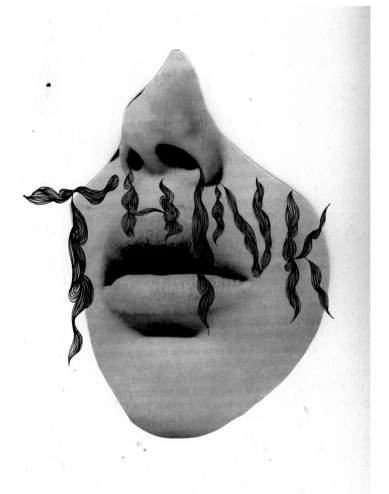

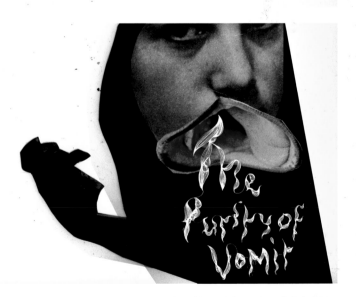

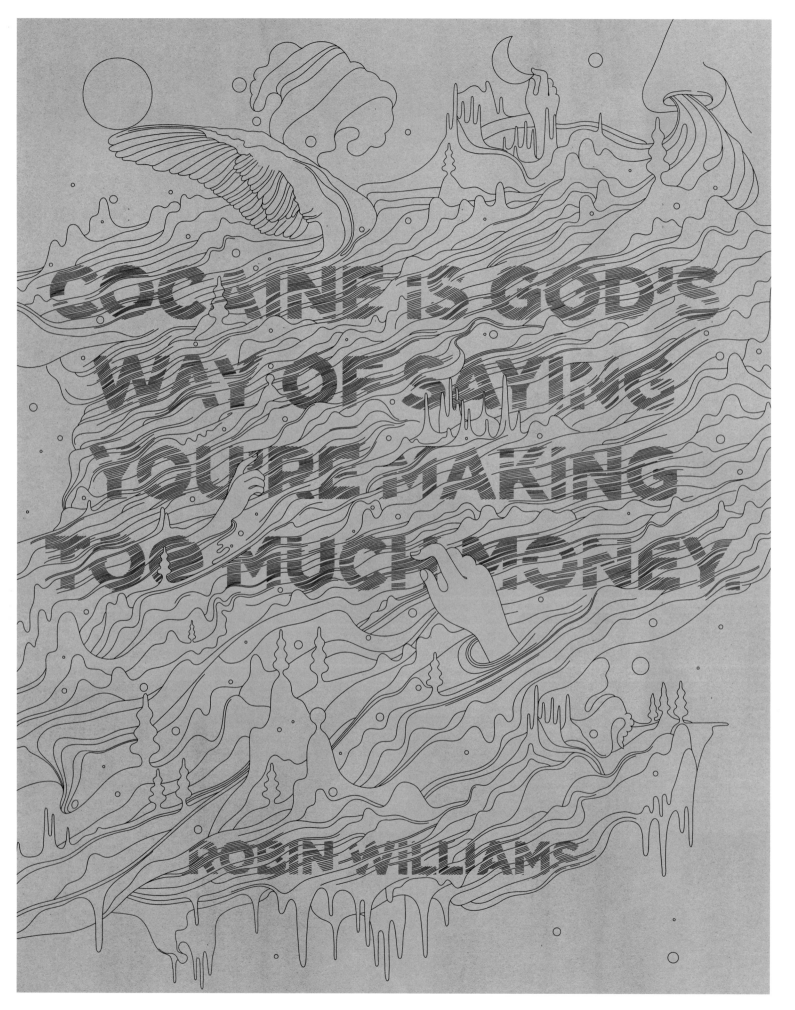

«MAN MUSS SICH AN DIE KÄLTE GEWÖHNEN» SAGTE ER. «MAN MUSS TIEFER ATMEN UND SCHNELLER GEHEN.»

FÜR TANTE HEDWIG WAREN nicht besonders GEEIGNET und ein Lebewohl IST EINE ernste Rede.

IN DIESEM MOMENT LIESS SIE DIE TASSEN FALLEN UND SIE ZERSPRANG IN TAUSEND STÜCKE

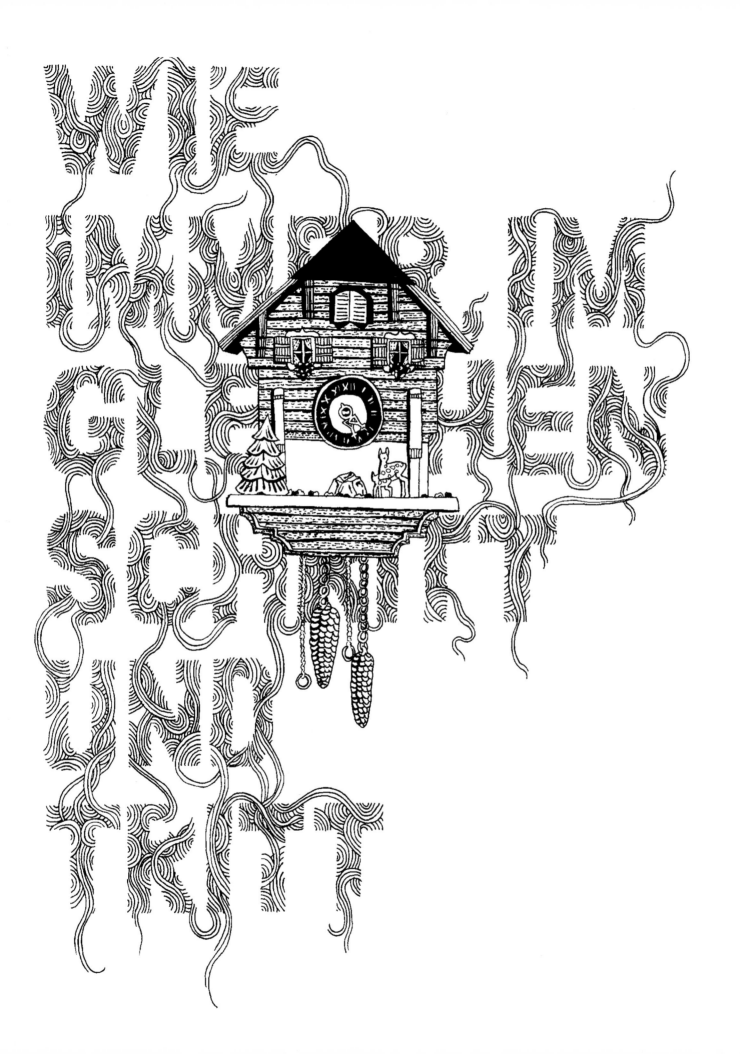

WIE IMMER IM GLETSCHER SCHLUND LIEGT

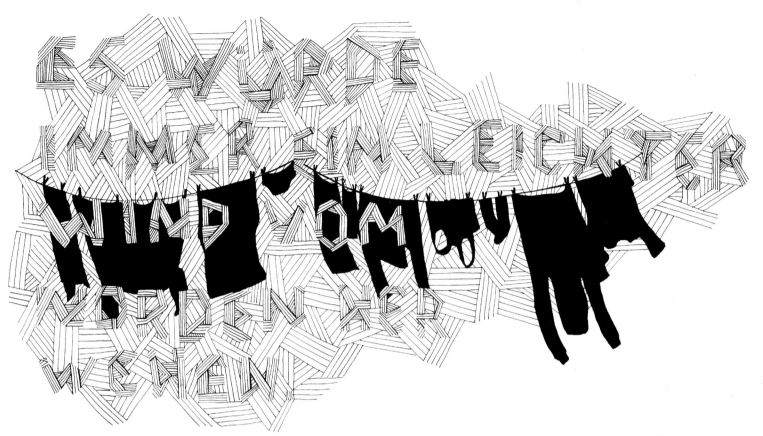

Alina Günter

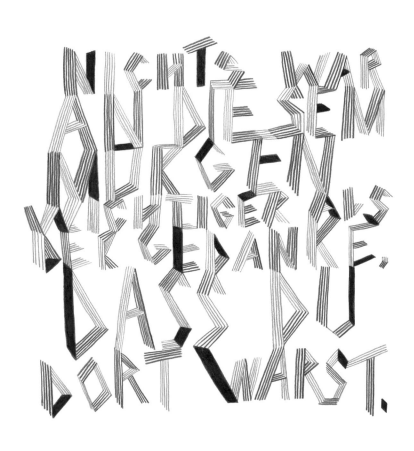

NICHTS WAR
AN DIESEM
MORGEN
WICHTIGER ALS
DER GEDANKE,
DASS DU
DORT WARST.

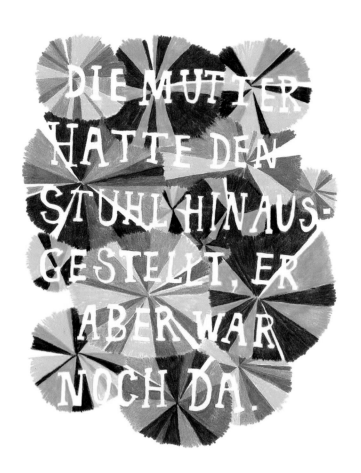

DIE MUTTER
HATTE DEN
STUHL HINAUS-
GESTELLT, ER
ABER WAR
NOCH DA.

IM
AUSLAND
IST ALLES
SCHRECKLICHE
MÖGLICH
UND
EINSAMKEIT
DIE GRÖSSTE
ANGST.

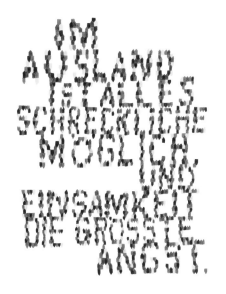

DIES WAR
SCHON
DER DRITTE
TAG UND DU
BIST IMMER
NOCH NICHT
ZURÜCKGE-
KOMMEN.

NOCH IMMER
WUSSTE ICH
NICHT, WELCHE
HAND SIE DAZU
GEBRAUCHT
HATTE. UND
DER GEDANKE
DARAN
MACHTE MICH
ERSTAUNLICH
MÜDE. x

Alina Günter

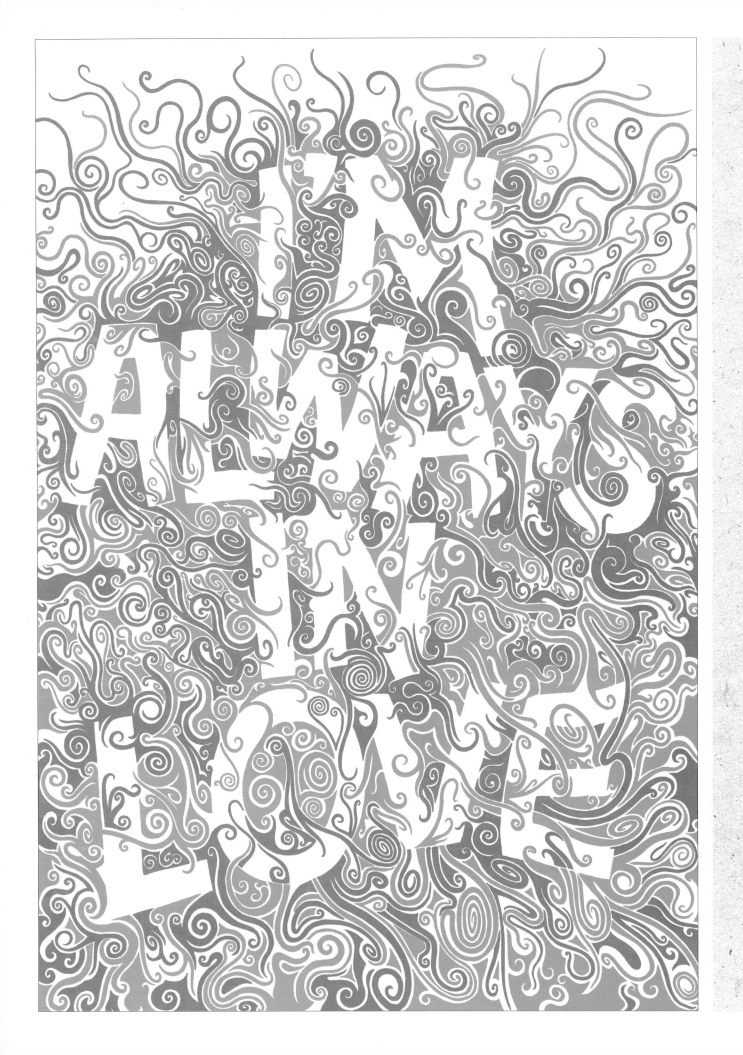

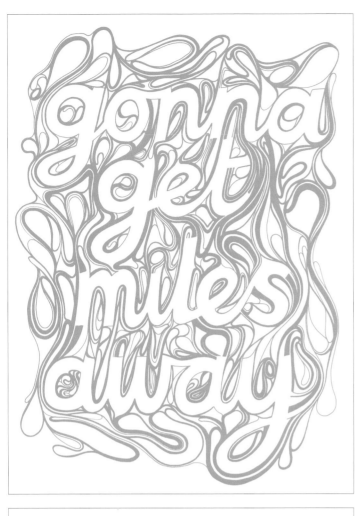

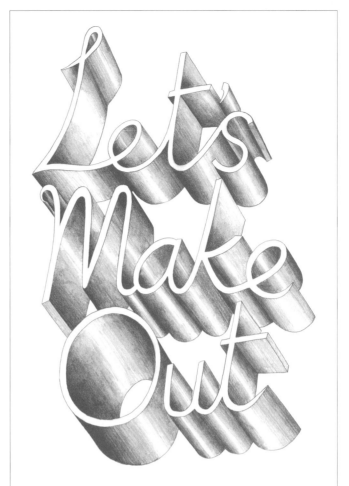

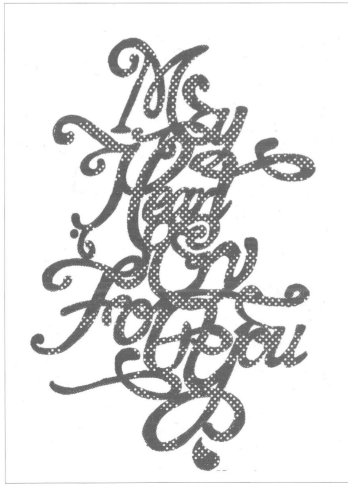

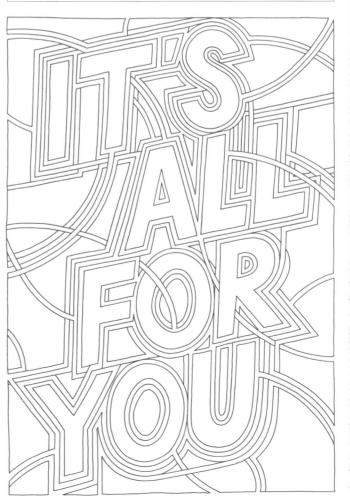

Adam Hayes (top, bottom right), Jonathan Calugi (botoom left)

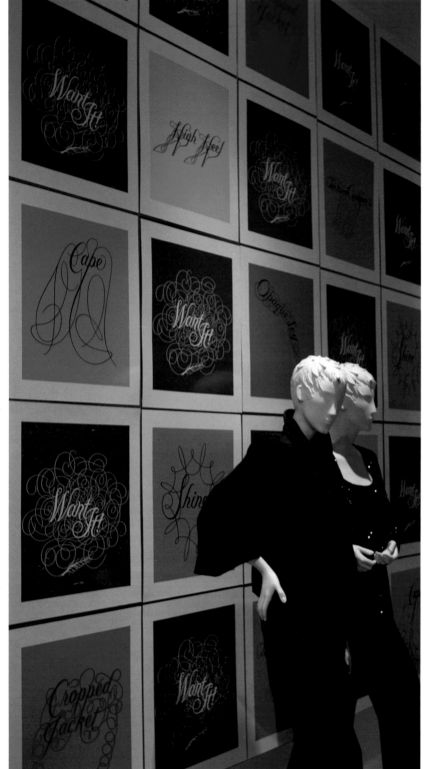

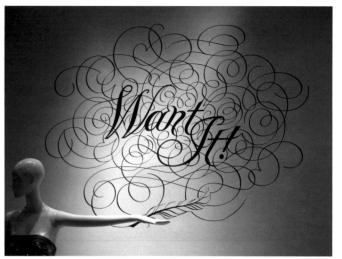

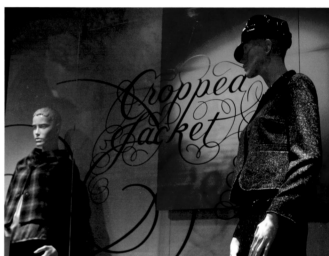

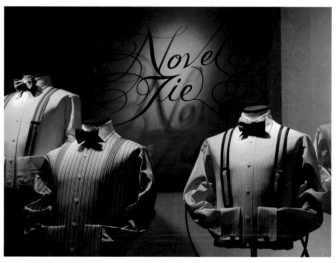

Cape

Textured Cardigan

Shoe Bootie

Opaque Leg

Puffy Vest

High Heel

Gentleman's Bag

Novel Tie

Structured Handbag

Winter White

Cropped Jacket

Extra Long Lace-up

Turtleneck

Tuxedo Dressing

Dramatic Lash

Shine

ALPHAFONT

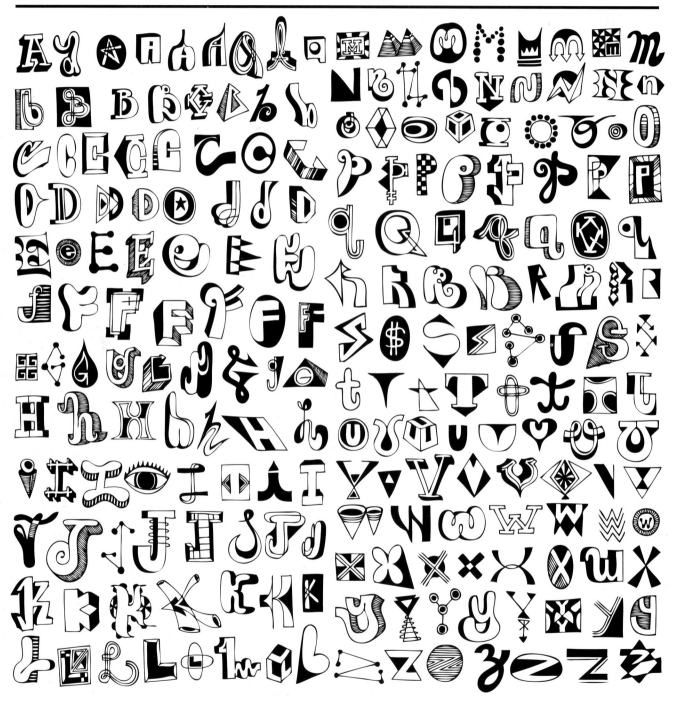

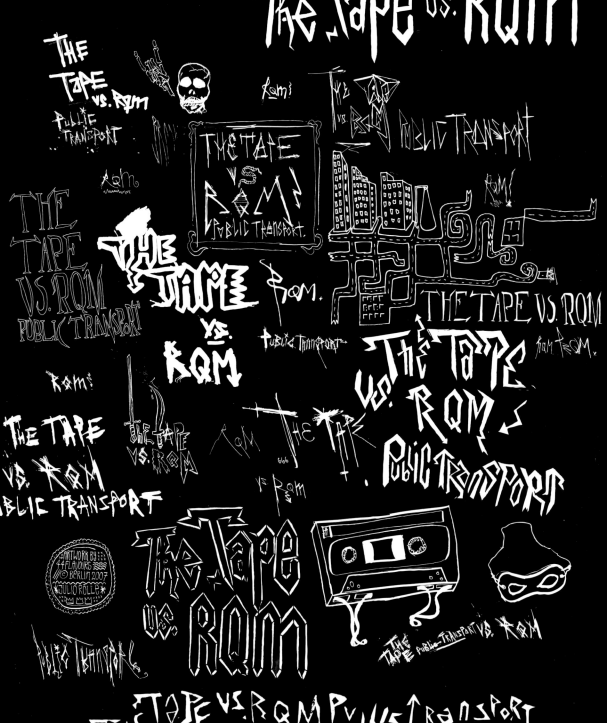

Deanne Cheuk

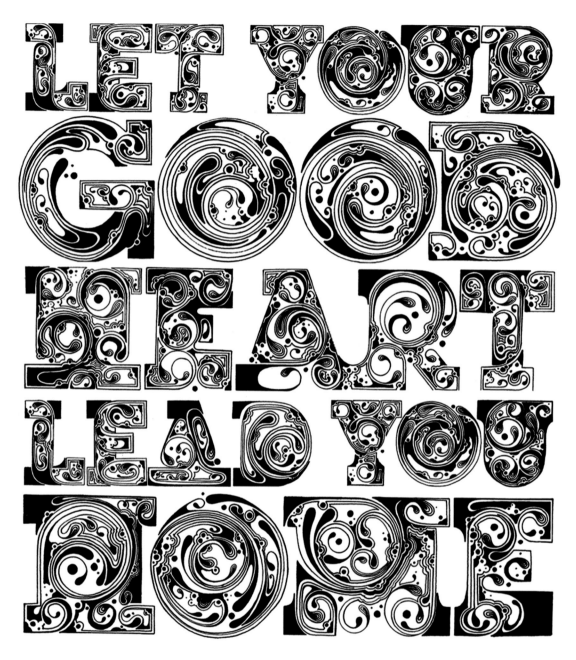

Sharks swim around your
Drowning soul
Let your good heart
Lead you home

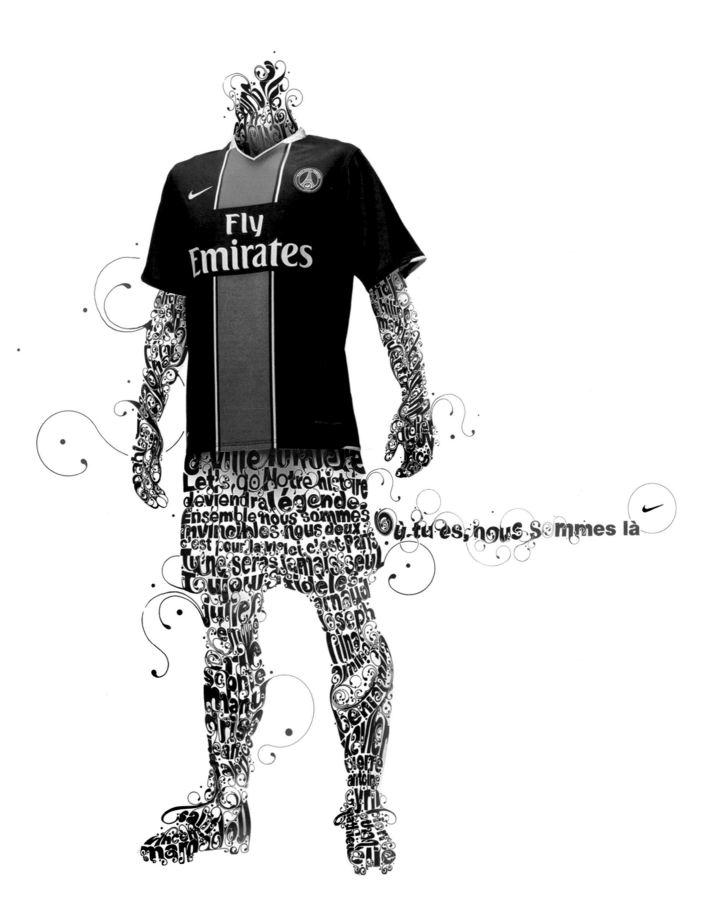

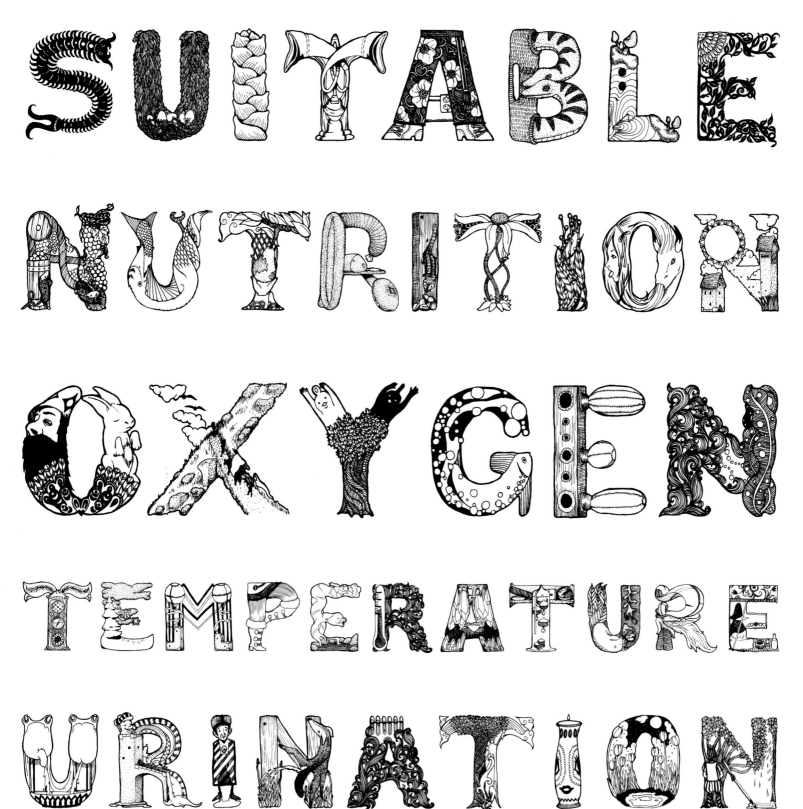

SUITABLE
NUTRITION
OXYGEN
TEMPERATURE
URINATION

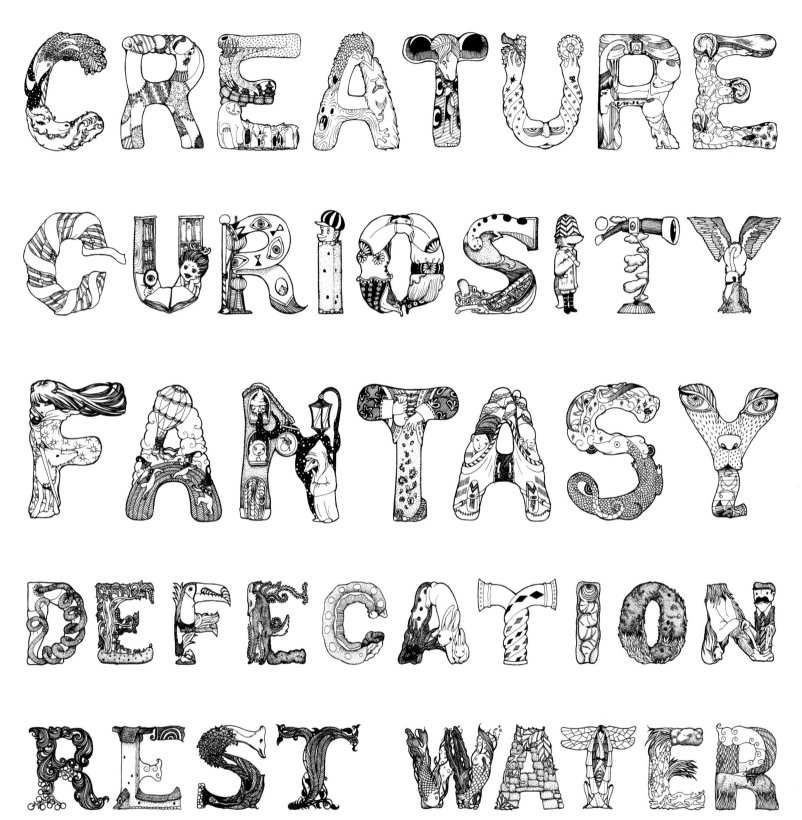

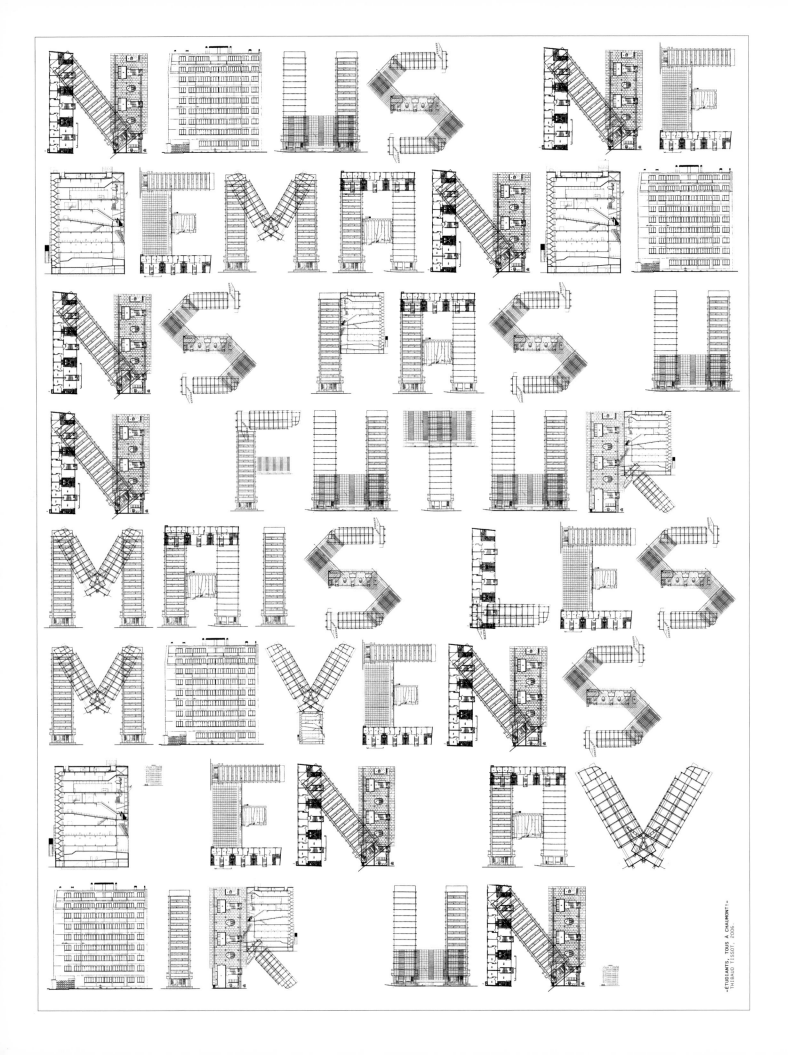

«ÉTUDIANTS, TOUS À CHAUMONT!»
THIBAUD TISSOT, 2006.

PORTES
OUVERTES
CIFOM-EA/
ÉCOLE D'ART

VENDREDI 25 NOVEMBRE 2005/ DE 17H À 21H/ SAMEDI 26 NOVEMBRE 2005/ DE 9H À 12H

RUE DE LA PAIX 60/ 2300 LA CHAUX-DE-FONDS/ 032 919 23 23/ WWW.CIFOM.CH

BIJOUTERIE/ CRÉATION DE VÊTEMENTS/ CRÉATION DE VÊTEMENTS N'MOD/ DÉCORATION/ DÉCORATION
D' INTÉRIEUR/ GRAPHISME/ DESIGN DE L'INFORMATION/ GRAVURE/ POLYGRAPHIE/ TECHNO-IMPRIMERIE
VISITES GUIDÉES/ VENDREDI À 18H , 19H ET À 20H ET SAMEDI À 10H ET À 11H. INFORMATIONS GÉNÉRALES/ VENDREDI À 18H. AULA CIFOM. RUE DE LA SERRE 62
PRÉSENTATION PAR PROFESSIONS/ GRAPHISME, POLYGRAPHIE, TECHNO-IMPRIMERIE. VENDREDI À 19H ET SAMEDI À 10H. SALLE 043. RUE JARDINIÈRE 68

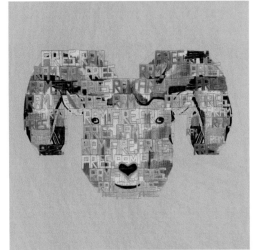
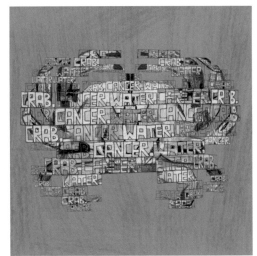
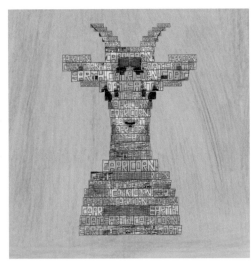
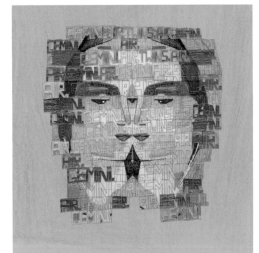
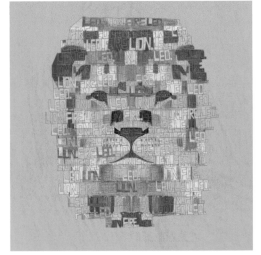
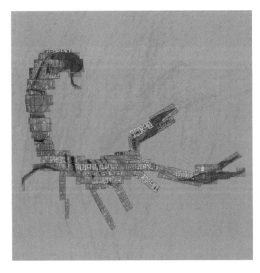
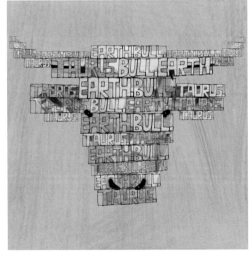
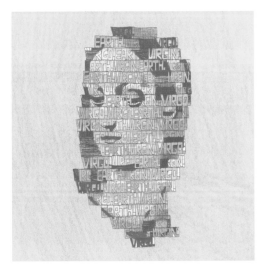

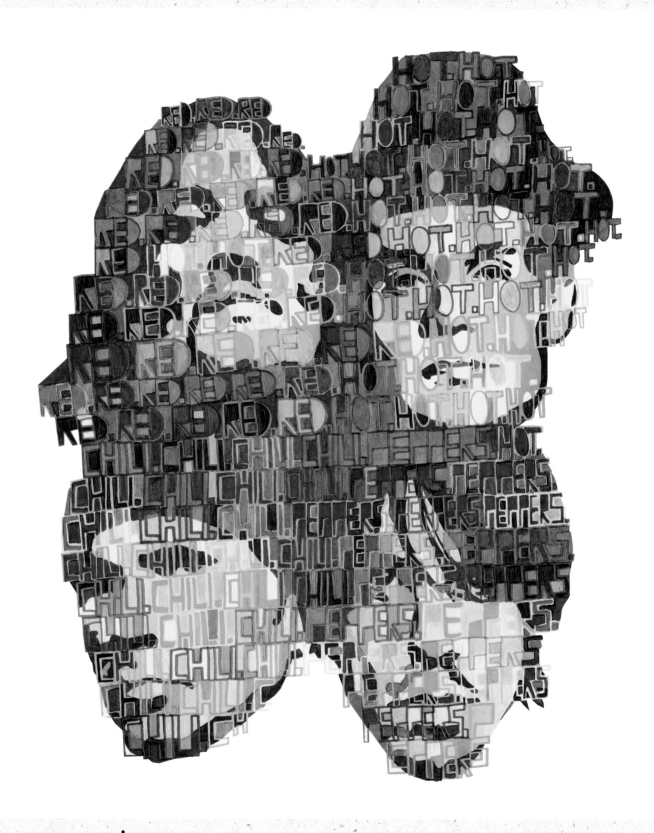

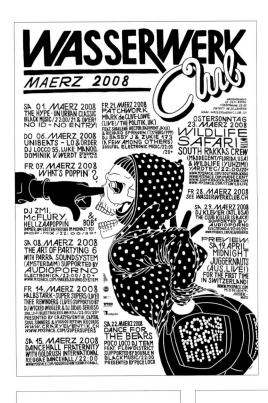
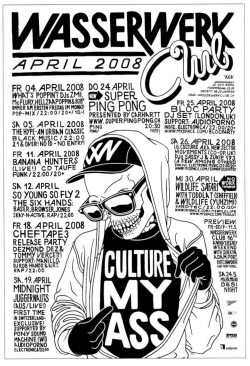
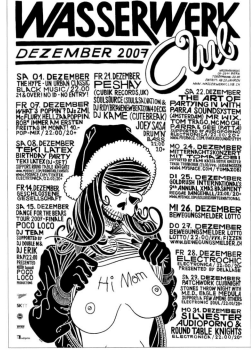

Nigel Peake

OF SEPT.
ON THE MID
NO EXPRESSO CONVERSATIONS
STRAW HAT
TATTERED PALE
SOME BISCUITS IN AN OLD
PAYPHONE CONVERSATION WITH
SOME LETTERS AND ANOTHER DESOLATE
ALTERNATING BETWEEN NUMBERS AND OF COURSE
POSTCODE GEOGRAPHY BY THE HARBOUR

FISHERMEN WILL PROBABLY SENSE HAS NO PLAY SOMETIMES I FELT
NEVER MAKE IT TO THE PLACE DISTANT DOESNT EXIST IT BREAK
WHERE I AM ABOUT TO DO SO MUCH TIME JUST SPENT RUNNING AROUND AND
SLEEP BUT I THINK THATS TRYING TO ORGANIZE STUFF-SOMETIMES IT NOW
O.K, I GUESS THEY WOULD WORKS OUT, SOMETIMES ITS MET WITH SILENCE IT IS REPAIRED
NEVER HAVE THOUGHT OF AND SEEMS THAT AS YOU GROW UP PEOPLE SEEM TO BE
PLEASE JUST IT - HAPPY TO JUST KEEP ON THROWING PROBLEMS AT
OK OK SO IT WASNT THE WISHING THAT AT TIMES I DID'NT LEAVE YOU - THEY KNOW YOU DONT HAVE THE ANSWER
CRAZY DAY OF TOO MUCH COFFEE PLAY BY THATS O.K THEY BUT THATS THE POINT - THEY MADE YOU WORRY
KNEW ANY BETTER BUT TO GO UP THE RULES THEY HAVE BEEN - GENERATIONS JUST PASS DOWN THIS TO KEEP WITH THE CASH
BUT YEAH THE WOLVES NEVER TO PLACES HERE AND THERE TIRED AND POINTLESS GIFT UNDERTONES SOUND SO COMFORTING
BE FORGOTTEN AS THE FAULT IT WAS FORGOTTEN TO SO IN TIMES LIKE THESE LIKE TO READ THAT GREY IS THE
AND EVERYTHING BEFORE WILL NEVER IT EVERYONE I LIKE TO THINK MARVIN COLOR FOR THE FORTHCOMING
BUT THEN THE TENSE CHANG FORGOTS TILL I TEXCEPT GAYE KNOWS HOW THE NEXT BIG THING SEASON. LAST NIGHT WAS ANOTHER
PHONE CALLS AT NIGHT SEEM LIKE IS REPLACED BY BY ME TO CALM THE THE RADIO MAN SIGHS BUT MAKING SURE LOST DREAM OF
MATCHES FLICKER WHILE THE DARKNESS STANDS ANOTHER SITUATION IN TO HIS MICROPHONE THAT EVERYTHING SOMETHING
STILL ONLY FORGETTING SOMETIMES THAT IT IS TO SCARE AND LEADS AND BOX SCREENS IS BACKED UP TWICE AND THRICE I TRIED
NOT TO COMFORT MEANWHILE THE ROCK AND ROLL STARS CAUSE THINGS AVOID THE ISSUE GROSS POINT BLANK IS TO OTHERWISE
CONTINUE TO COMFORT THE OPINION THAT THEY ARE TO WORK WITH POPSONG FROM MAYBE IT IS A SIGN MYSELF
JUST NOISE PRETEND FOR NOW DARKNESS FAILS AND OUT US EVER WAY OUT WEST BY OF A ONCE GOOD ACTOR
ALSO THE IS THINGS BEGIN TO CHANGE. WISHING DOESNT UNDERSTANDING A DUDE WHO SEEMS WAY BETTER THAN
FORECASTS FORGAVE MOST OF THE TIMES I AM SEEM TO MAKE A HOPEFUL IN THE RAMBO NO MATTER
FALLING IN LOVE HASNT BEEN NOT TO SURE OF DIFFERENCE BEYOND THE SWITCH SADNESS OF
A WHILE LAST TIME KINDA WHAT TO DO BUT AROUND THIS BUT ENOUGH OF THAT BECAUSE A C'MINOR WHAT NUMBER
KILLED ME FOR A YEAR WHEN THEN MOST OF THE TIME SEEMS TO FALL ON DEAF SOUNDS FROM THE PAST TO THAT EVEN
IT FELT UNLIKE A MOVIE FOR IT WORKS OUT JUST LIKE MAN SHOW HIM WHAT YOU CAN DO AND HOW THINGS WENT WRONG WITH
ACTION HERO DAYS SEEMS U R E SOMETIMES YOU THAT WHAT ARE THE GOTH KIDS FAULTED IN GREEN STRIPES HISTORY OF
TO HAVE GONE FOR NOW BUT M HAVE TO WONDER WHAT HOPING FOR - THE STEREO DAYS AMONG BIRDS SING IT ALL CHASING
AYBE THEY WILL RETURN SOME WAS GOING ON AND HOW BEFORE THE DAY AFTER THE FALL OBLIV. THEMSELVES ME LIKE
OTHER DAY HOPEFULLY ON THE AT THE TIME IT DID'NT AND THE PRESSURE CONTINUED TO US STUPID, AN ACUTE
AS OPPOSE TO THE SOONER MAKE SENSE BUT TO TO BUILD IN THE BOMBSHELTER NON BIRD SPEAKING ANGLE
POINT ALT ALL A LATER JUST LET IT GO SEEMED THE BEST HUMANS WHO UNLIKE
ROUND ME · GIVEN A GHOST WHERE YOU CAN WAIT TILL IT + UP AND AROUND KNOW OF NOTHING 40°
RULERS AND DOXES FALL UP IN THIS TOWN IS TIME FOR THE BUS TO ARRIVE IDEA FOR WITH NO WISHING EXCEPT TRAGEDY IN
AND THEN IT MAKES ME BEGIN A THEN THE AROUND AND SADNESS THE SHADE
WONDER DOES SHE EVEN THE BANAL INTRO OF COFFEE BEGINS SURE. BT BAKERIES FOR THESE WORDS TAKE SHE
NOW THINK OF ME AT CODIFICATION OF SOMETHING THAT MAN JUST 14 HOURS FISHBONES TOO MUCH TIME STOLE
TIMES OF SUCH A DIS-PHONE BOOTHS ON CORNERS NO LONGER EXISTS EITHER HERE OR FELL TO DAMN IT BEFORE MY HEART IN
TANCE THAT I DONT KNOW IN THE PURSUIT OF A BALCONY TO ON THE I HAVE TO NO MORE
EVEN NOW THINK IF SEE THE COAST THAT WHICH YOUR HISKNEE IT FALLS HOLMES GO AND THAN ONE
IS NORMAL OR FOR IGNORE DURING THE DAYTIME + AND CALLED PART OF ME THEORY FINISH MONTH
ME THINK OVER AND LIKE THE OLD MAN FROM A S TO HIS LORD STOP THE MUSIC AND ANOTHER
OVER AGAIN LIKE A CAMUS SHORT STORY. BUT AS FOR AND SILENCE GO HOME AND HEAR
POP SONG I REALLY LIKE I DONT THINK I KNOW FORGIVENESS OTHER THE EVEN NOW THESE
AT THE MOMEMENT A BUT I STILL HOPE THAT THE POST WILL DELIVER PLACE OF WORDS FALL SHORT
TIME THAT WILL PROB. SOMETHING NEW AND UNEXPECTED BECAUSE THE PAST WHEN THE BUS I WAS
BE FORGOTTEN IN THE ALWAYS, SOUNDS STILL SEEM HOPEFUL. PERHAPS IT IS TIME THAT MOMENT
ALTOGETHOR IT WILL A SEND SOME MORE WINNING A GAME + THAT CROSSROADS THE WAITING ON LEFT I
SENSE FOR HIDE+SEEK ISNT WORTH WINNING ON A MEANS TO AN AND OVER BY THE IT COULDNT GET ON
AND I CANT EVEN RE END YOU SEE AND WITH THAT THE TOYS DONT MEAN TOO BARBER IT BECAUSE FIGURE SOME
MEMBER WHEN I FIRST MUCH ANYMORE TO ANYONE - ITS A SHAME AND JUST BELOW SOMETHING THINGS OUT
RAN OR EVEN WALKED JUKEBOX DAYS SELECT WHAT IS IN MY HEAD INSIDE WAS WHEN
BACKWARDS FOR THE V. SOME DAYS YOU JUST CANT BUT HELP THINK THE FORTH BROKEN FOR SURE
FIRST TIME AND IF OF THAT GIRL - THE ONE WHO YOU LOVED NOT BLOCK BUT ALL WITH THREE WORDS
IT EVEN MADE ME H. KNOW THAT THERE WILL BE A TWILIGHT AS FAR AS FROM IGNORANCE
HAPPY AND THIS BE SINGLE DAY THAT SINGLE FACT WILL MAKE IT THE TALL NARROW A GIRL IN THE CZECH
FORE I EVEN KNE WORTHWHILE LIKE THAT FOR THIRD TIME IN AS M. BRIDGE WOKE UP FOR ANOTHER DAY AT REP.
BUT THEN I THE FACTORY SHOOTING TIMBER YARDS LIKE A BAD DIRECTOR EMAILS FROM RIO
EVERY SOMETIMES 22 MAIL FROM X BUT HEY ITS GOT A POSTER MAKE ME SMILE
OVER ROLLED SMOKES THERE A ITS GOT TO BE O.K I THINK THAT IS THE A GREE
AVEC BAD AND CAPTAIN AND THIS EXACT SAME FIRST TIME I GOT
SAIL MEAN COLLECTS O ATTITUDE HAS BUT DON'T CRY BELAUSE
CALLS OVER BY THE IT CAUSED GENERALLY IT IS NOT WORTH THE
BY STATION IS ME TO SEE TOO MANY FINAL TEARS TAPED
HOME THE BOY BAD FILMS, SURE THE CUSTOM OVER WINTER
IS WHO FOR DESIGN WAS IMPRESSIVE MARKED FOR
FOR NOW BUT IT WAS A MUSICAL NOW
SEEMED TO KNOW NO BETTER AND THAT WILL JUST
I THINK IN THIS TOWN MY BY NOT PASS NOT
LIFE COULD PASS BY WITH MY
WAITING FRUSTRATION MY

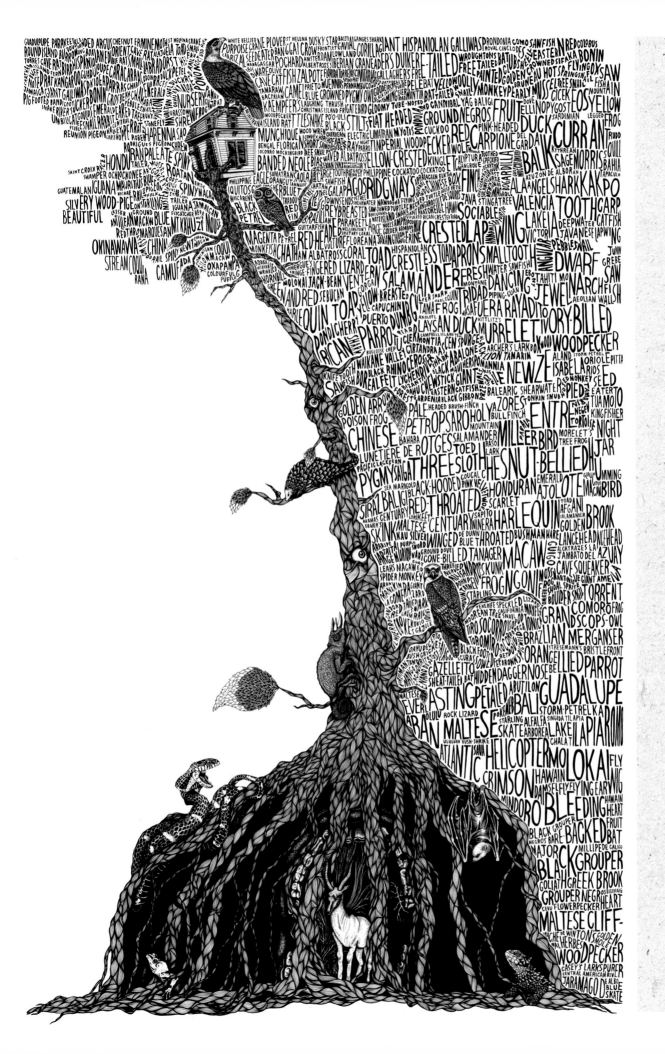

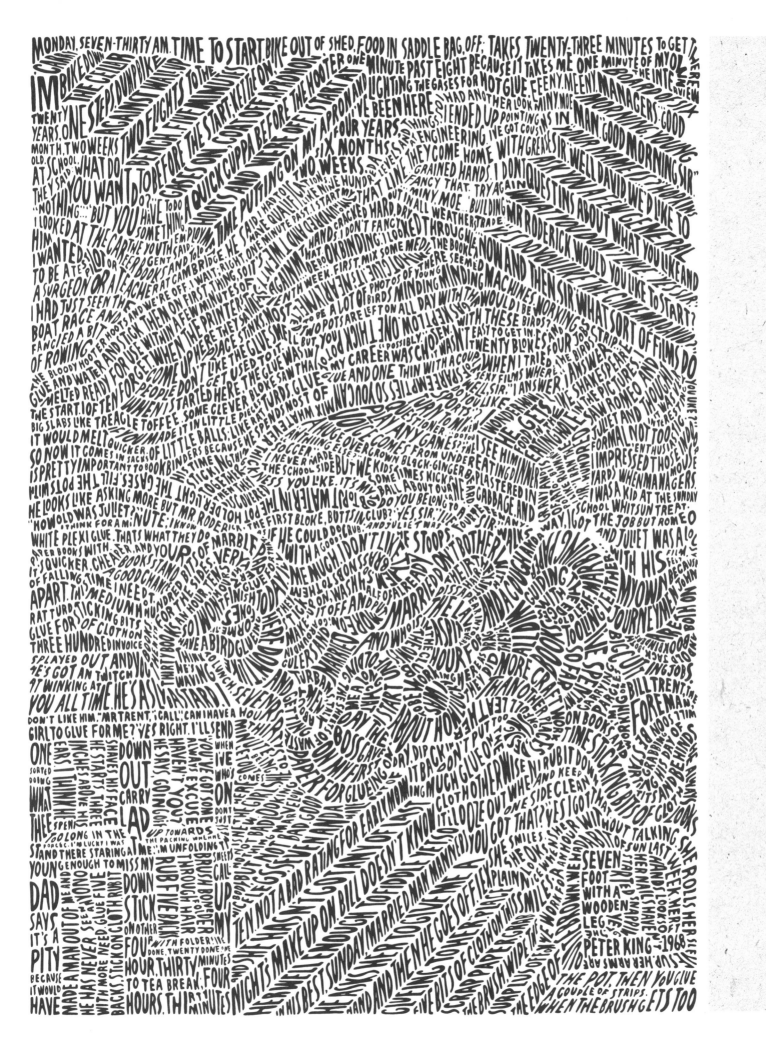

Sarah King

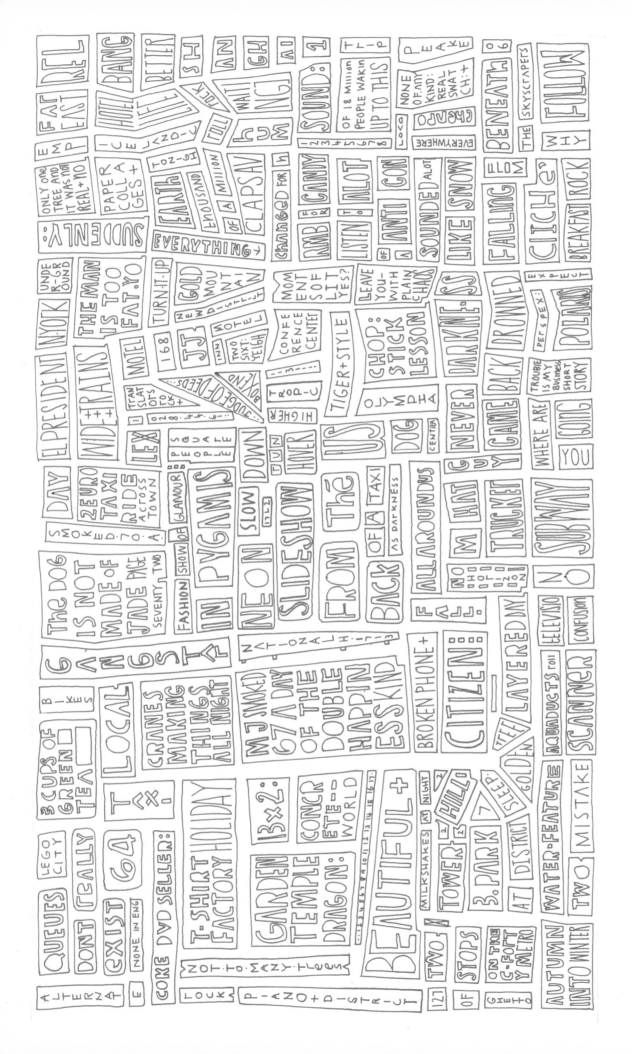

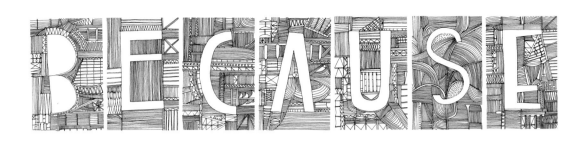

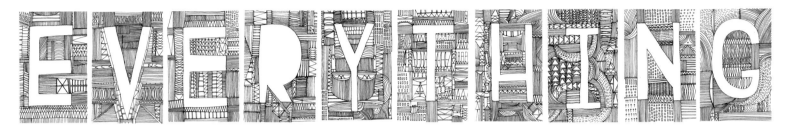

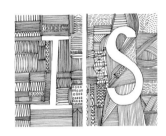

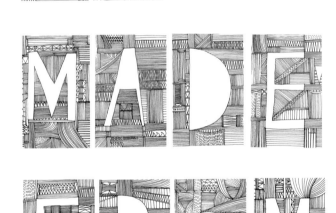

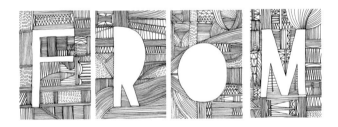

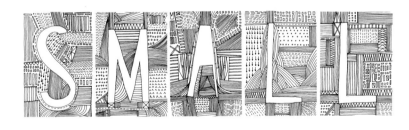

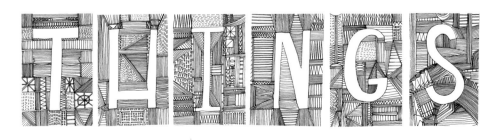

BECAUSE EVERYTHING IS MADE FROM SMALL THINGS

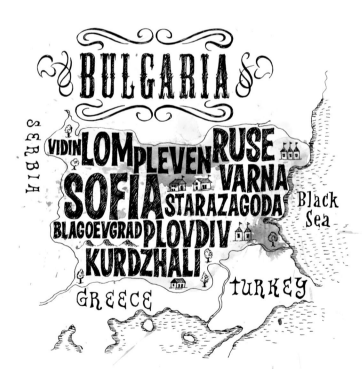

FINLAND.

RUSSIA

IVALO

ROVANIEMI

OULU

KOKKOLA

KUOPIO

JOENSUU

PORI VAASA VARKAUS

RAUMA TAMPERE

UUSIKAUPUNKI LAHTI

TURKU HAMINA

HELSINKI KOTKA

LOVIISA

Gulf of
Bothnia

Gulf of Finland

Lake
Ladoga

Fiodor Sumkin

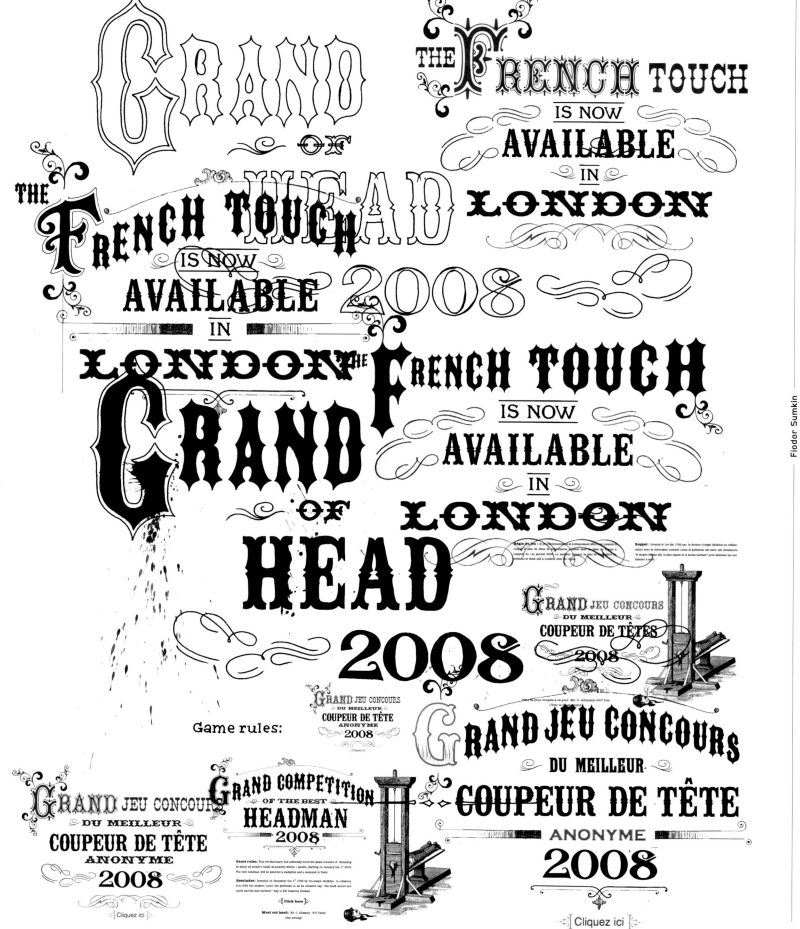

GRAND
OR
HEAD

THE FRENCH TOUCH
IS NOW
AVAILABLE
IN
LONDON

THE FRENCH TOUCH
IS NOW
AVAILABLE
IN
LONDON

2008

THE FRENCH TOUCH
IS NOW
AVAILABLE
IN
LONDON

GRAND
OF
HEAD
2008

GRAND JEU CONCOURS
DU MEILLEUR
COUPEUR DE TÊTES
2008

GRAND JEU CONCOURS
DU MEILLEUR
COUPEUR DE TÊTE
ANONYME
2008

Game rules:

GRAND JEU CONCOURS
DU MEILLEUR
COUPEUR DE TÊTE
ANONYME
2008

GRAND JEU CONCOUR
DU MEILLEUR
COUPEUR DE TÊTE
ANONYME
2008

-:[Cliquez ici]:-

GRAND COMPETITION
OF THE BEST
HEADMAN
2008

Game rules: This revolutionary and politically incorrect game consists of beheading as many ad people's heads as possible within 1 month, starting on January the 1st 2008. The best headman will be awarded a medallion and a weekend in Paris.

Reminder: Invented on December the 1st 1789 by Dr.Joseph Guillotin, in collaboration with the surgeon Louis, the guillotine is, as its creators say, "the most secure and quick and the less barbaric" way to kill someone doomed.

-:[Click here]:-

Most cut head: Mr G. Altmann- 547 times
(See sorting)

-:[Cliquez ici]:-

Règle du jeu : ce jeu révolutionnaire et politiquement incorrect consiste à couper le plus de têtes de publicitaires possibles dans un délai de 1 mois à compter du 1er janvier 2008. Le meilleur coupeur de tête se verra offrir un médaillon et week end à Londres chez les frères.

Rappel : inventée le 1er déc 1789 par le docteur Joseph Guillotin en collaboration avec le chirurgien Antoine Louis la guillotine est selon ses inventeurs "le moyen le plus sûr, le plus rapide et le moins barbare" pour exécuter les condamner à mort.

Tête la plus coupée à ce jour Mr G. Altmann-547 fois
(Voir le classement)

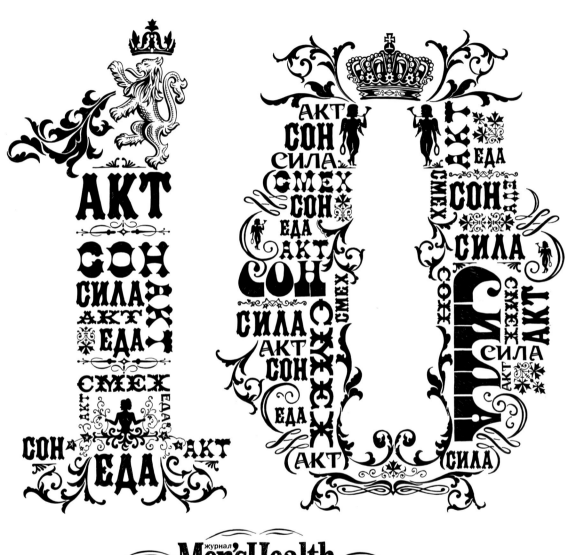

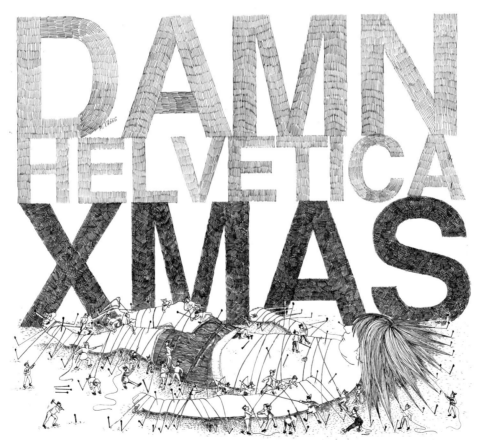

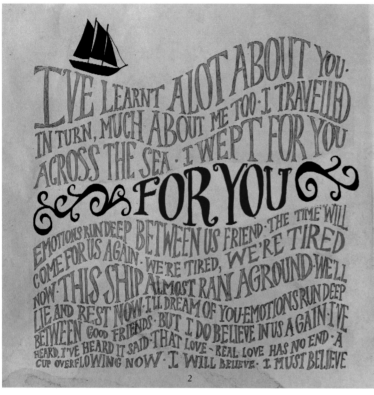

I'VE LEARNT ALOT ABOUT YOU. IN TURN, MUCH ABOUT ME TOO. I TRAVELLED ACROSS THE SEA. I WEPT FOR YOU. **FOR YOU** EMOTIONS RUN DEEP BETWEEN US FRIEND. THE TIME WILL COME FOR US AGAIN. WE'RE TIRED, WE'RE TIRED NOW. THIS SHIP ALMOST RAN AGROUND. WELL LIE AND REST NOW. I'LL DREAM OF YOU. EMOTIONS RUN DEEP BETWEEN GOOD FRIENDS. BUT I DO BELIEVE IN US AGAIN. I'VE HEARD, I'VE HEARD IT SAID THAT LOVE - REAL LOVE HAS NO END - A CUP OVERFLOWING NOW. I WILL BELIEVE. I MUST BELIEVE

2

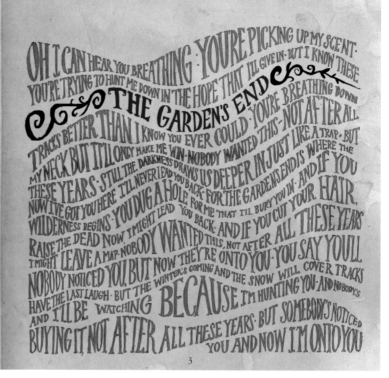

OH I CAN HEAR YOU BREATHING. YOU'RE PICKING UP MY SCENT. YOU'RE TRYING TO HUNT ME DOWN IN THE HOPE THAT I'LL GIVE IN. BUT I KNOW THESE **THE GARDEN'S END** TRACKS BETTER THAN I KNOW YOU EVER COULD. YOU'RE BREATHING DOWN MY NECK BUT IT'LL ONLY MAKE ME WIN. NOBODY WANTED THIS. NOT AFTER ALL THESE YEARS. STILL THE DARKNESS DRAWS US DEEPER IN JUST LIKE A TRAP. BUT NOW I'VE GOT YOU HERE I'LL NEVER LEAD YOU BACK. FOR THE GARDEN'S END IS WHERE THE WILDERNESS BEGINS. YOU DUG A HOLE FOR ME THAT I'LL BURY YOU IN. AND IF YOU RAISE THE DEAD NOW, I MIGHT LEAD YOU BACK. AND IF YOU CUT YOUR HAIR, I MIGHT LEAVE A MAP. NOBODY WANTED THIS, NOT AFTER ALL THESE YEARS. NOBODY NOTICED YOU, BUT NOW THEY'RE ONTO YOU. YOU SAY YOU'LL HAVE THE LAST LAUGH. BUT THE WINTER'S COMING AND THE SNOW WILL COVER TRACKS AND I'LL BE WATCHING **BECAUSE** I'M HUNTING YOU. AND NOBODY'S BUYING IT, NOT AFTER ALL THESE YEARS. BUT SOMEBODY'S NOTICED YOU AND NOW I'M ONTO YOU

3

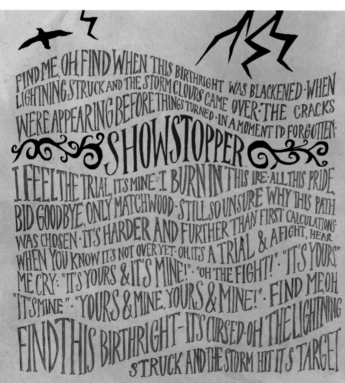

FIND ME, OH FIND WHEN THIS BIRTHRIGHT WAS BLACKENED. WHEN LIGHTNING STRUCK AND THE STORM CLOUDS CAME OVER. THE CRACKS WERE APPEARING BEFORE THINGS TURNED. IN A MOMENT I'D FORGOTTEN. **SHOWSTOPPER** I FEEL THE TRIAL, IT'S MINE. I BURN IN THIS IRE. ALL THIS PRIDE, BID GOODBYE. ONLY MATCHWOOD. STILL SO UNSURE WHY THIS PATH WAS CHOSEN. IT'S HARDER AND FURTHER THAN FIRST CALCULATIONS. WHEN YOU KNOW IT'S NOT OVER YET. OH, IT'S A TRIAL & A FIGHT, HEAR ME CRY: "IT'S YOURS & IT'S MINE!" "OH THE FIGHT!" "IT'S YOURS," "IT'S MINE", "YOURS & MINE, YOURS & MINE!". FIND ME, OH **FIND THIS** BIRTHRIGHT - IT'S CURSED - OH THE LIGHTNING STRUCK AND THE STORM HIT IT'S TARGET

12

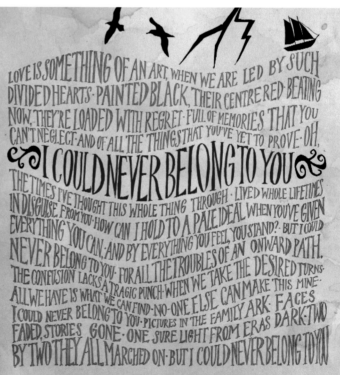

LOVE IS SOMETHING OF AN ART, WHEN WE ARE LED BY SUCH DIVIDED HEARTS. PAINTED BLACK, THEIR CENTRE RED. BEATING NOW, THEY'RE LOADED WITH REGRET. FULL OF MEMORIES THAT YOU CAN'T NEGLECT. AND OF ALL THE THINGS THAT YOU'VE YET TO PROVE. OH, **I COULD NEVER BELONG TO YOU** THE TIMES I'VE THOUGHT THIS WHOLE THING THROUGH. LIVED WHOLE LIFETIMES IN DISGUISE FROM YOU. HOW CAN I HOLD TO A PALE IDEAL WHEN YOU'VE GIVEN EVERYTHING YOU CAN. AND BY EVERYTHING YOU FEEL, YOU STAND? BUT I COULD NEVER BELONG TO YOU. FOR ALL THE TROUBLES OF AN ONWARD PATH. THE CONFUSION LACKS A TRAGIC PUNCH. WHEN WE TAKE THE DESIRED TURNS. ALL WE HAVE IS WHAT WE CAN FIND. NO-ONE ELSE CAN MAKE THIS MINE. I COULD NEVER BELONG TO YOU. PICTURES IN THE FAMILY ARK. FACES FADED, STORIES GONE. ONE SURE LIGHT FROM ERAS DARK. TWO BY TWO THEY ALL MARCHED ON. BUT I COULD NEVER BELONG TO YOU

13

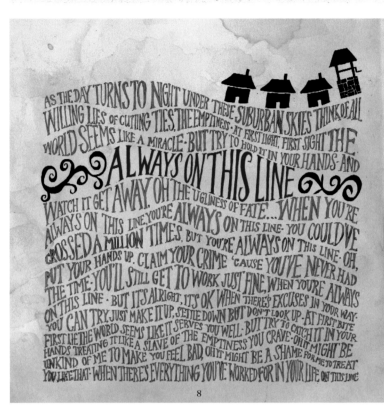

AS THE DAY TURNS TO NIGHT UNDER THESE SUBURBAN SKIES THINK OF ALL WILLING LIES OF CUTTING TIES, THE EMPTINESS - AT FIRST LIGHT, FIRST SIGHT THE WORLD SEEMS LIKE A MIRACLE - BUT TRY TO HOLD IT IN YOUR HANDS - AND

ALWAYS ON THIS LINE

WATCH IT GET AWAY - OH THE UGLINESS OF FATE... WHEN YOU'RE ALWAYS ON THIS LINE, YOU'RE ALWAYS ON THIS LINE - YOU COULD'VE CROSSED A MILLION TIMES, BUT YOU'RE ALWAYS ON THIS LINE - OH, PUT YOUR HANDS UP, CLAIM YOUR CRIME 'CAUSE YOU'VE NEVER HAD THE TIME - YOU'LL STILL GET TO WORK JUST FINE, WHEN YOU'RE ALWAYS ON THIS LINE - BUT IT'S ALRIGHT, IT'S OK WHEN THERE'S EXCUSES IN YOUR WAY - YOU CAN TRY, JUST MAKE IT UP, SETTLE DOWN BUT DON'T LOOK UP - AT FIRST BITE FIRST LIE THE WORLD SEEMS LIKE IT SERVES YOU WELL - BUT TRY TO CATCH IT IN YOUR HANDS TREATING IT LIKE A SLAVE OF THE EMPTINESS YOU CRAVE - OH IT MIGHT BE UNKIND OF ME TO MAKE YOU FEEL BAD, OH IT MIGHT BE A SHAME FOR ME TO TREAT YOU LIKE THAT - WHEN THERE'S EVERYTHING YOU'VE WORKED FOR IN YOUR LIFE ON THIS LINE

8

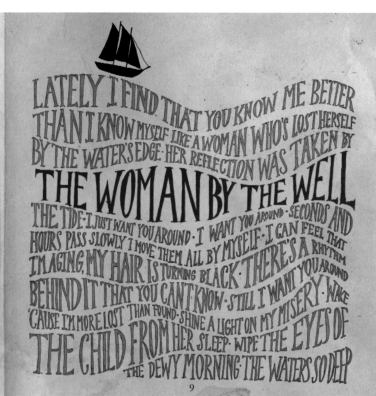

LATELY I FIND THAT YOU KNOW ME BETTER THAN I KNOW MYSELF - LIKE A WOMAN WHO'S LOST HERSELF BY THE WATER'S EDGE - HER REFLECTION WAS TAKEN BY

THE WOMAN BY THE WELL

THE TIDE - I JUST WANT YOU AROUND - I WANT YOU AROUND - SECONDS AND HOURS PASS SLOWLY I MOVE THEM ALL BY MYSELF - I CAN FEEL THAT I'M AGING, MY HAIR IS TURNING BLACK - THERE'S A RHYTHM BEHIND IT THAT YOU CAN'T KNOW - STILL I WANT YOU AROUND 'CAUSE I'M MORE LOST THAN FOUND - SHINE A LIGHT ON MY MISERY - WAKE THE CHILD FROM HER SLEEP - WIPE THE EYES OF THE DEWY MORNING THE WATERS SO DEEP

9

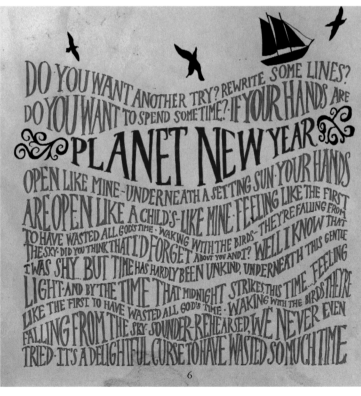

DO YOU WANT ANOTHER TRY? REWRITE SOME LINES? DO YOU WANT TO SPEND SOME TIME? IF YOUR HANDS ARE

PLANET NEW YEAR

OPEN LIKE MINE - UNDERNEATH A SETTING SUN - YOUR HANDS ARE OPEN LIKE A CHILD'S - LIKE MINE - FEELING LIKE THE FIRST TO HAVE WASTED ALL GOD'S TIME - WAKING WITH THE BIRDS - THEY'RE FALLING FROM THE SKY - DID YOU THINK THAT I'D FORGET ABOUT YOU AND I? - WELL I KNOW THAT I WAS SHY... BUT TIME HAS HARDLY BEEN UNKIND, UNDERNEATH THIS GENTLE LIGHT - AND BY THE TIME THAT MIDNIGHT STRIKES, THIS TIME... FEELING LIKE THE FIRST TO HAVE WASTED ALL GOD'S TIME - WAKING WITH THE BIRDS THEY'RE FALLING FROM THE SKY - UNDER-REHEARSED, WE NEVER EVEN TRIED - IT'S A DELIGHTFUL CURSE TO HAVE WASTED SO MUCH TIME

6

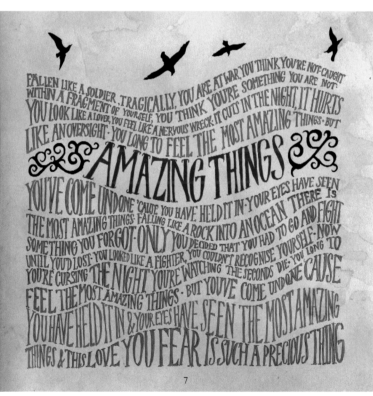

FALLEN LIKE A SOLDIER - TRAGICALLY, YOU ARE AT WAR, YOU THINK YOU'RE NOT CAUGHT WITHIN A FRAGMENT OF YOURSELF, YOU THINK YOU'RE SOMETHING YOU ARE NOT - YOU LOOK LIKE A LOVER, YOU FEEL LIKE A NERVOUS WRECK, IT CUTS IN THE NIGHT, IT HURTS LIKE AN OVERSIGHT - YOU LONG TO FEEL THE MOST AMAZING THINGS - BUT

AMAZING THINGS

YOU'VE COME UNDONE 'CAUSE YOU HAVE HELD IT IN - YOUR EYES HAVE SEEN THE MOST AMAZING THINGS - FALLING LIKE A ROCK INTO AN OCEAN THERE IS SOMETHING YOU FORGOT - ONLY YOU DECIDED THAT YOU HAD TO GO AND FIGHT UNTIL YOU'D LOST - YOU LOOKED LIKE A FIGHTER, YOU COULDN'T RECOGNISE YOURSELF - NOW YOU'RE CURSING THE NIGHT YOU'RE WATCHING THE SECONDS DIE - YOU LONG TO FEEL THE MOST AMAZING THINGS - BUT YOU'VE COME UNDONE 'CAUSE YOU HAVE HELD IT IN & YOUR EYES HAVE SEEN THE MOST AMAZING THINGS & THIS LOVE YOU FEAR IS SUCH A PRECIOUS THING

7

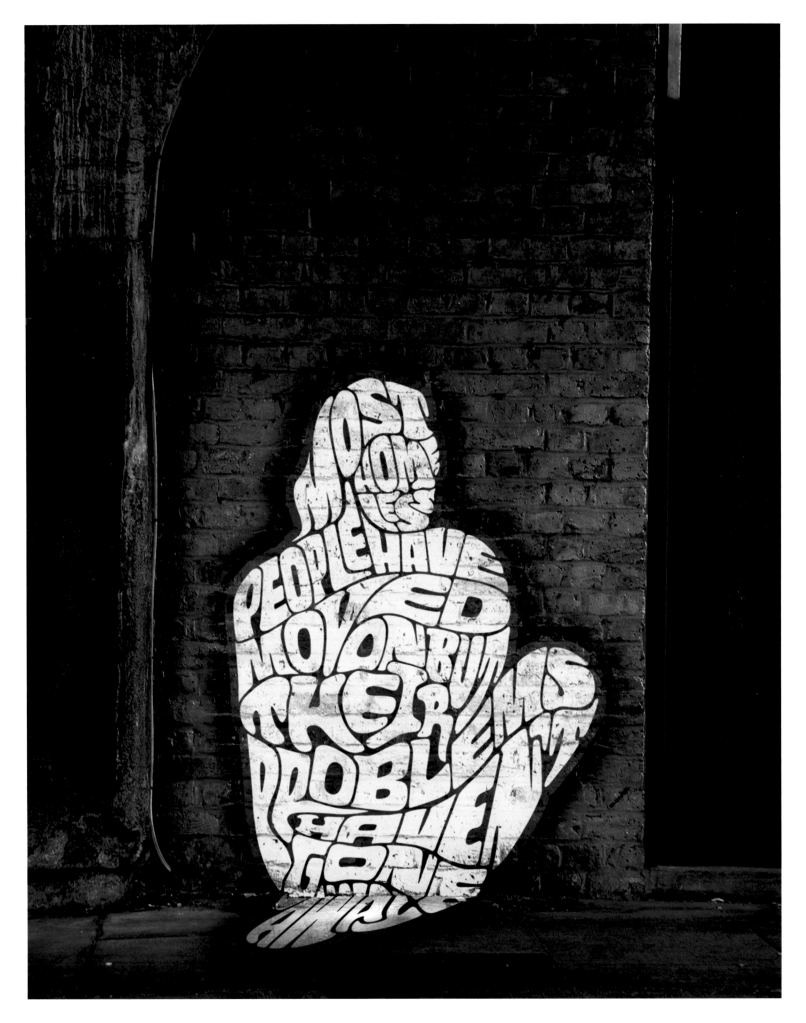

EXTREMELY & LOUD INCREDIBLY CLOSE

AUTHOR OF THE INTERNATIONAL BESTSELLER EVERYTHING IS ILLUMINATED

JONATHAN SAFRAN FOER

A NOVEL

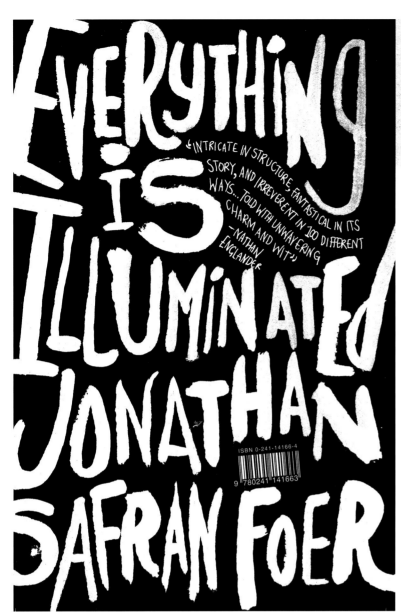

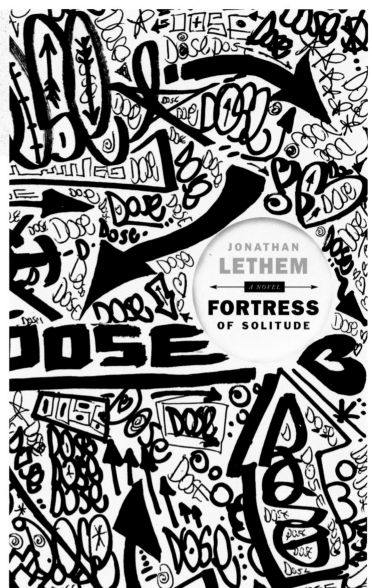

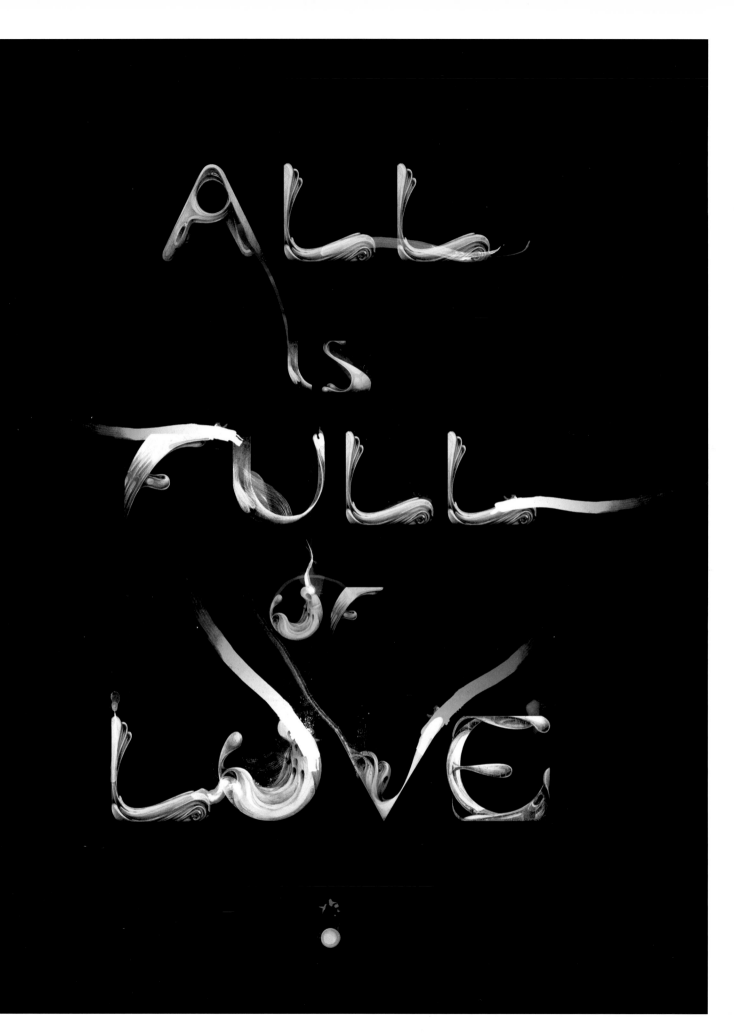

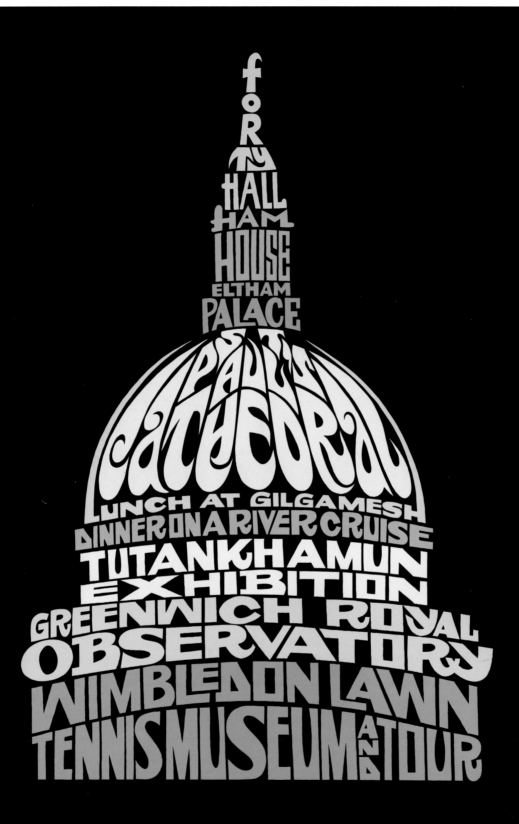

FORTY HALL
HAM HOUSE
ELTHAM PALACE
ST PAULS CATHEDRAL
LUNCH AT GILGAMESH
DINNER ON A RIVER CRUISE
TUTANKHAMUN EXHIBITION
GREENWICH ROYAL OBSERVATORY
WIMBLEDON LAWN TENNIS MUSEUM AND TOUR

'Best UK City' as awarded by Group Leisure
Magazine and www.groupleisure.com.
For great ideas on group visits to London
visitlondon.com

Studio Oscar

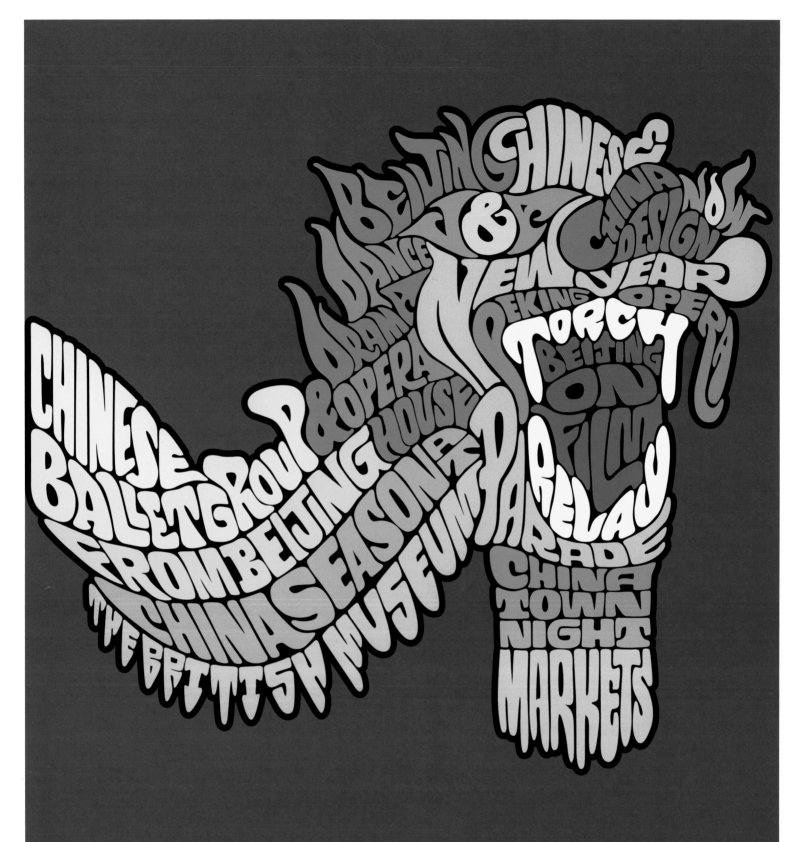

China comes to London.
To enjoy events and festivals across the capital
www.visitlondon.com/china

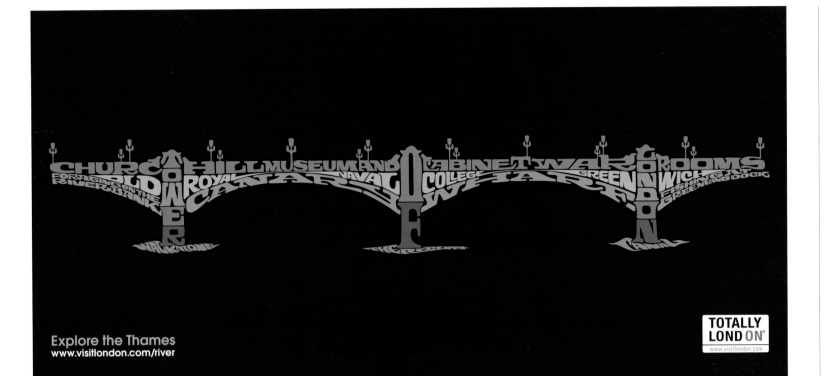

Explore the Thames
www.visitlondon.com/river

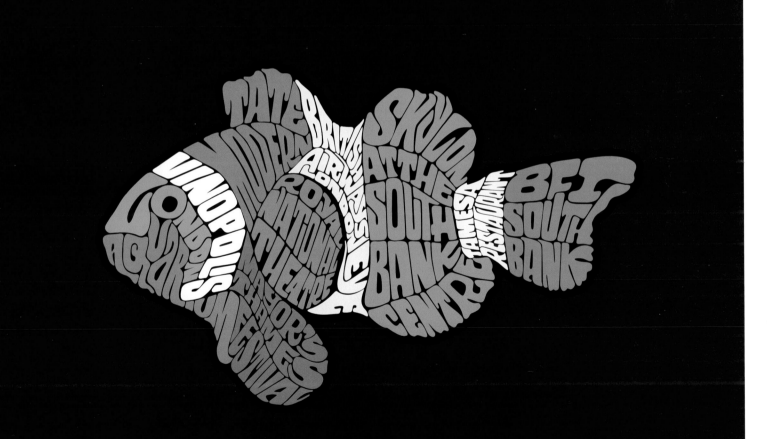

Explore the Thames
by the Southbank
www.visitlondon.com/river

TYPE SUPREME • • • • • • • • •

Powerful colours clash, fresh shapes twist and shift, typography gets built up from scratch and constructed to a shiny new type experience. The fascination lies in the originality and challenge of these graphical creations. Readable or not, they certainly engage the viewer, trigger the eye through pulsating patterns and blur the line between letter and ornament, typography and illustration.

The second chapter of Playful Type introduces constructed type solutions, which almost entirely abstain from using existing fonts. Instead, partly similar to designing a logo, a free arrangement of graphical shapes and patterns to a word, sentence or headline acts as the starting point of creation. The playfulness lies in the free experimentation with shapes, colours, structure and handling the odds. Some of the typographical principals developed for these unique pieces can later be extended and worked into a full alphabet. This is especially conducive when creating a certain identity with these strong letters, particularly in the field of editorial design.

When taking a quick look at the current situation and future scenarios of the magazine and newspaper market, it is easy to understand why free and individual headlines and titles, hence new typographic solutions, are so in demand at present. The Internet as an omnipresent and interactive medium has already taken over much of the up-to-the-minute information formerly assigned to newspapers or television. In response, newspapers are forced to focus on longer, more in depth background reports resulting in newspapers taking on more of a magazine character.

This is already evident when viewing the layout changes made by many newspapers (longer texts and editorials, series of non-time-related information, magazine supplements such as the German Die Zeit's magazine "Leben" or the British The Guardian's "The Observer" magazine).

These shifts will have – and already have had – consequences for designers throughout the world, since the popularity of special interest publications in the field of magazines has already drastically improved. Germany, for instance, has around 3,500 magazine titles and nearly 400 daily, weekly and Sunday newspapers appearing regularly at present, but on top of this it is currently experiencing a veritable boom. Not only are the flagships of the print era being thoroughly revamped to ensure that they can live up to the new requirements, but in publishing houses throughout, new niche magazines are popping up like mushrooms. Due to the fact that adverts are able to target a highly specific readership, especially with the evolution of additional newspaper-esque magazines – this also promises economical success, which is one of the reasons for more leeway being granted to designers with room for experimentation.

But this is not the only reason why fresh and unusual typographic approaches are in demand. It is the omnipresent craving for identity, uniqueness and individuality that drives designers to create these unique type solutions. Influences in this typographic field of constructing letters are anything from simple geometry to 70s posters, organic shapes to vector-graphic patterns. Other huge fields of application alongside editorial design are posters, flyers and individual purpose-contingent creations.

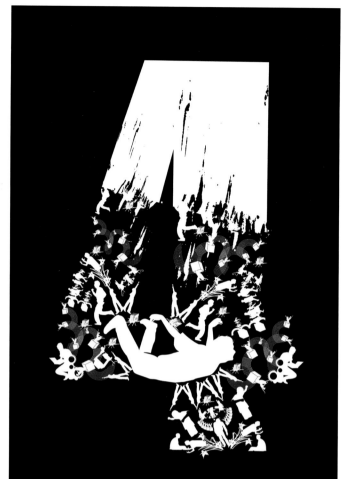
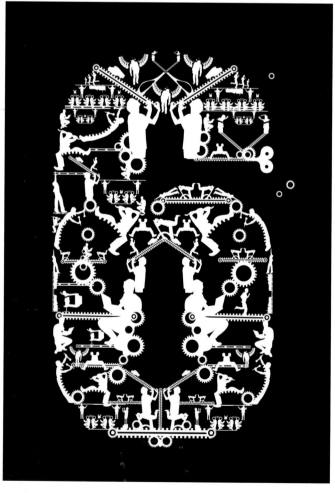
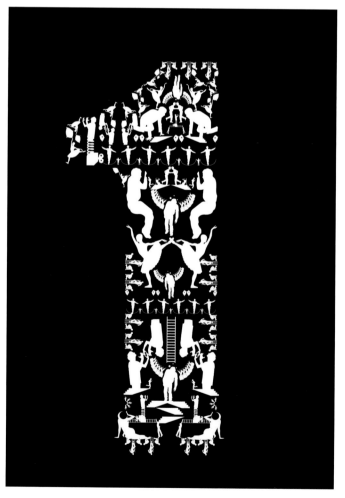

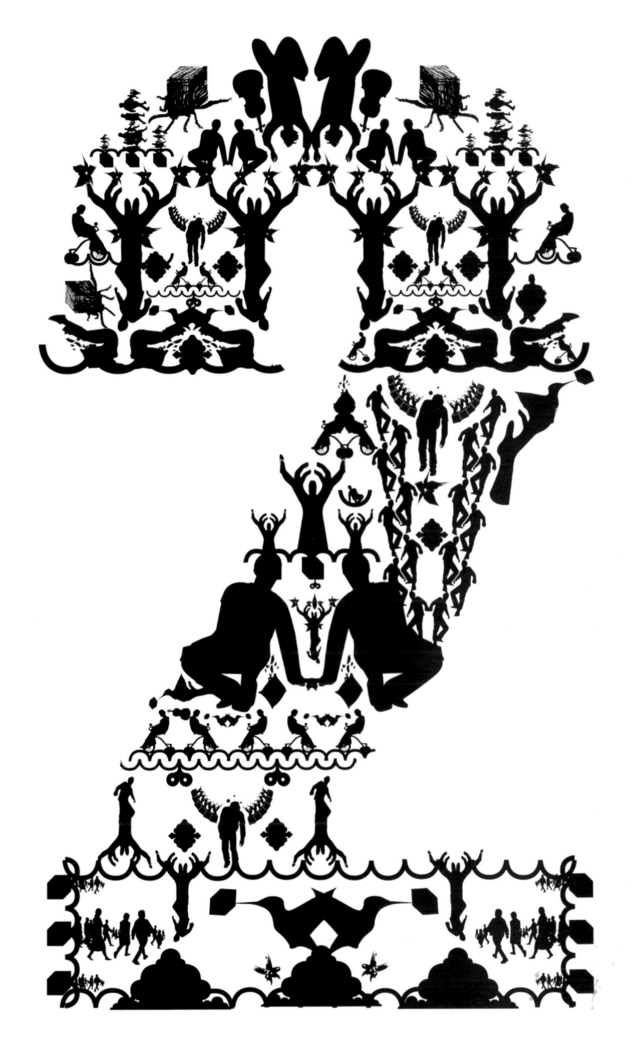

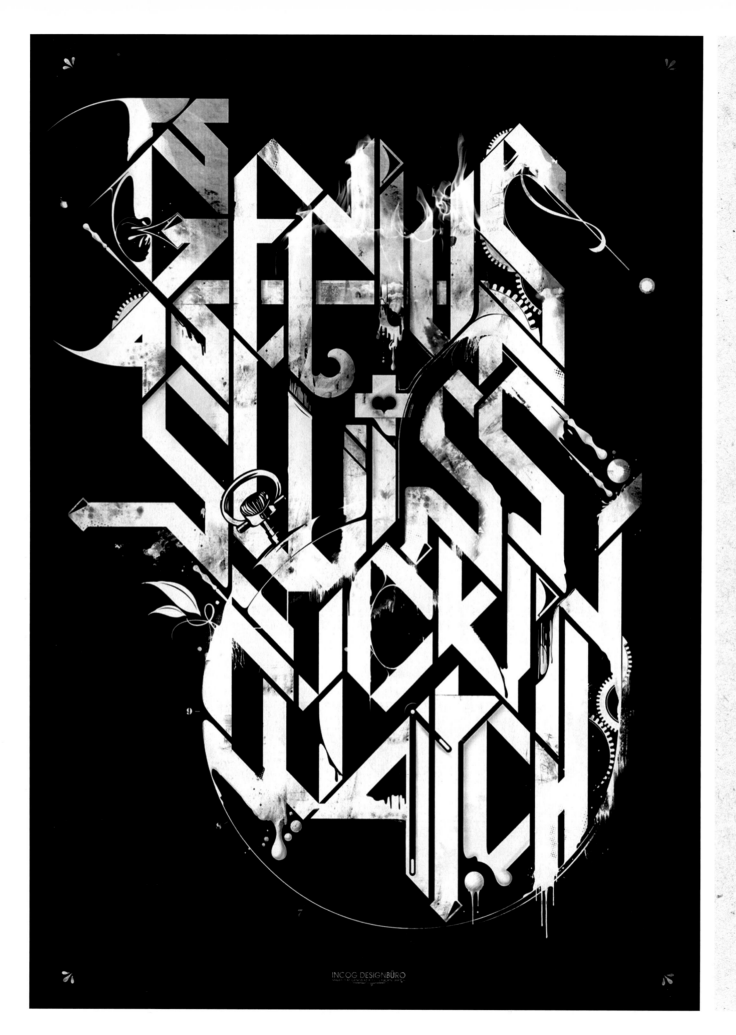

Damien Vignaux

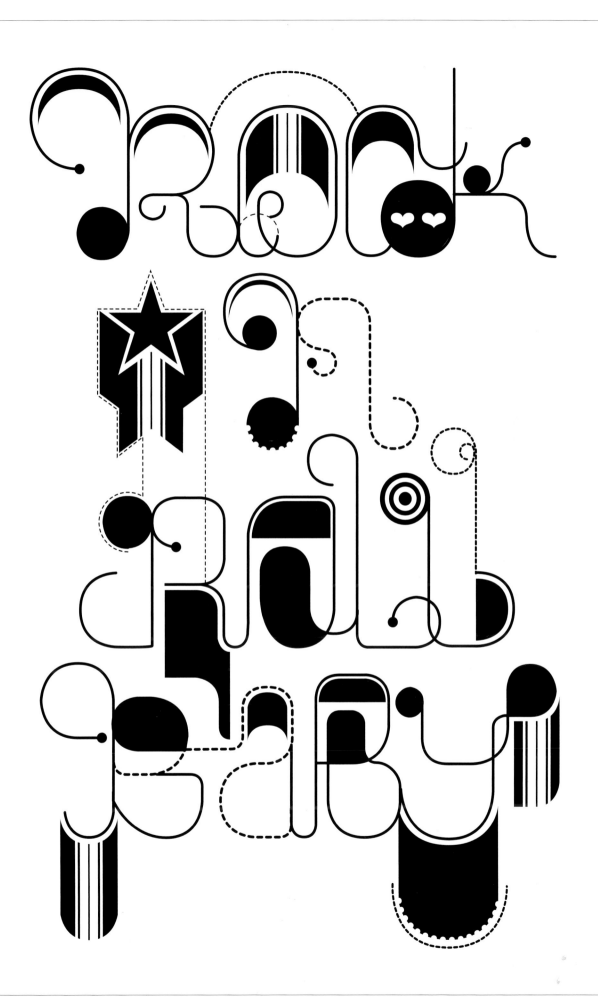

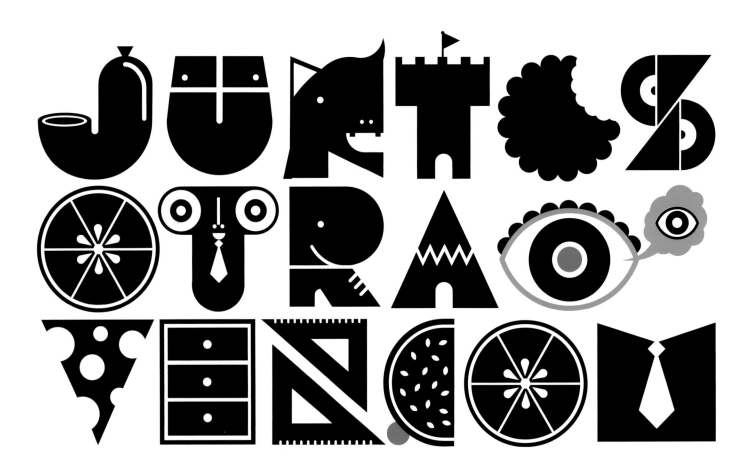

TOGETHER ONE MORE TIME.COM

JUNTOS OTRA VEZ.COM

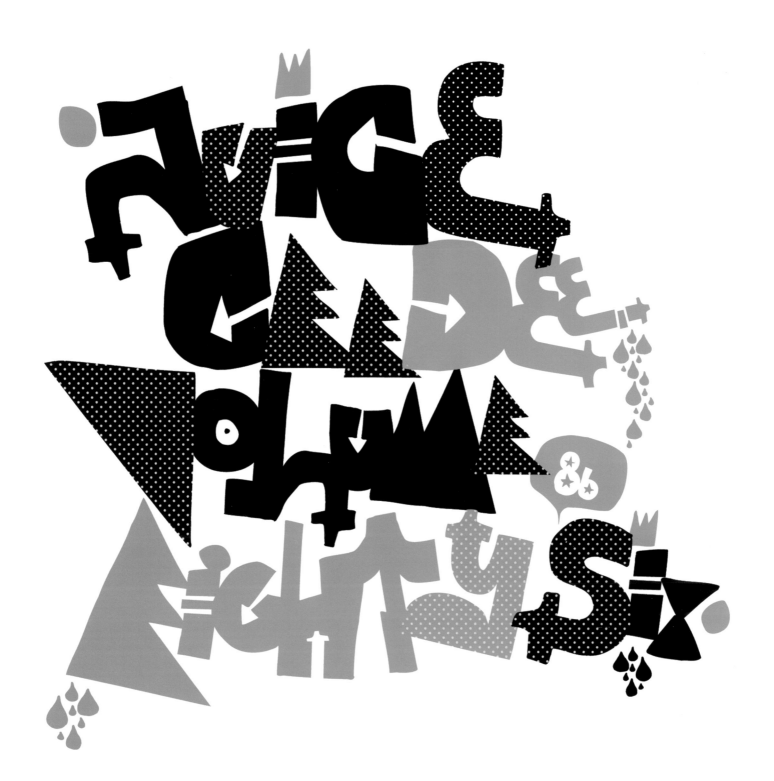

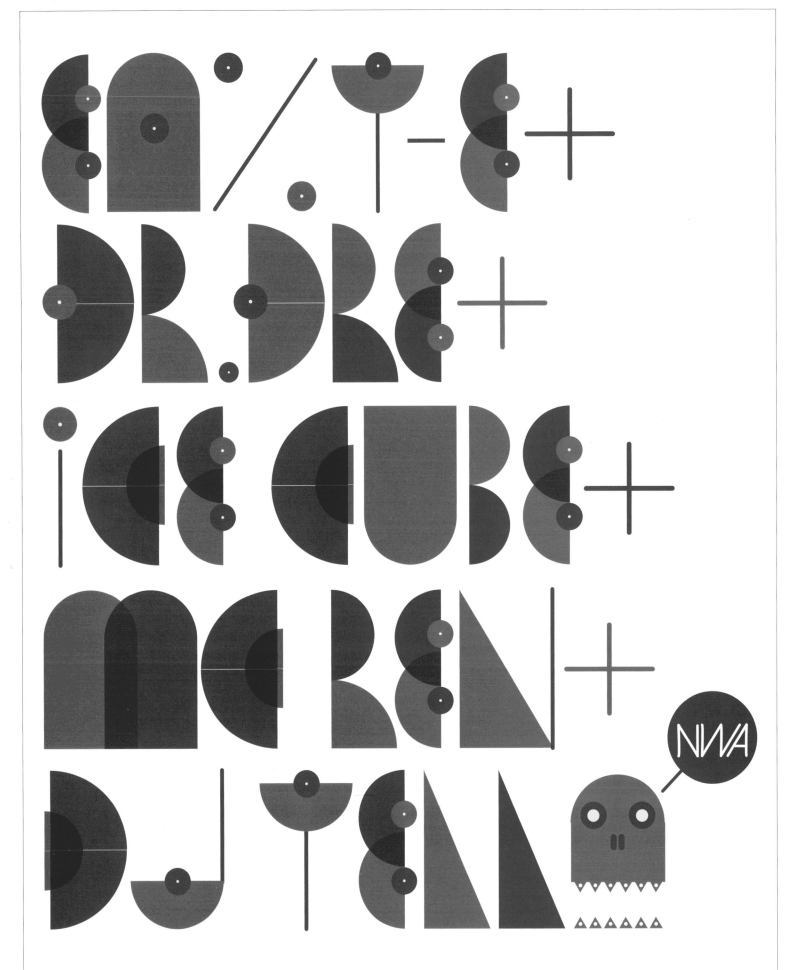

THE BEAUTIFUL CITY OF LISBON.

MUI NOBRE E SEMPRE LEAL
CIDADE DE LISBOA

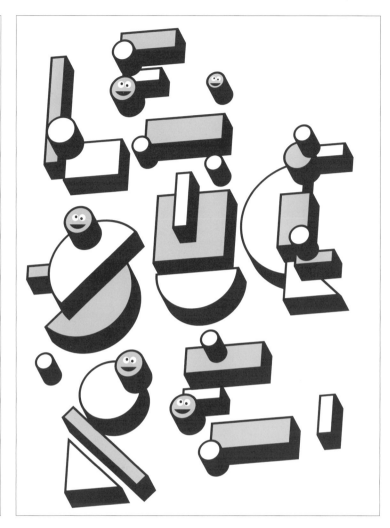

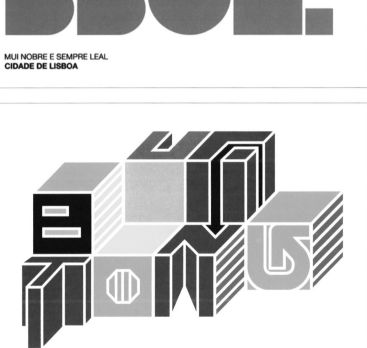

FINDERS
KEEPERS
LOSERS
WEEPERS

Mediaone Unltd. (top left), Falko Ohlmer (top right), Soldier Design (bottom left), Karoly Kiralyfalvi (bottom left)

MARK AND THE SPIES

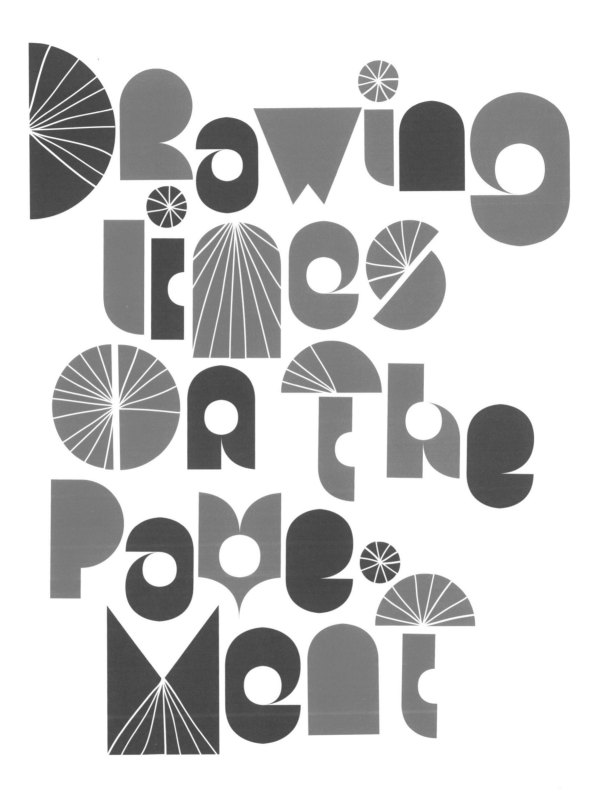

Drawing lines on the pavement

Emil Kozak

Jonathan Prêteux

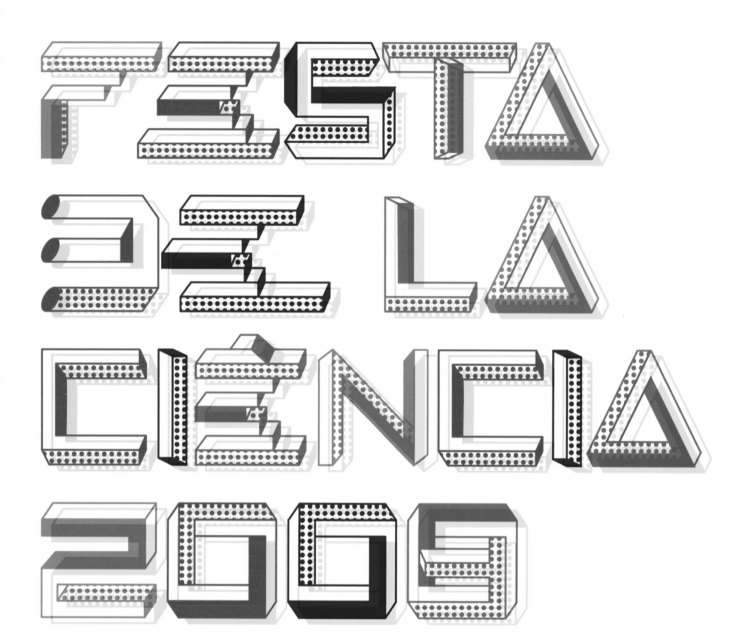

FESTA
DE LA
CIÈNCIA
2008

Vine al
Parc de la
Ciutadella el
7 i 8 de juny

Més de
50 activitats
per a tots
els públics!

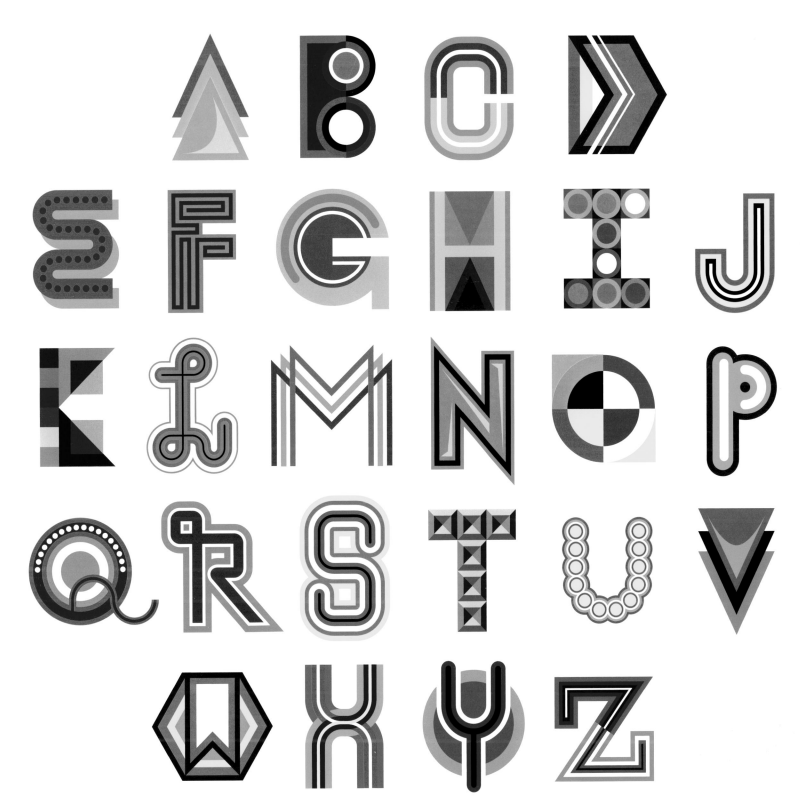

Matt W. Moore

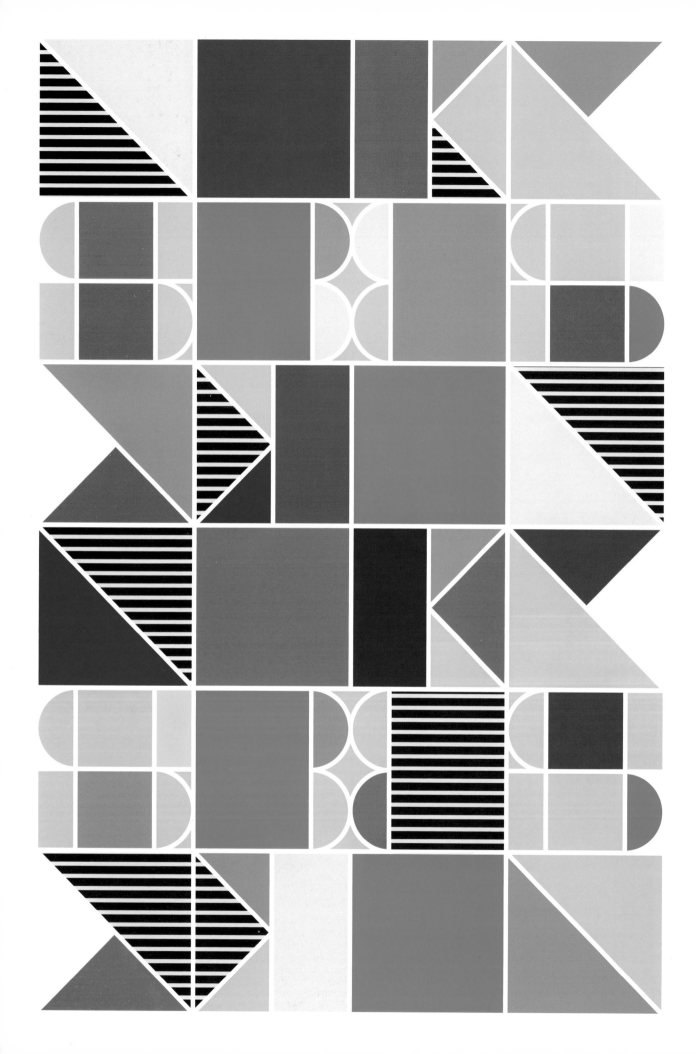

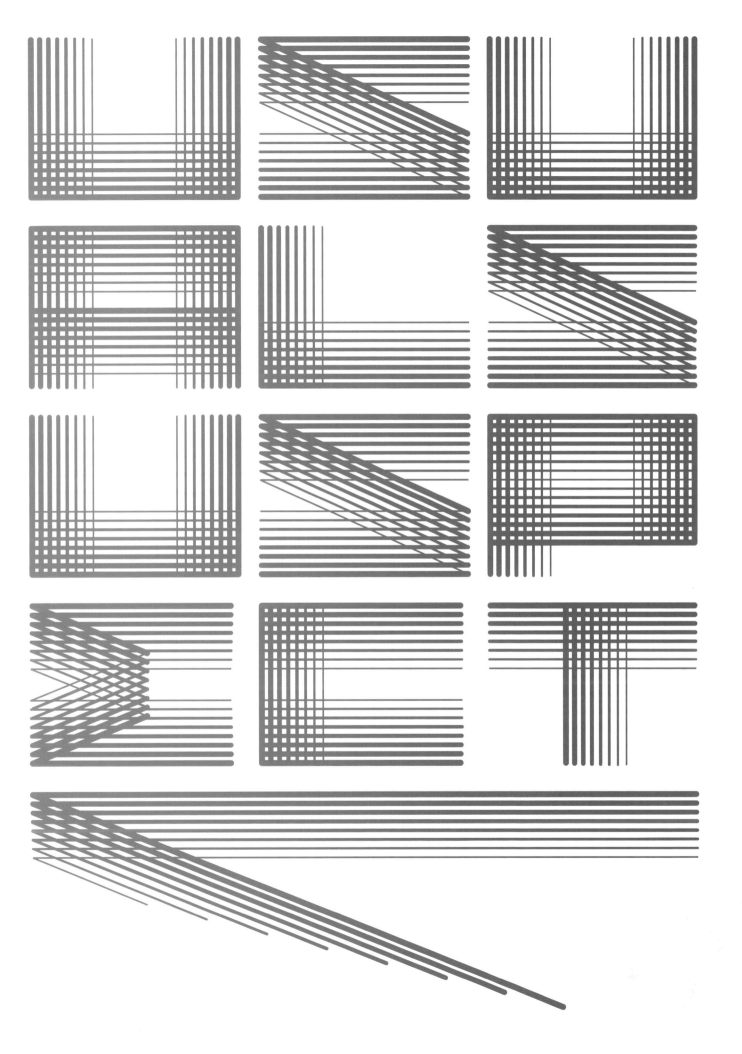

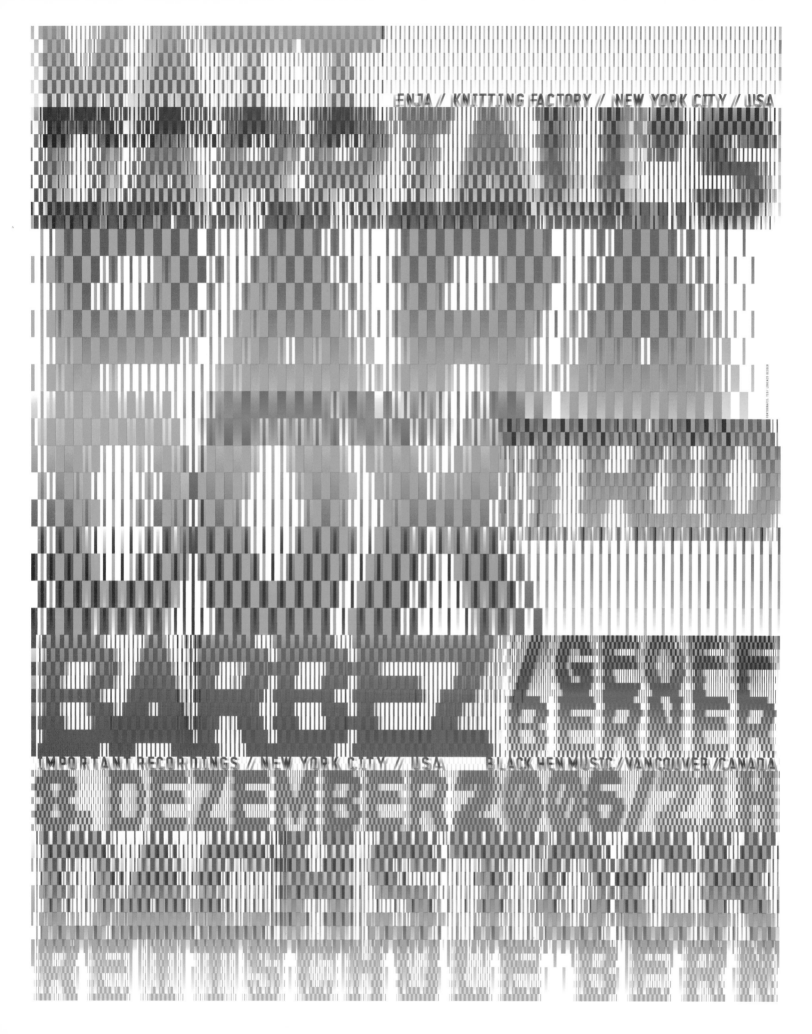

IMPORTANT RECORDINGS // NEW YORK CITY // USA BLACK HEN MUSIC // VANCOUVER // CANADA

Lorenzo Geiger

VERNON REID/JAMAALADEEN TACUMA/G.CALVIN WESTON
A.K.A. **FREE FORM FUNKY FREQS**
SUPPORTED BY EXPANDER (BE) / DJ SUPERFINO (BE)
FRIDAY, 16TH NOVEMBER 2007/DOORS 21:00
DACHSTOCK REITSCHULE BERN

TYPOGRAPHICDESIGN: TD/LORENZO GEIGER

Killer sudoku, whodunnit?, giant crossword … plus Christmas TV and radio guide

Marian Bantjes

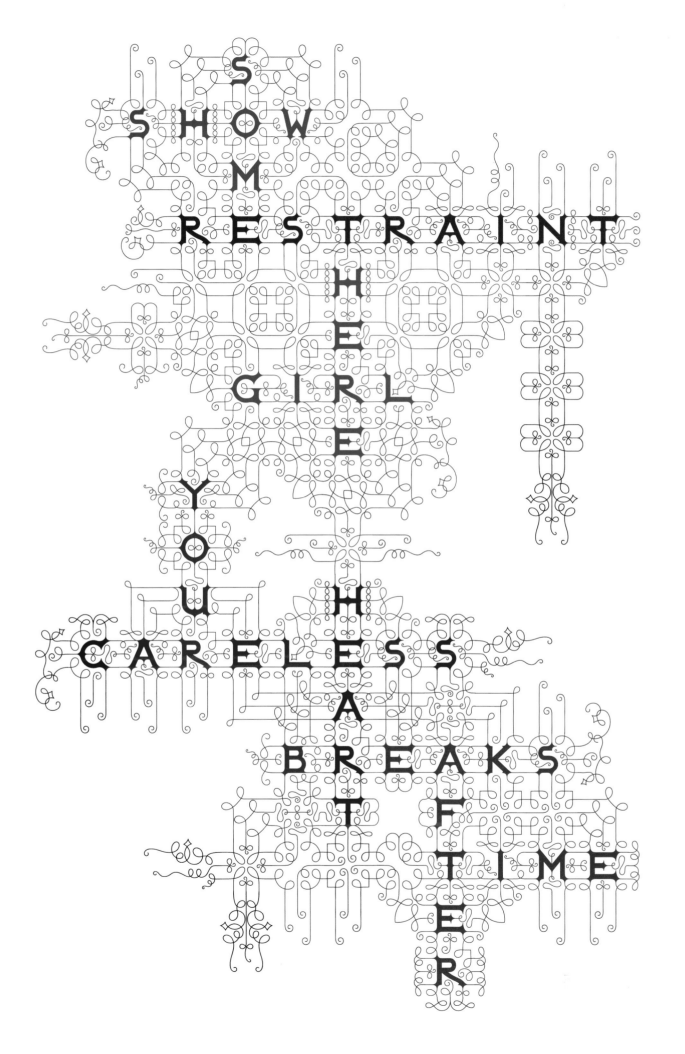

SHOW SOME RESTRAINT THE GIRL YOU CARELESS HEART BREAKS AFTER TIME

print

DESIGN CULTURE MEDIA
JUL/AUG 2006 US$12.95/CAN$15.95

Print's Past, Present, Future

Soviet Children's Books

The Girls' Guide to Chick Lit

New Novels' Tricky Type

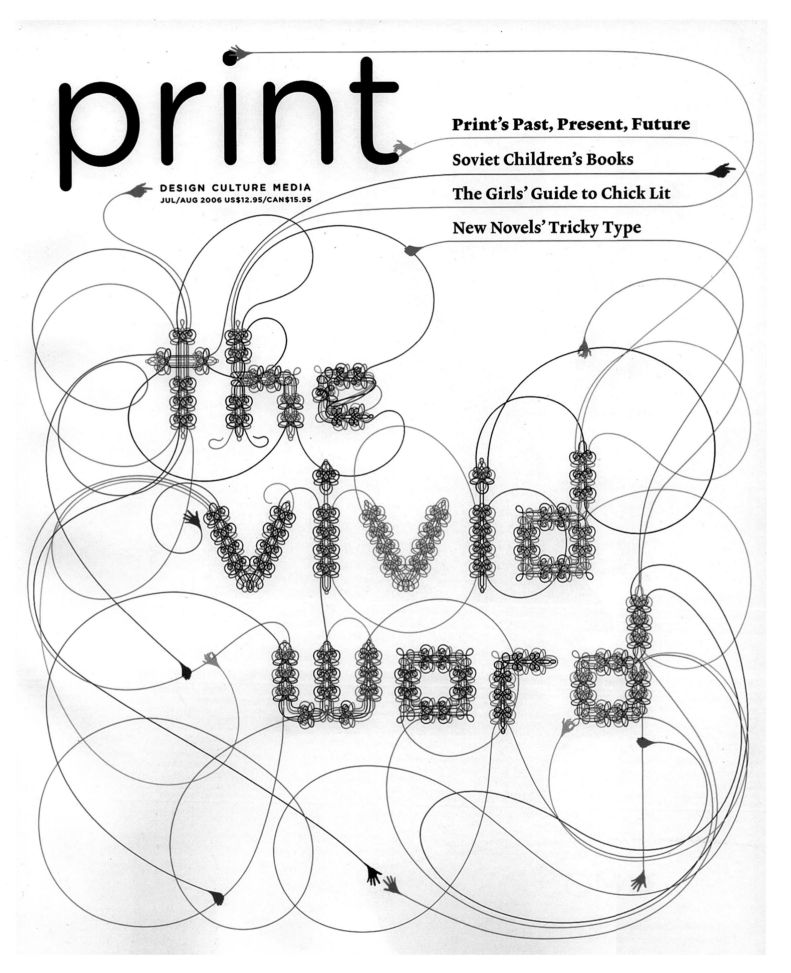

Yoshi Tajima

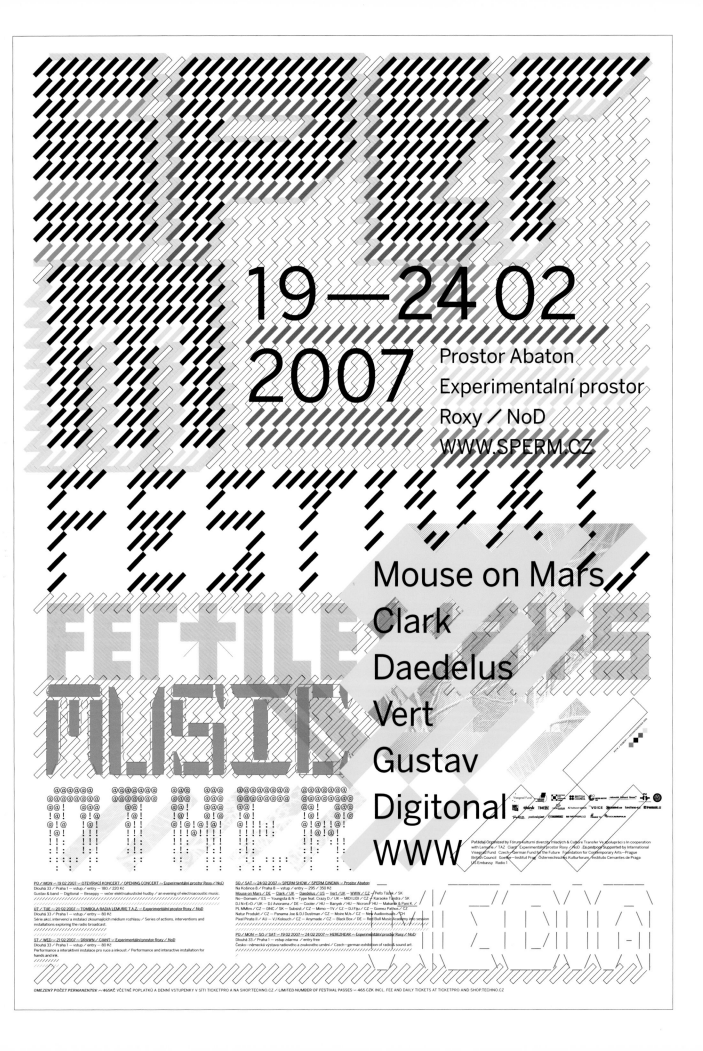

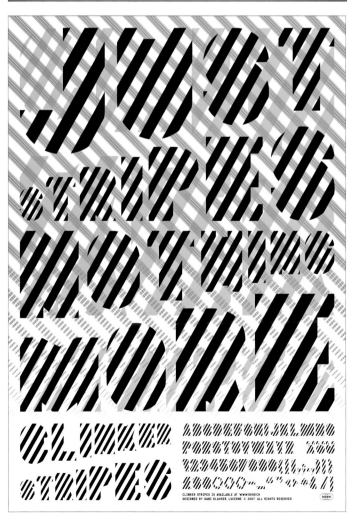

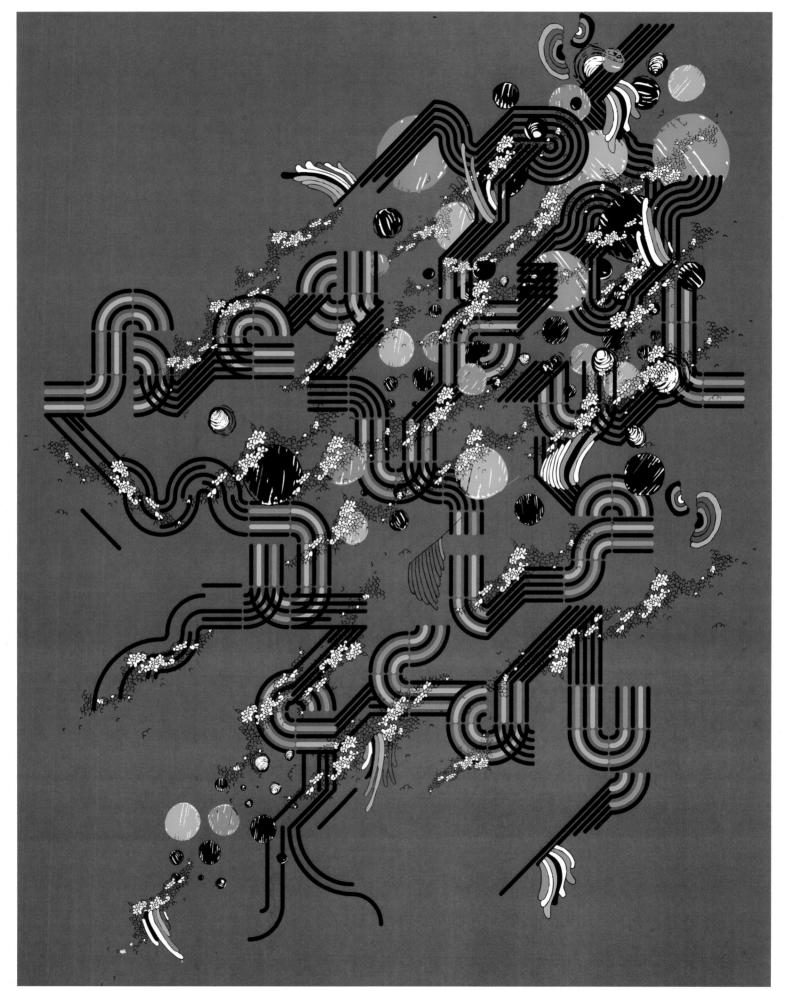

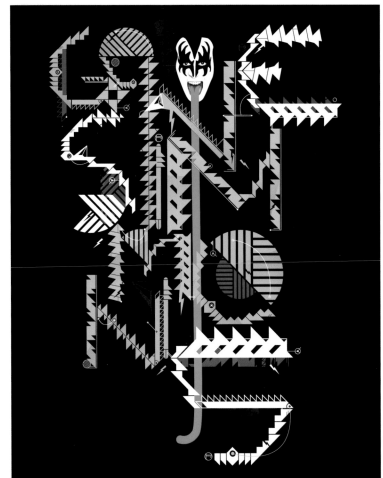

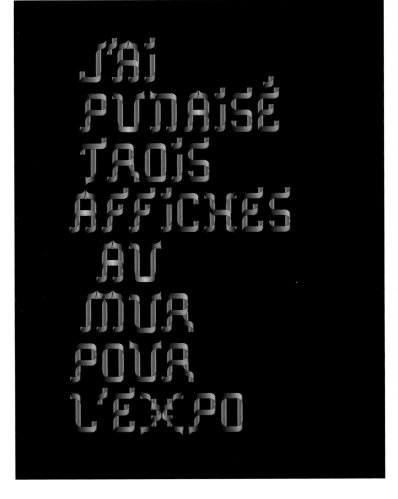

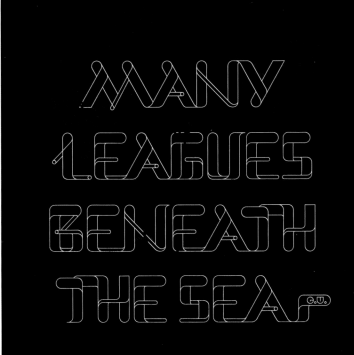

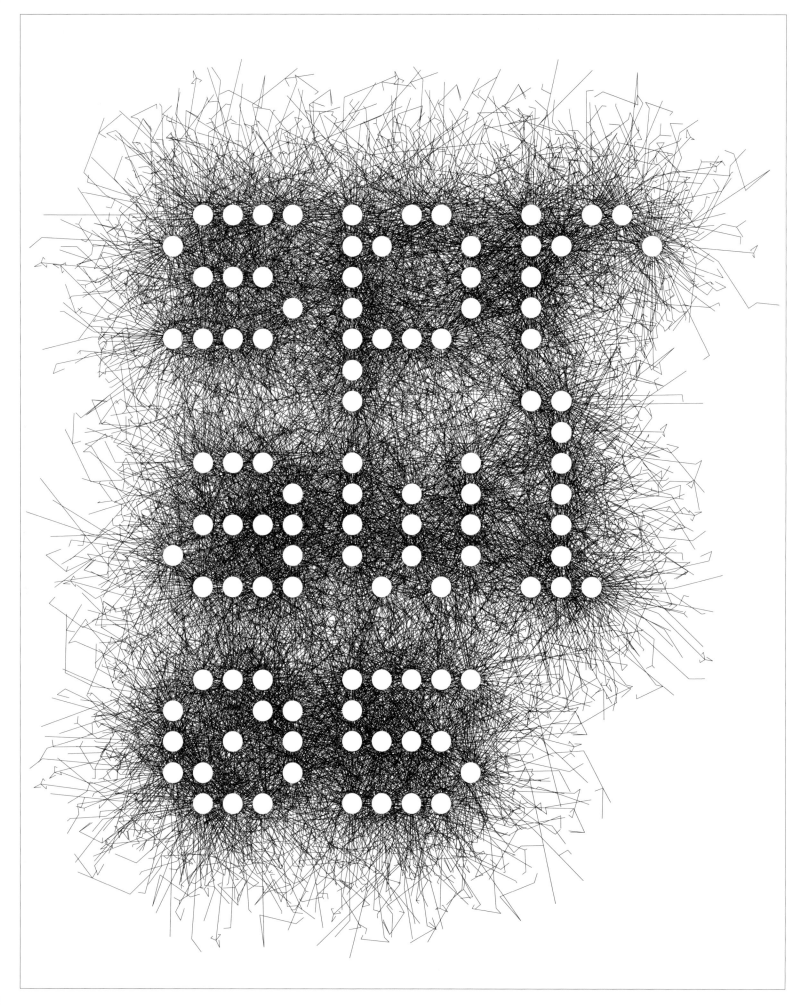

Alex Robbins

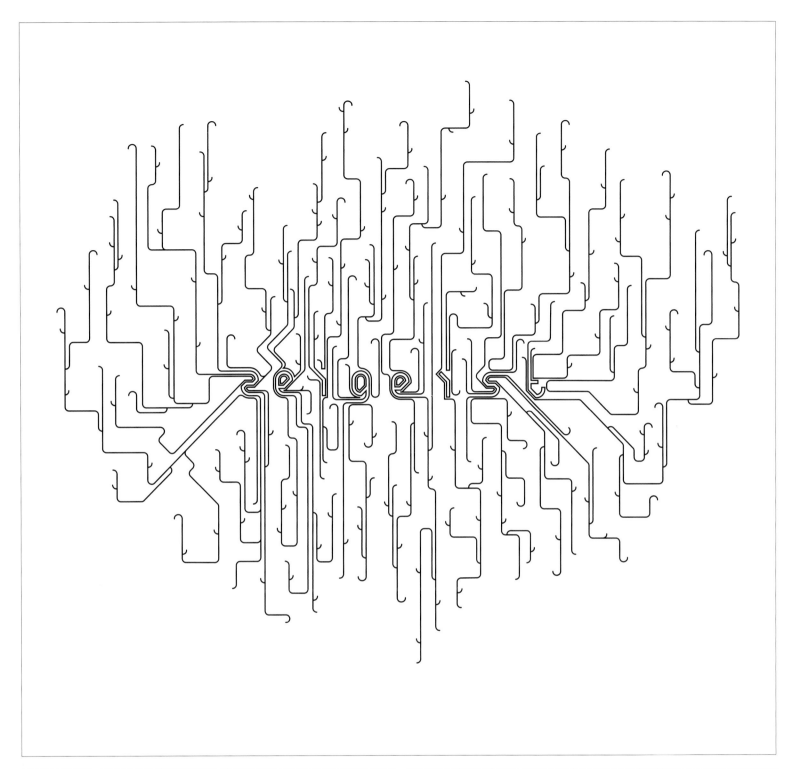

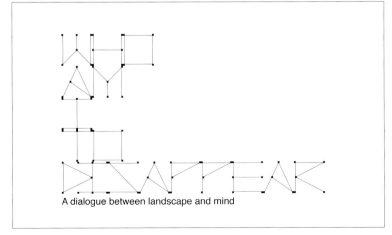

A dialogue between landscape and mind

Niklas-H (top), DTAM™ (bottom left), GVA Studio (bottom right)

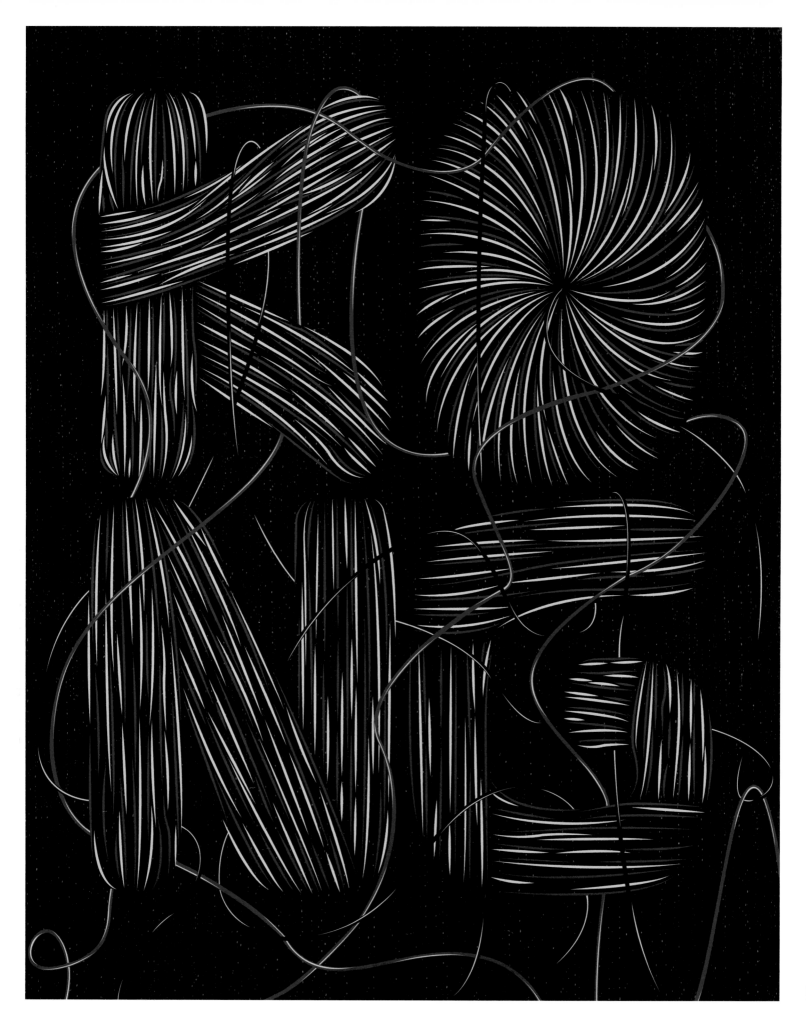

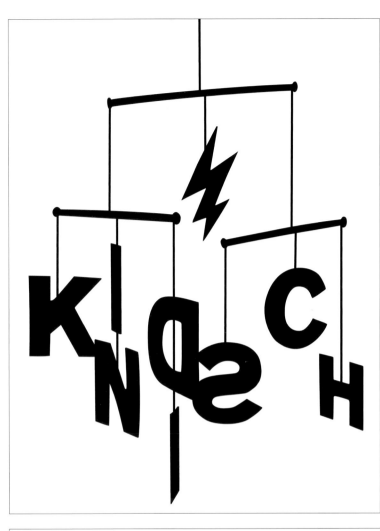

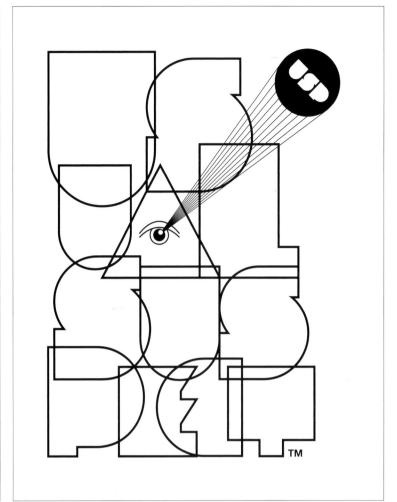

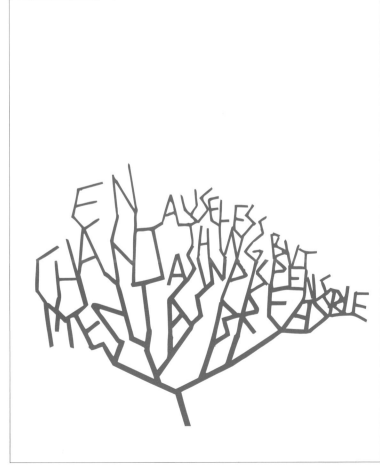

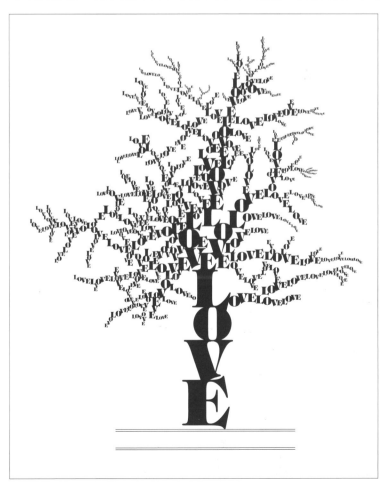

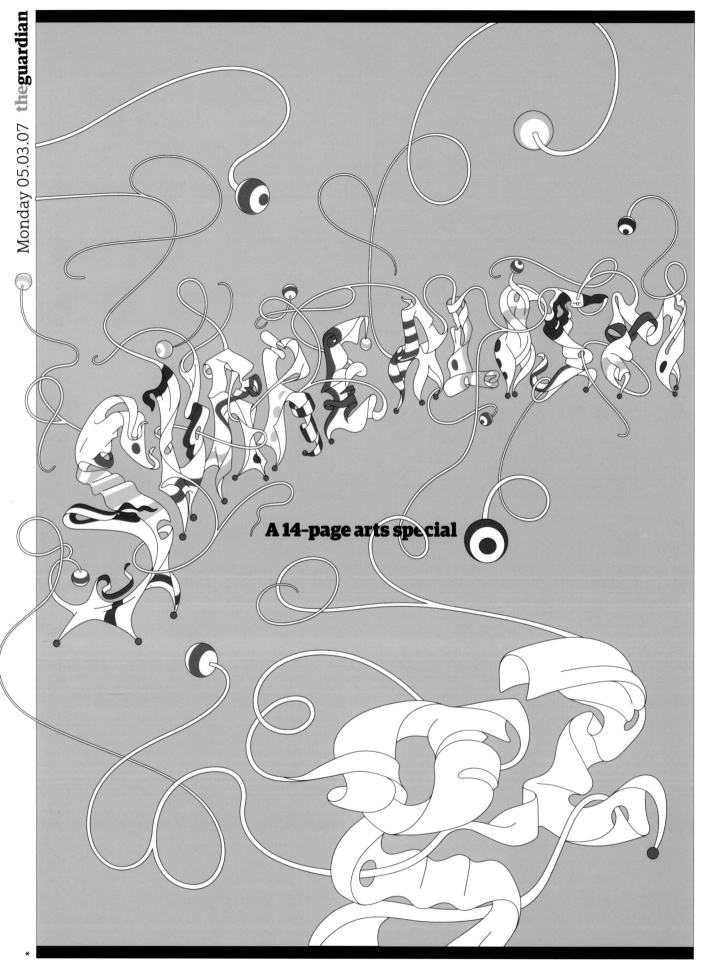

A 14-page arts special

The meaning of 'meh' Charlie Brooker Urban cycling: a survival guide

Marian Bantjes

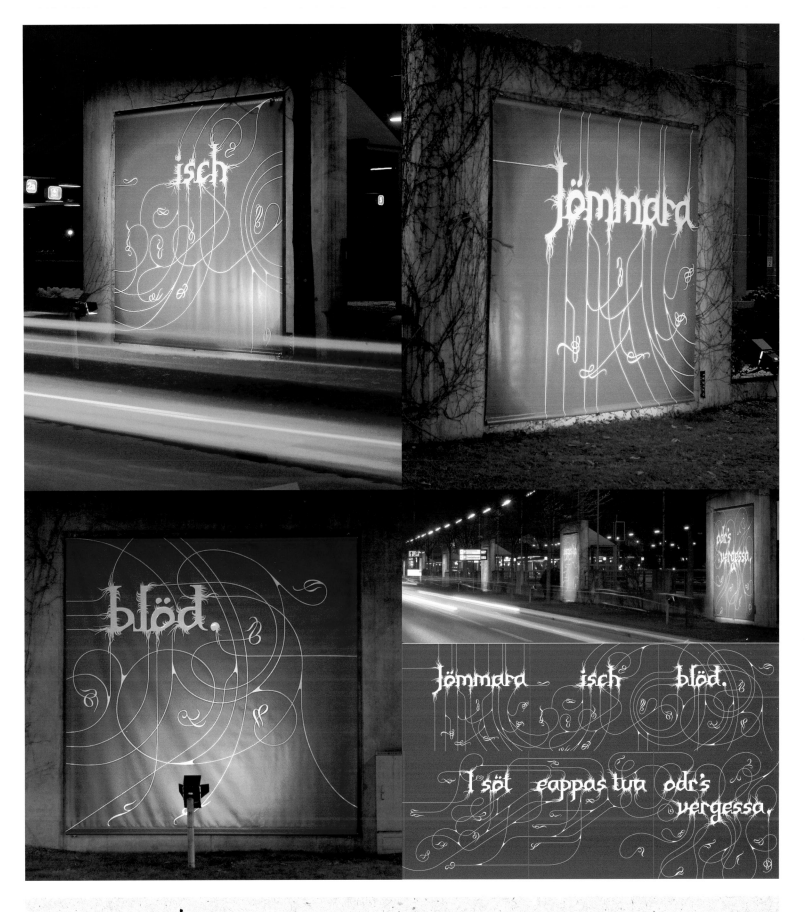

16. JULY - 10. AUGUST 2007

www.thelighthouse.co.uk/diynow

DIY questions the uniqueness of the experts expertise, and promotes the ability of the ordinary person to learn to do more than he or she thought was possible.
An exhibition exploring DIY culture in todays society.

Thursday, Friday, Saturday	10-12, 13-17 hr
Sunday	10-12, 13-17 hr
Monday, Tuesday	10-12, 13-17 hr
Wednesday	closed

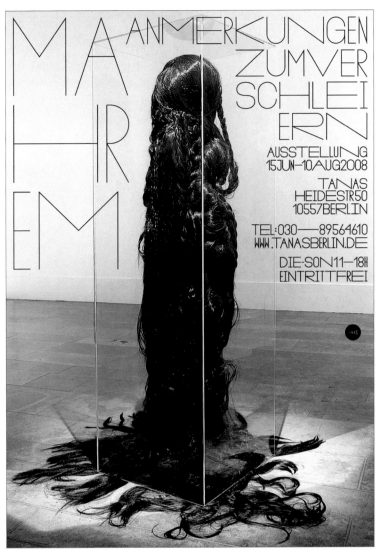

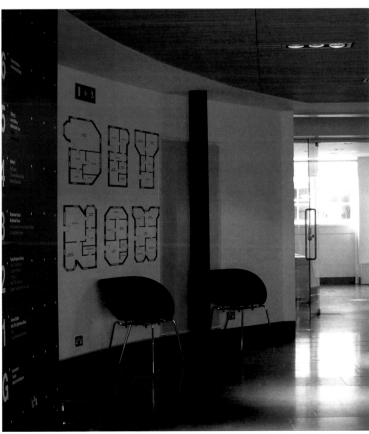

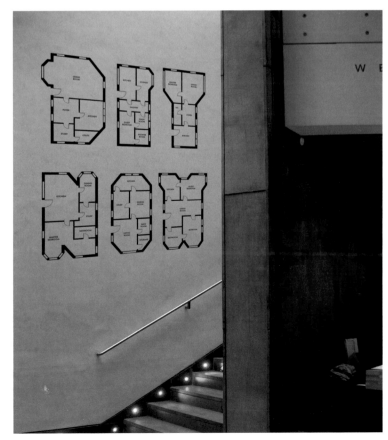

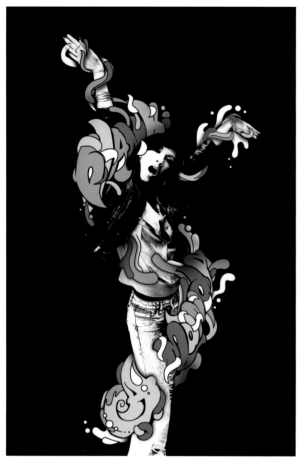

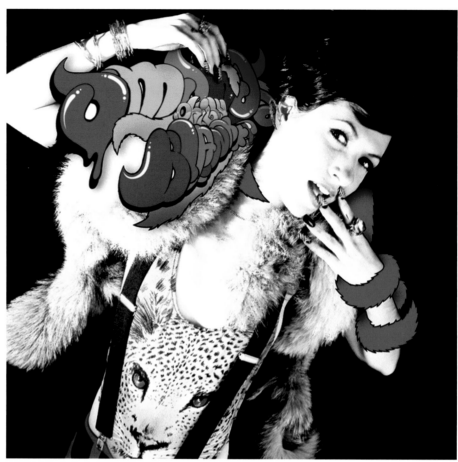

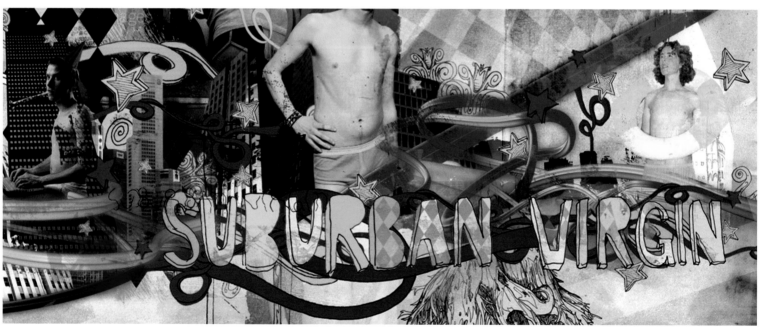

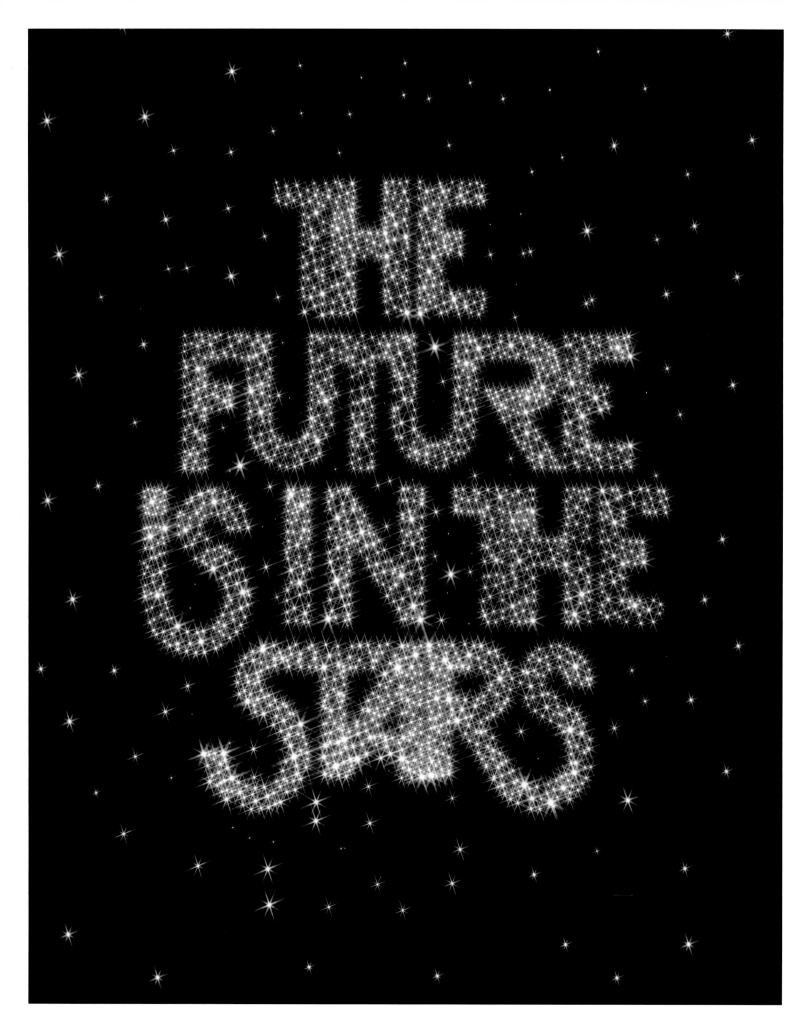

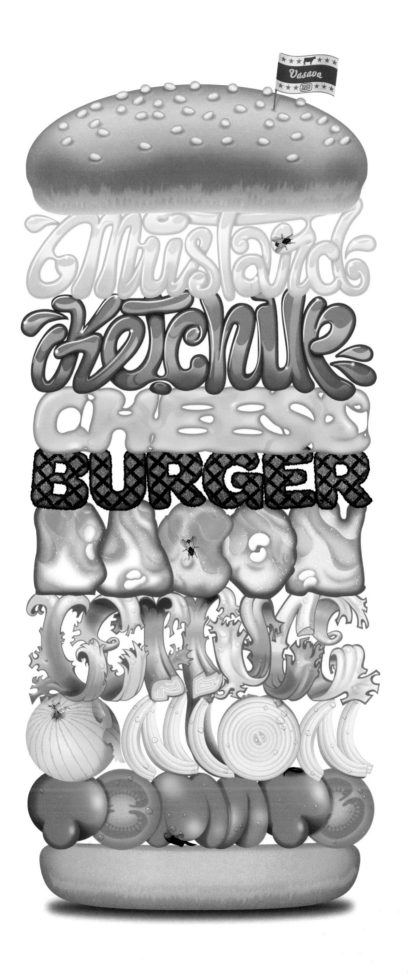

GRADUATES PRESENT
THEIR WORKS
ABSOLVENTEN
STELLEN AUS

SCHOOL OF ART
AND DESIGN KASSEL
KUNSTHOCHSCHULE
KASSEL

EXAMEN 07
09.—21.JUNI 2007

KULTURBAHNHOF
SÜDFLÜGEL
BAHNHOFSPLATZ 1
KASSEL

VERNISSAGE
ERÖFFNUNG
09.JUNI 2007 19:00 H

OPENING HOURS
ÖFFNUNGSZEITEN
09.—21.JUNI 2007
14:00—20:00 H

EINSzweiDrei

EinsZWEIdrei

EinsZweiDREI

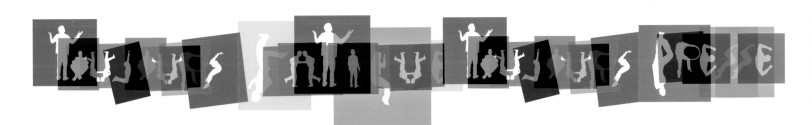

Slawek Michalt (top), Jonathan Prêteux (centre), Klon 2 (bottom)

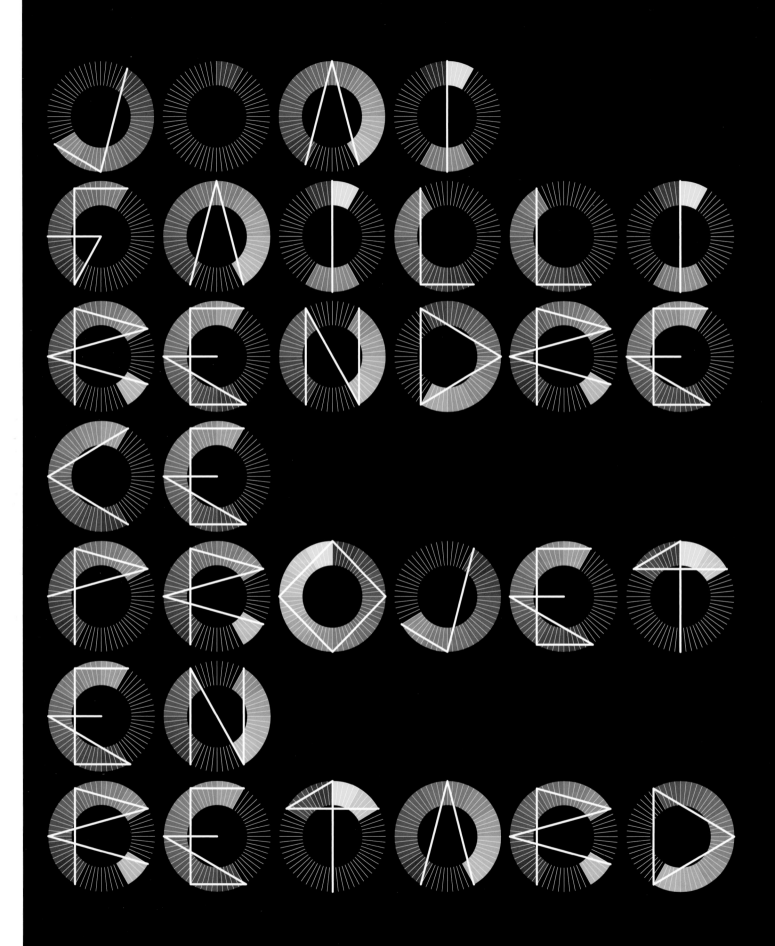

Linda Sweenie

THE SYMBOLS THAT COMPOSE AN ALPHABET ARE PHONOGRAMS THIS MEANS THAT STAND FOR SPEECH SOUNDS NOT FOR OBJECT OR IDEAS

Tomeri

type is a vessel. it conveys information. it encrypts ideas, dreams, protests, laundry lists, biographies, secrets, outrageous lies. catches them and fixes them to the page. type is a vessel, but it is not neutral. type is form and content, all in one. as type designers, we use signs and symbols to tell you what you need to know. while conveying a message of our own: about our visual landscape, about the information we've been asked to share, about this moment in global design. in the end, type is a conversation. TOMERI is our contribution to that conversation. and your opportunity to join in.

Tomeri Nu · Tomeri No
neue typo

Tomeri NuNo was developed in 2006
Nuria Gonzalez & Noël Nanton

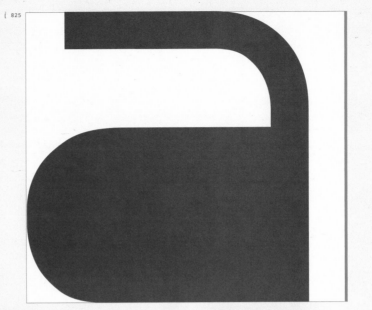

¡ 825

¡ 375

¡ 227

¡ 300

¡ 112

¡ 340

¡ 144

¡ 055

Tomeri NuNo
Toronto, Mexico City,
Rio de Janeiro.

A series of type inspired posters
by typotherapy+design inc.
www.typotherapy.com

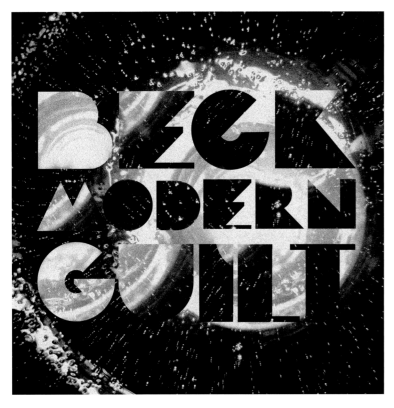

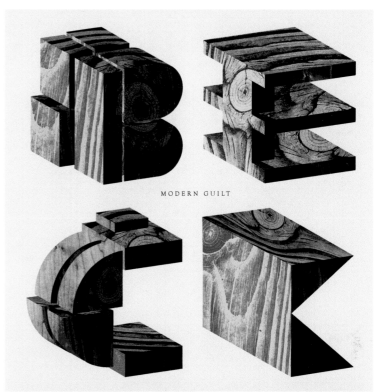

MODERN GUILT

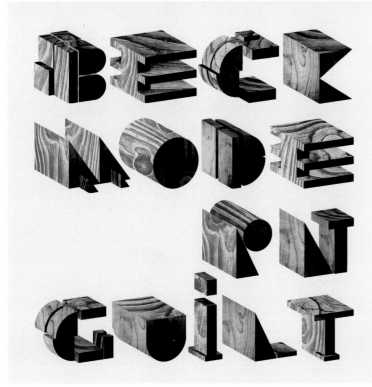

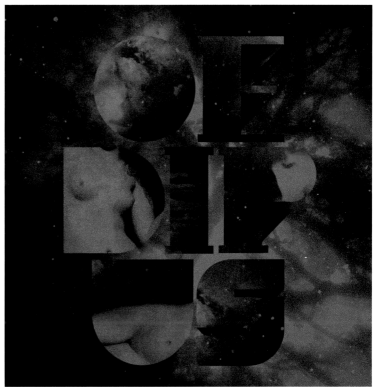

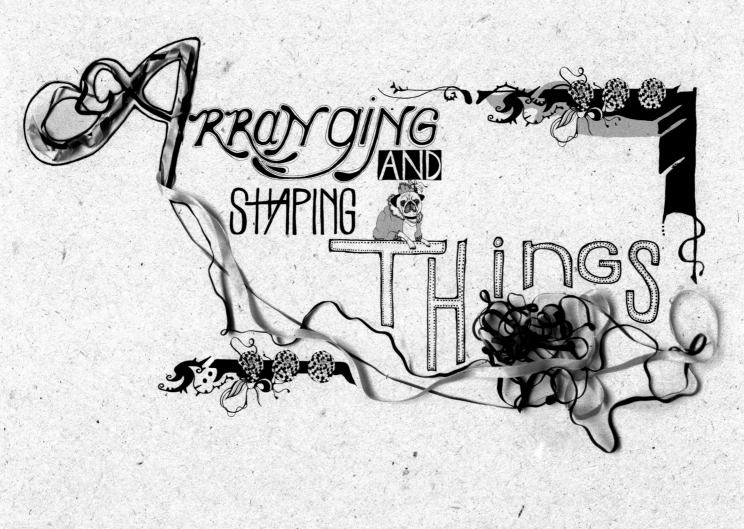

ARRANGING AND SHAPING THINGS

GO OUT AND PLAY! • • • • • •

A seemingly spontaneous arrangement of any sort of material into letters, words or sentences makes this the most liberated and playful category in this book. It is important to note, that many of those arising works consist of objet trouvé – materials found at hand and arranged without doing too much to alter them. This is particularly obvious when looking at words or alphabets made from leaves, scrap wood pieces, bricks, earrings or dominoes. The joy of coincidence, the freedom of play and overall originality are what count first and foremost. The idea often stands above the graphical quality of the actual solution. These are works of surprise, wit and carefree creativity.

The pure, unadulterated use of material is the key when it comes to arranging. When considering the general need for authenticity, human touch and a way for the viewer to relate to art works, the use of familiar materials (and in some cases storytelling) can be recommended. Consider the letters in "Happy that you are born day" by Annemarie van den Berg, taken out of their context and displayed on white paper only. A lot of information would be lost: the surroundings, the tools, the process of creating the piece and the atmosphere – all of which are essential to actually make the piece interesting and involving. Or the alphabet created by BANK™, where the inner tube of a bicycle

gets bent every which way to form odd letters. The heart-warming element of this work is that the hands that bend the tubes are still visible and are integrated as part of the letters.

But not all type presented in this chapter is unaltered material. The borders to slightly more complex forms of arranging and modifying are fleeting. There is circuit wire bent into shape or tape wound around nails to convey a message. Wooden blocks are slightly modified and function as a bridge between letter and sculpture. The work for Specialten by Thorbjorn Ankerstjerne in collaboration with Jonas Lund, sticks out a little due to its rather complicated arrangement of small folded paper elements into a hanging typographic structure. Their brief was to work on a cover, a menu system and pages within the book for the most recent issue of the DVD magazine Specialten #21. It is interesting that they created a materialized, haptic menu consisting of small paper arrows evolving around the big paper letters, filmed with a 16mm camera while paying maximum attention to bestow a tactile, analogue experience and warmth onto a digital medium.

There certainly is an explicit trend of graphic design moving into three-dimensional objects and works that interact with a space. With photography playing a vital role in documenting the process of these works, type has never been as tactile as it is today.

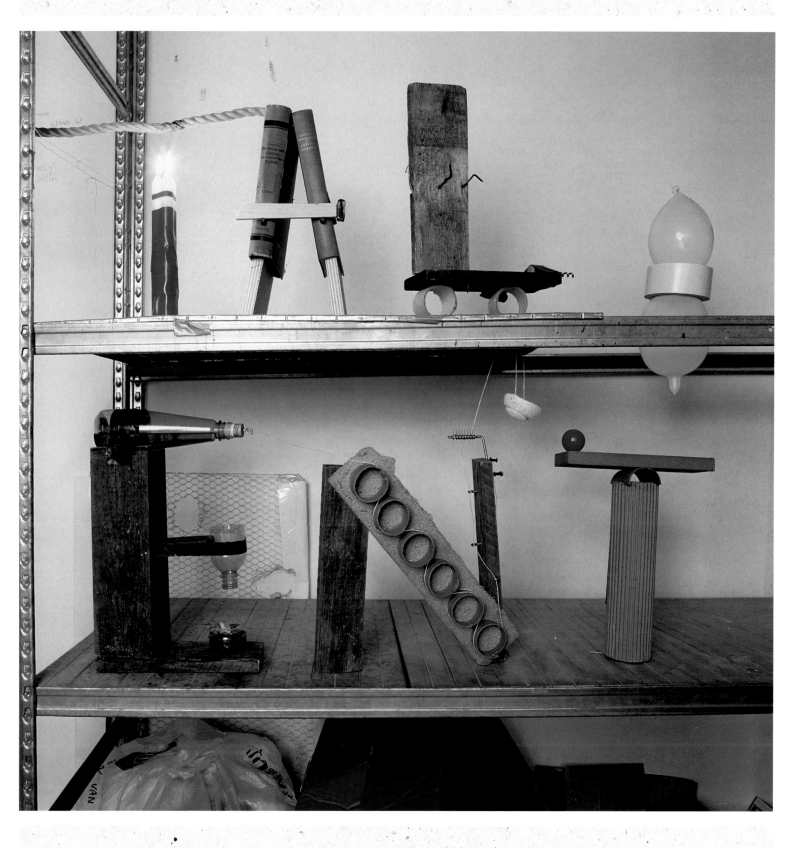

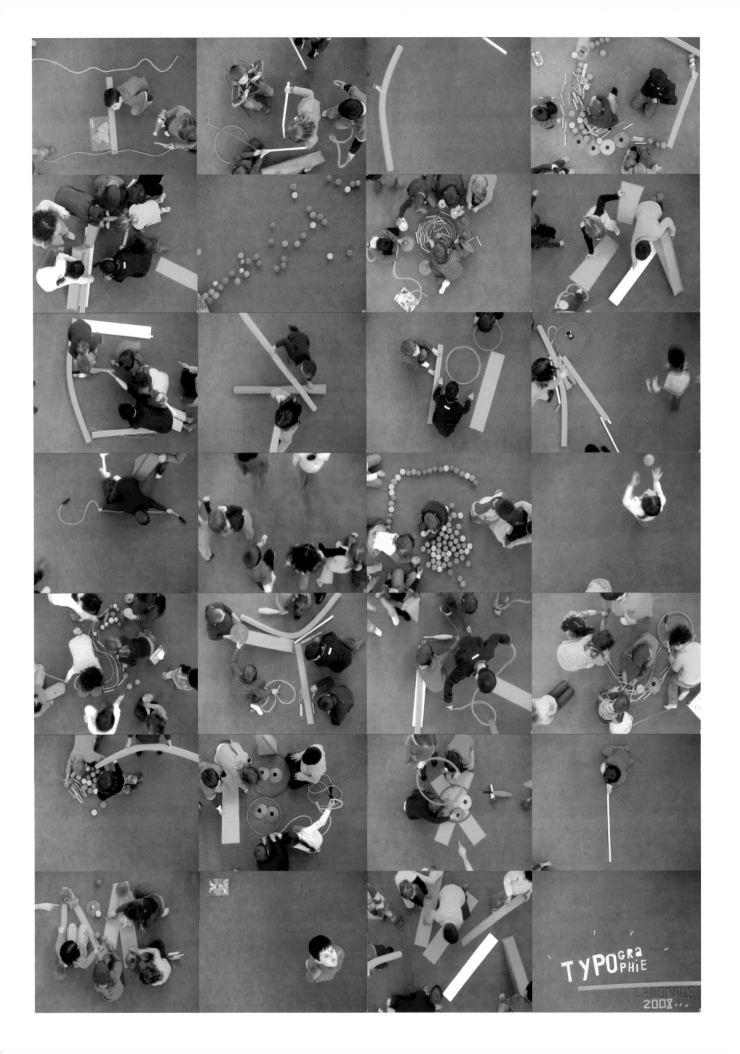

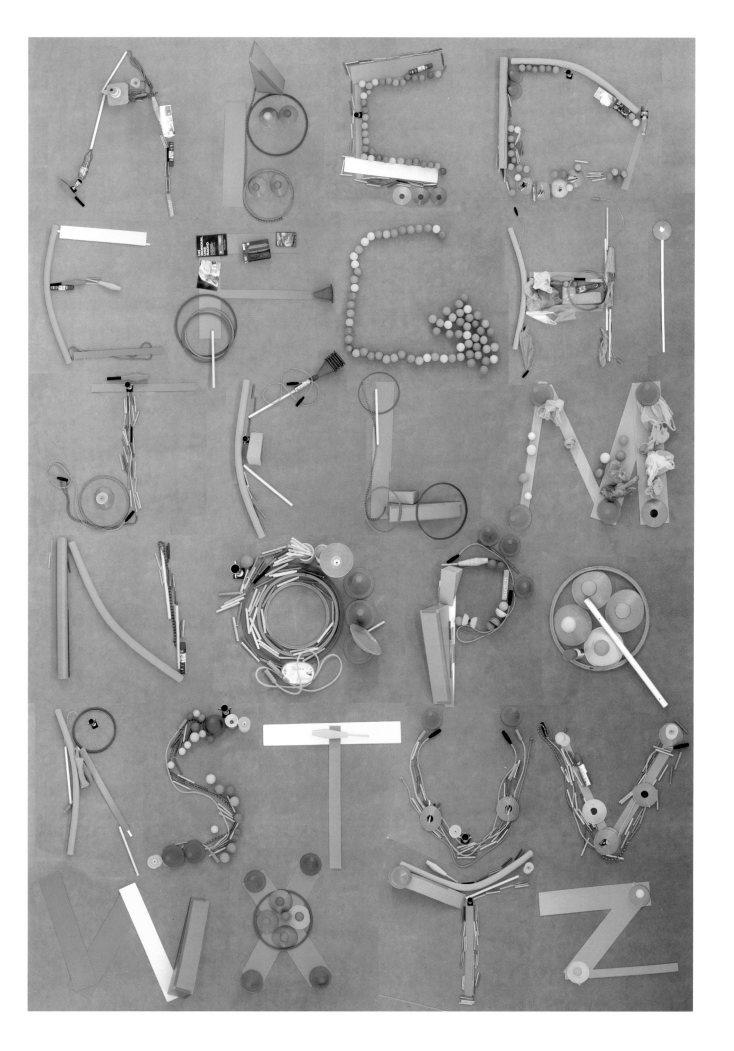

Camille Lebourges

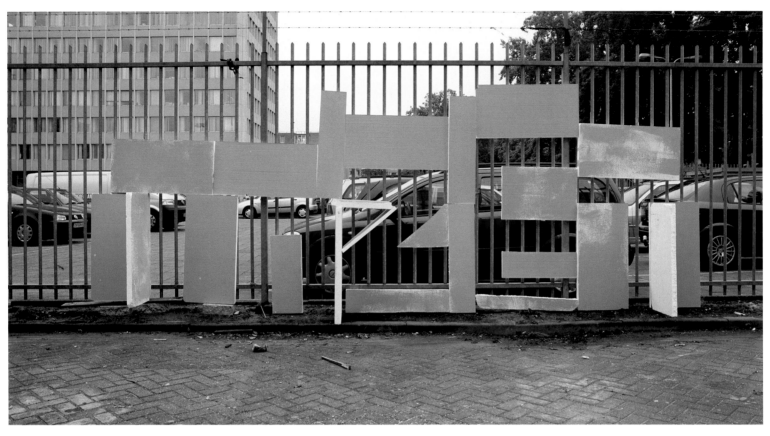

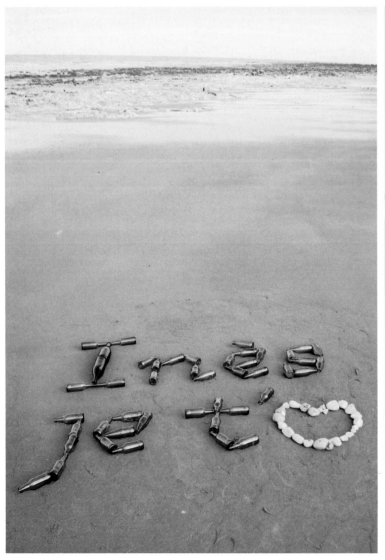

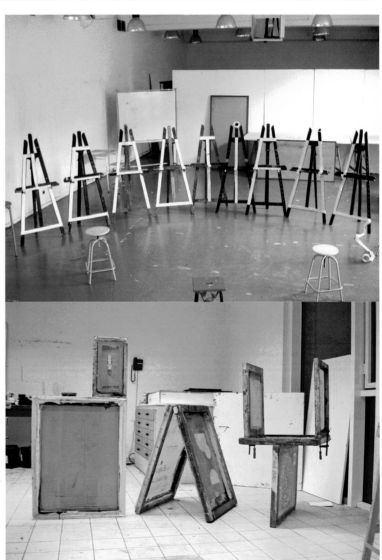

Jonathan Prêteux (bottom), Corriette Schoenarts (top)

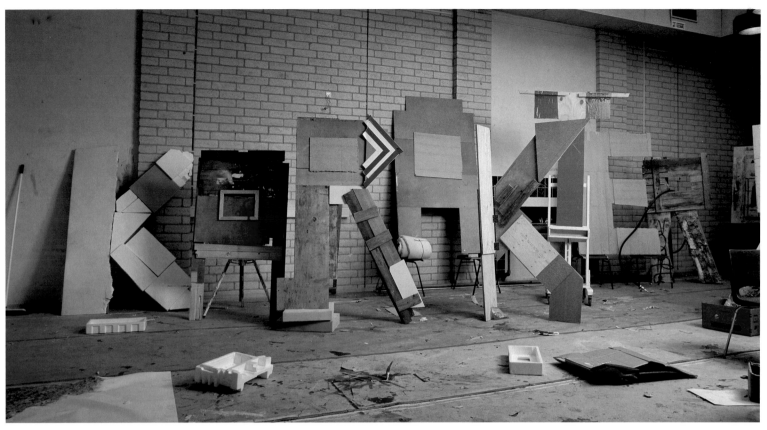

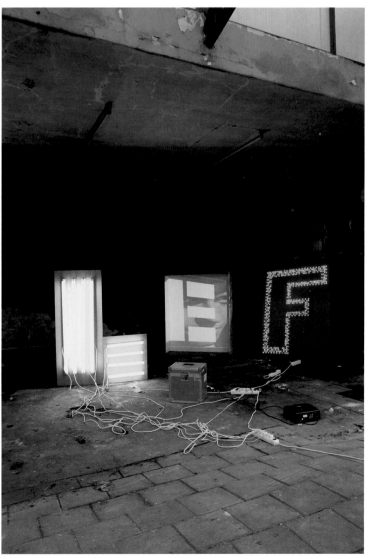

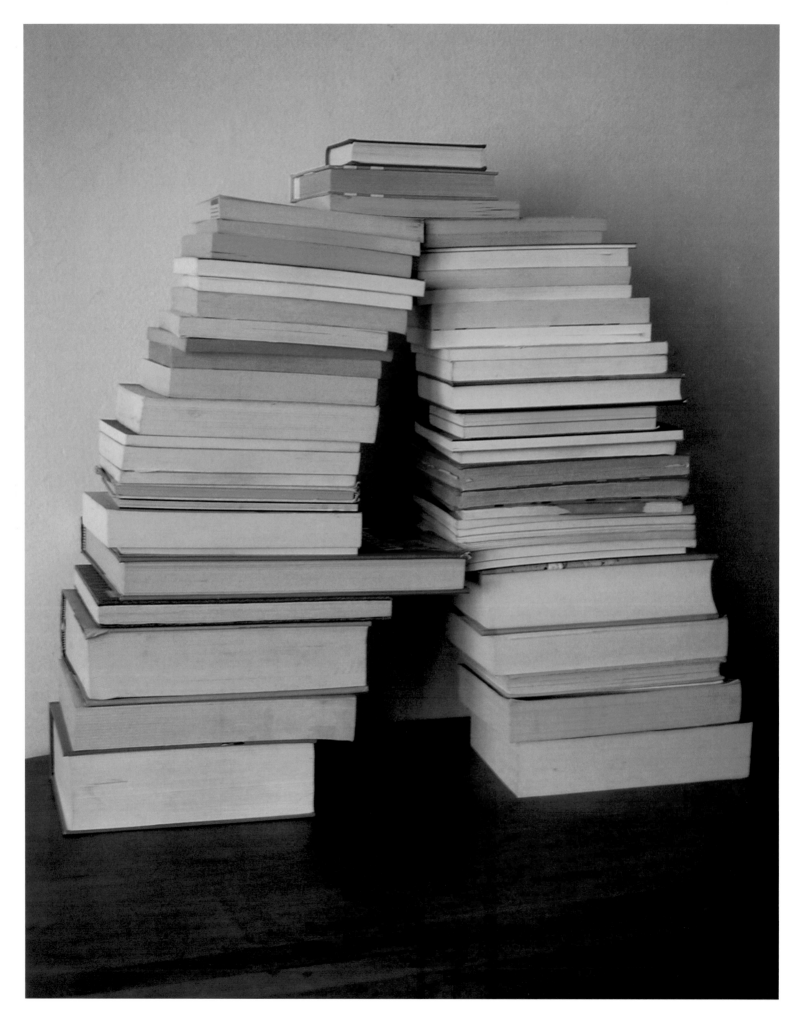

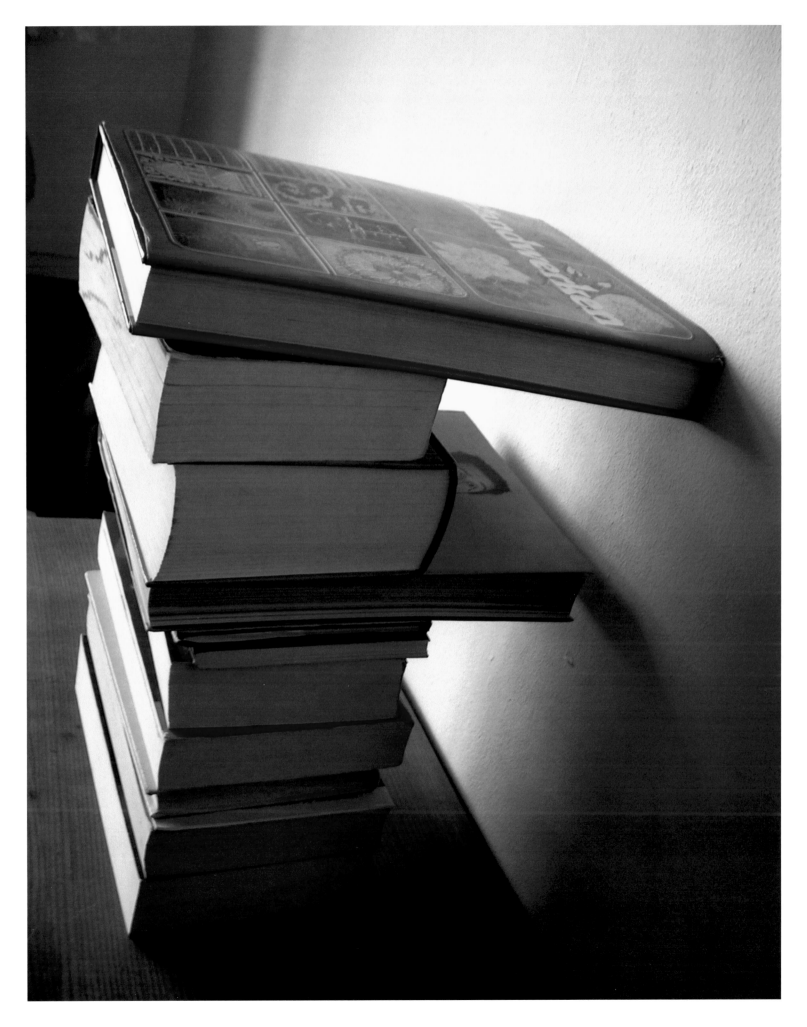

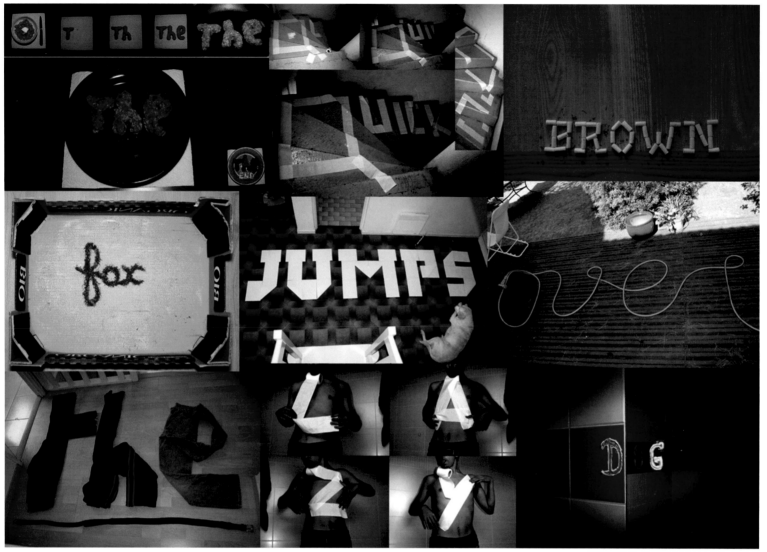

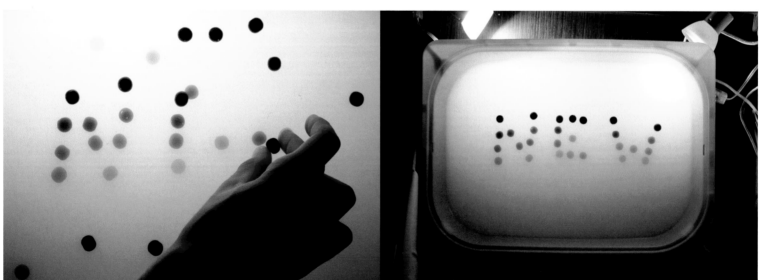

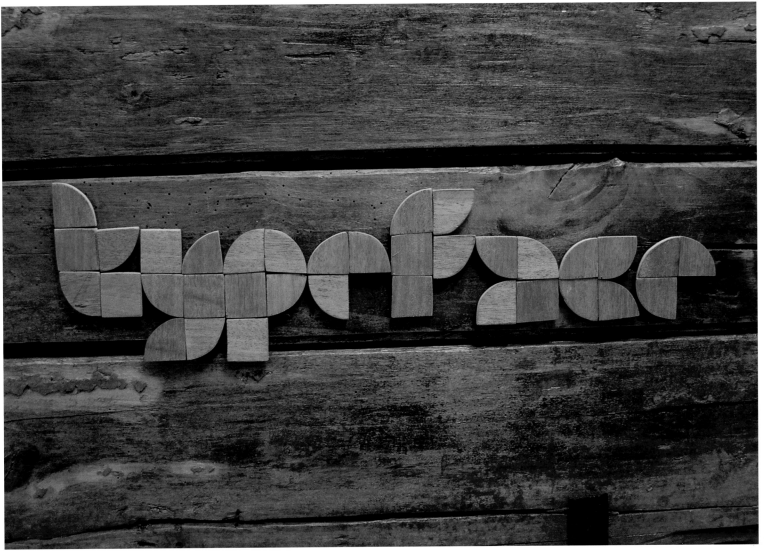

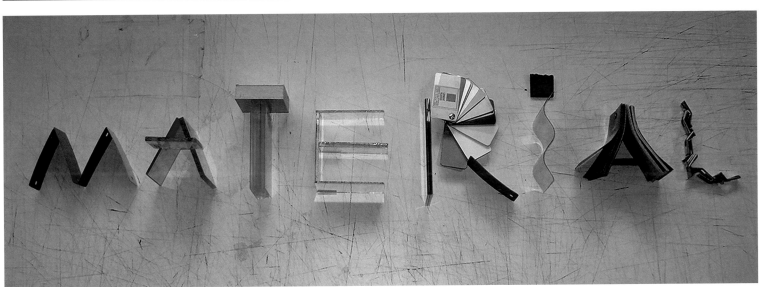

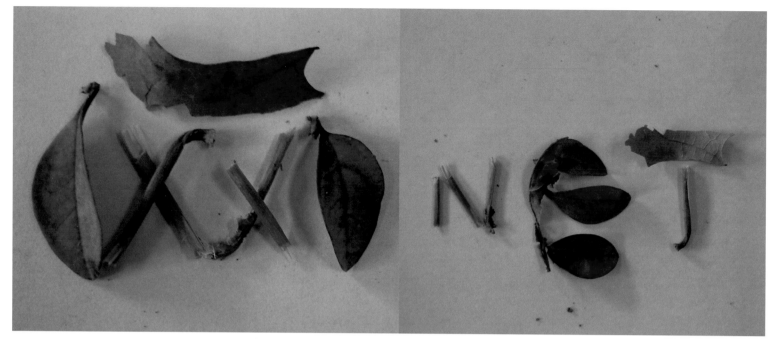

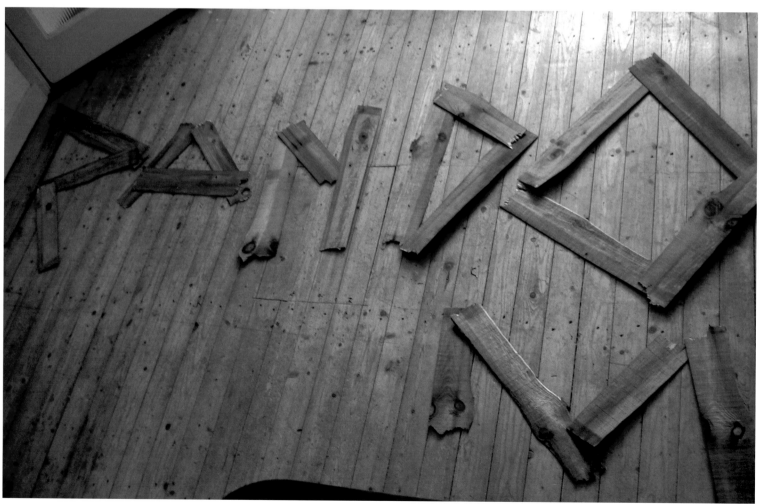

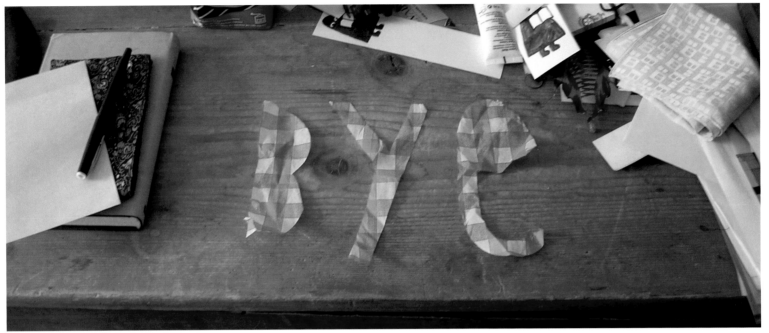

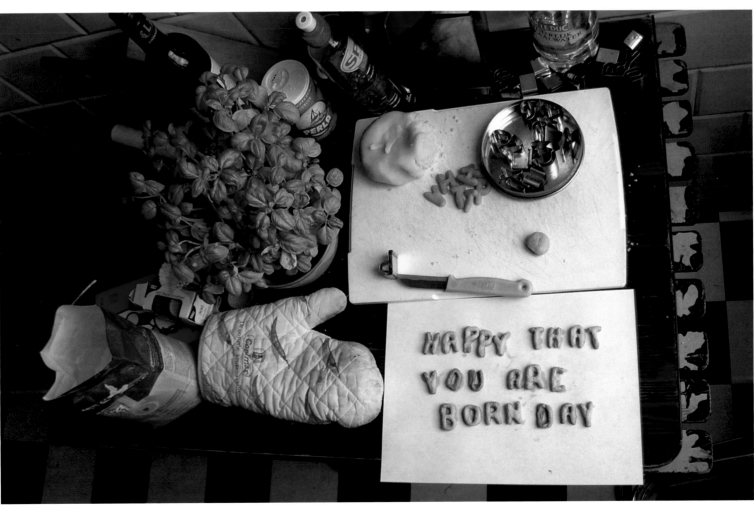

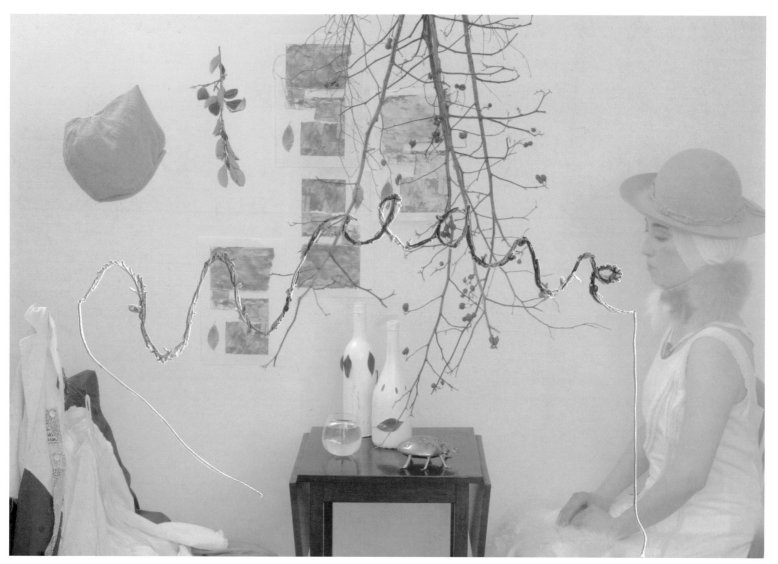

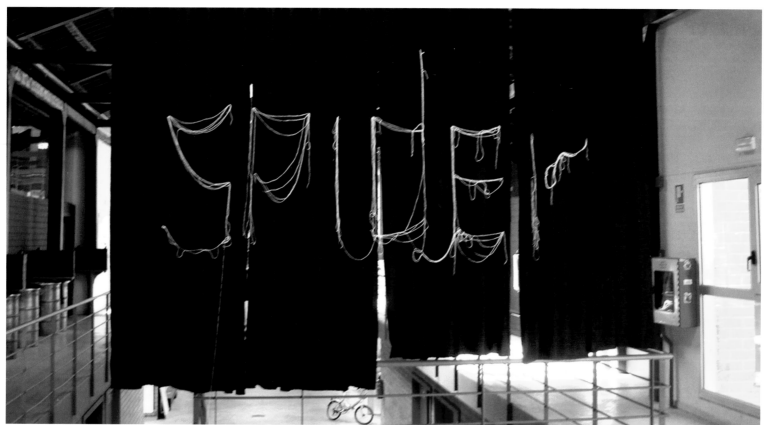

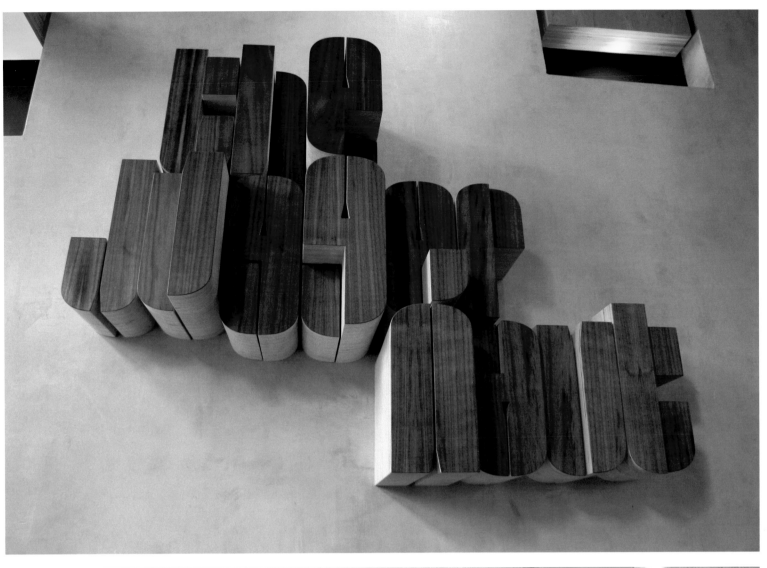

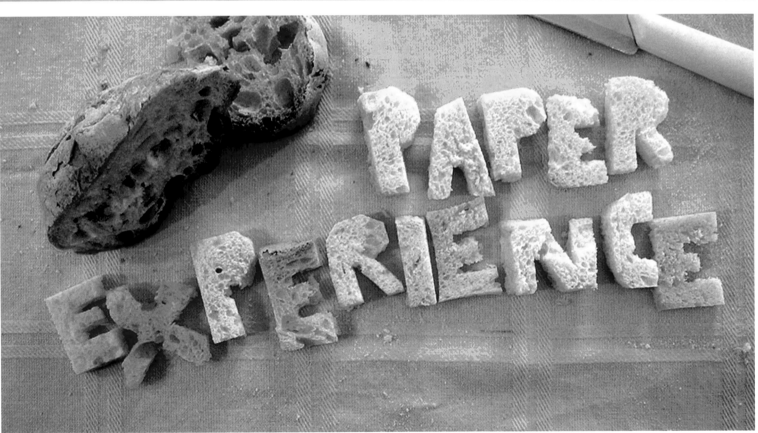

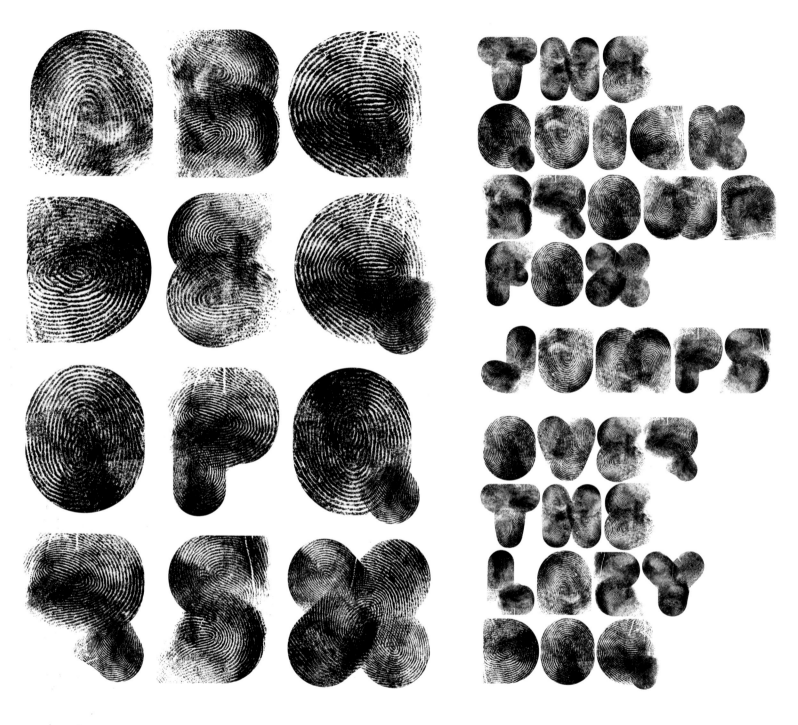

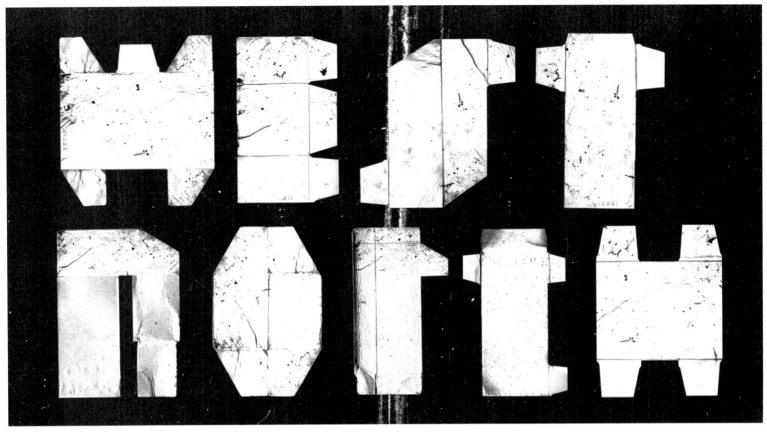

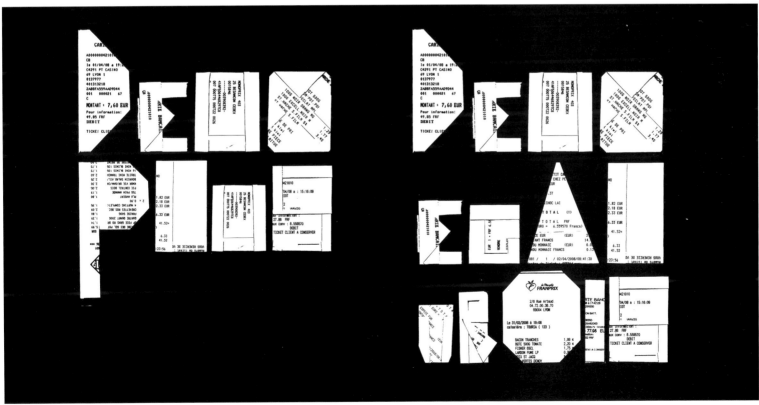

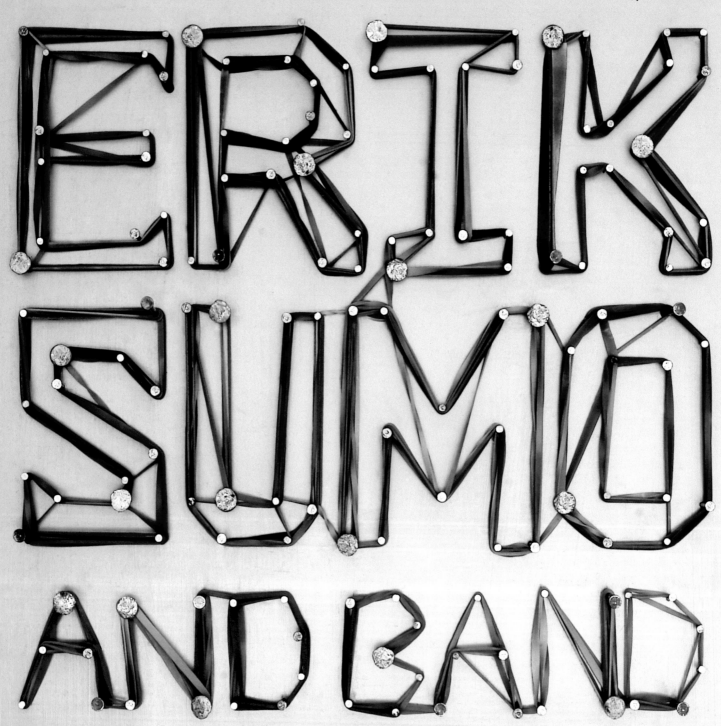

FROM PULVER RECORDS / BUDAPEST, HUNGARY

ERIK SUMO AND BAND

Lorenzo Geiger

SURREALISTIC WORLD MUSIC DANCEFLOOR SOUNDTRACKS

SUPPORTED BY DJ RINGMASTER

FRIDAY SEPTEMBER 29 TH 2006 DOORS 22H

DACHSTOCK REITSCHULE BERN

PRESALE AT ROCKAWAY BEACH, SPEICHERGASSE 35, BERN

SAVE THE RUBBER PLANTS! HANDICRAFT BY TED.

144

YOU ARE FREE TO DO WHAT THEY TELL YOU

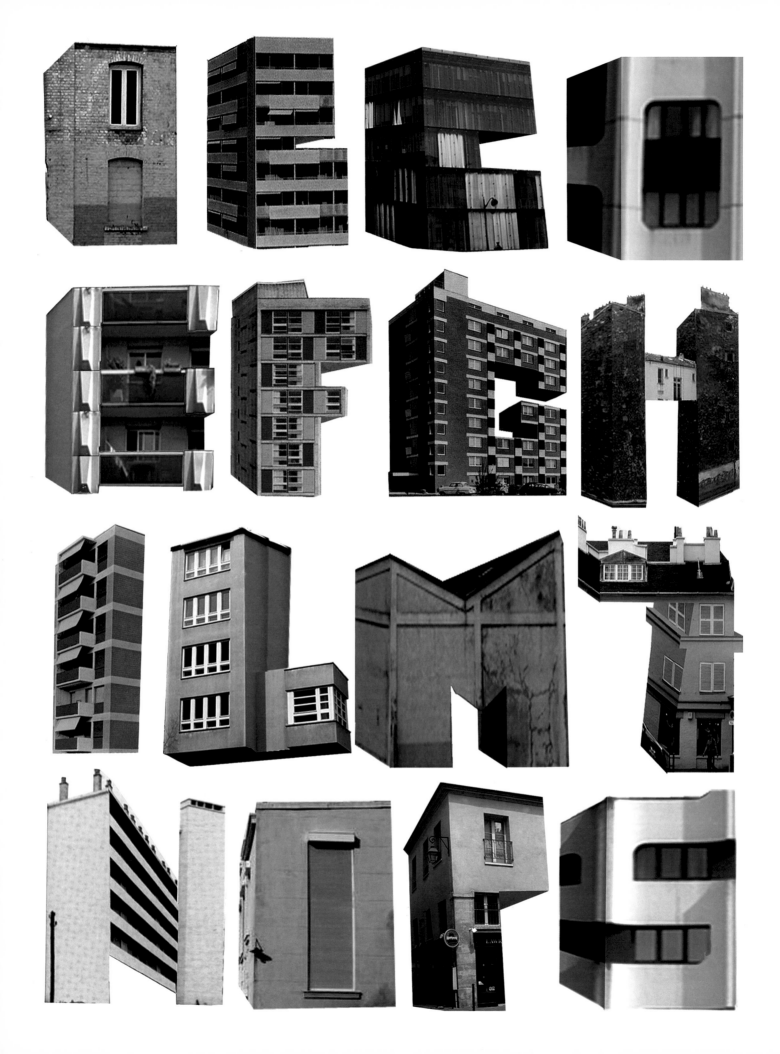

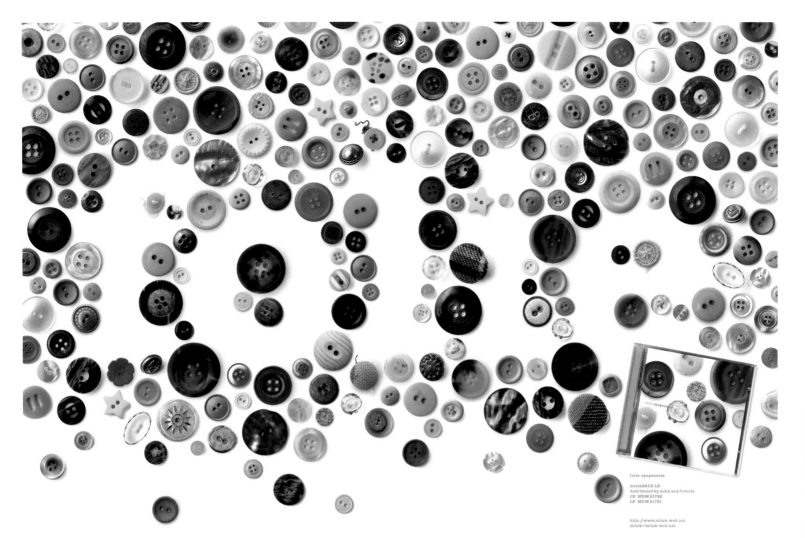

folie: eyepennies

mitek22CD.LP
distributed by mdm and friends
CD MDM 21722
LP MDM 21721

http://www.mitek-web.net
mitek@mitek-web.net

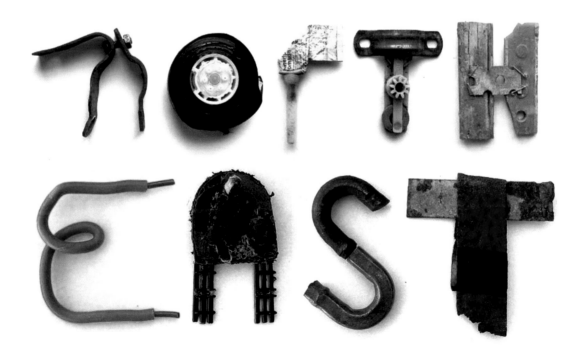

Angela Lorenz (top), 21bis (bottom)

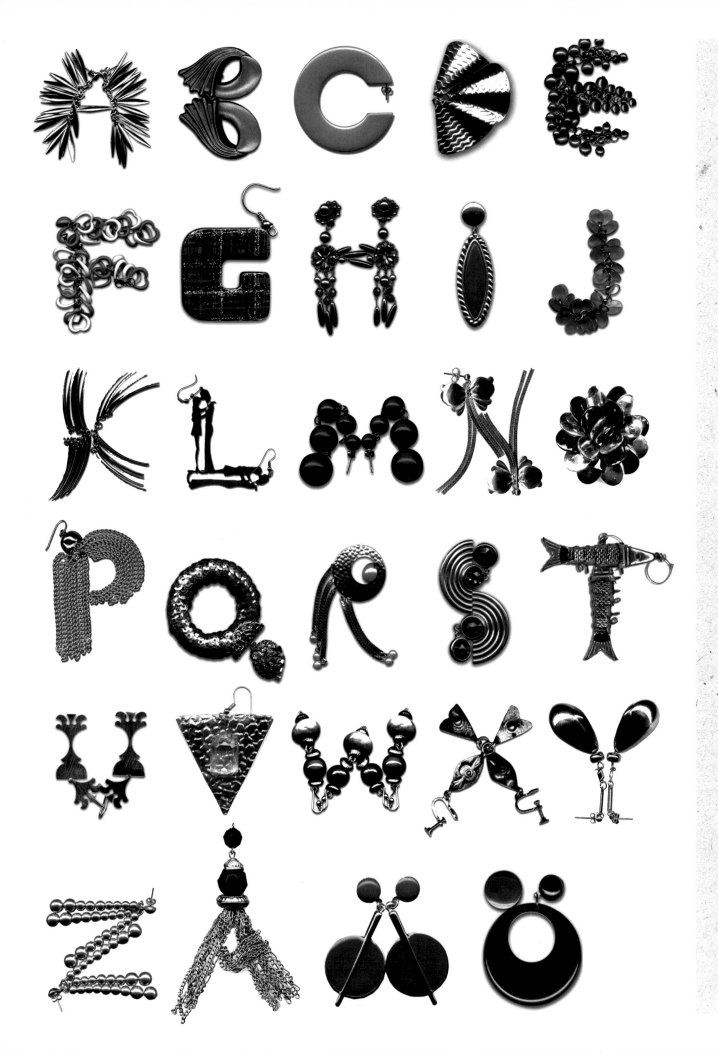

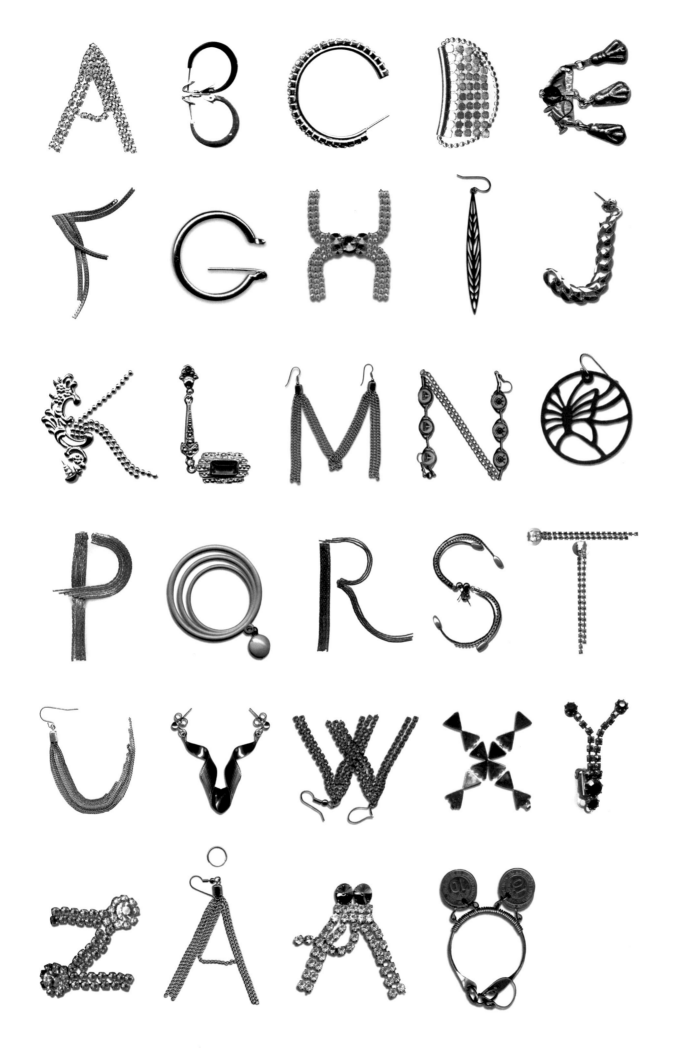

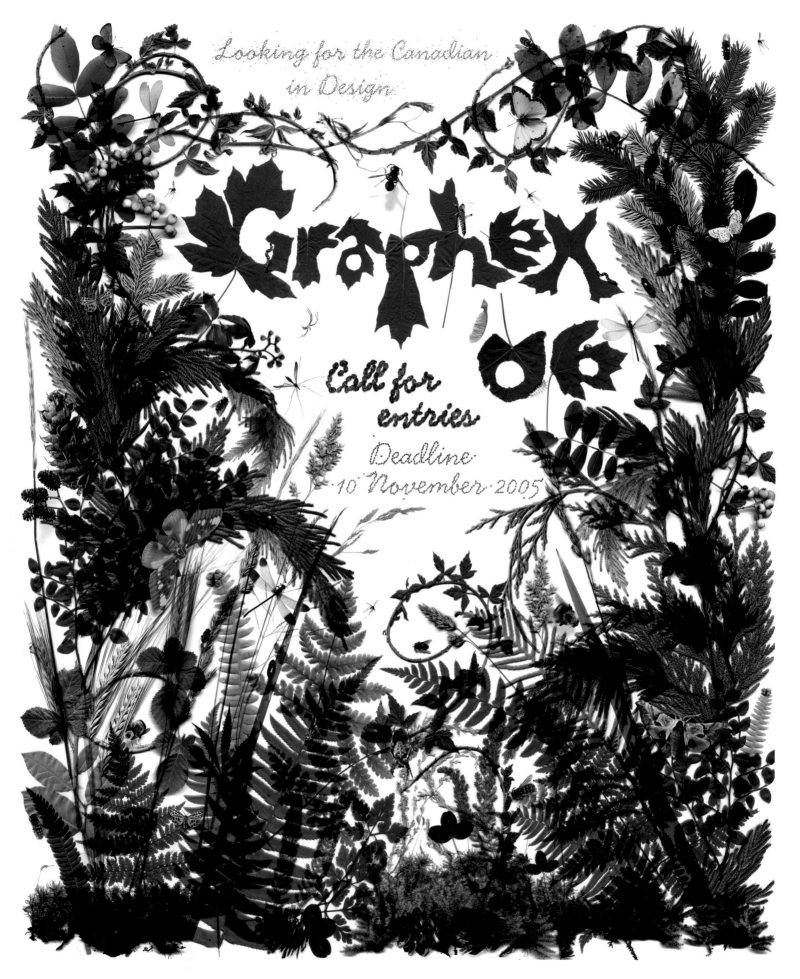

Looking for the Canadian
in Design

Graphex '06

Call for
entries
Deadline
10 November 2005

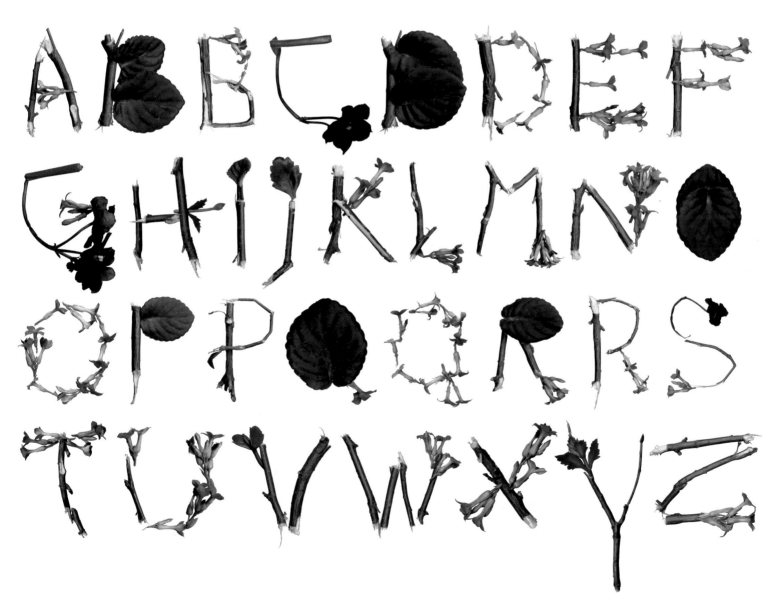

bank™

Pneuma

ABCdefghijklm
nopqrstuvwxyz

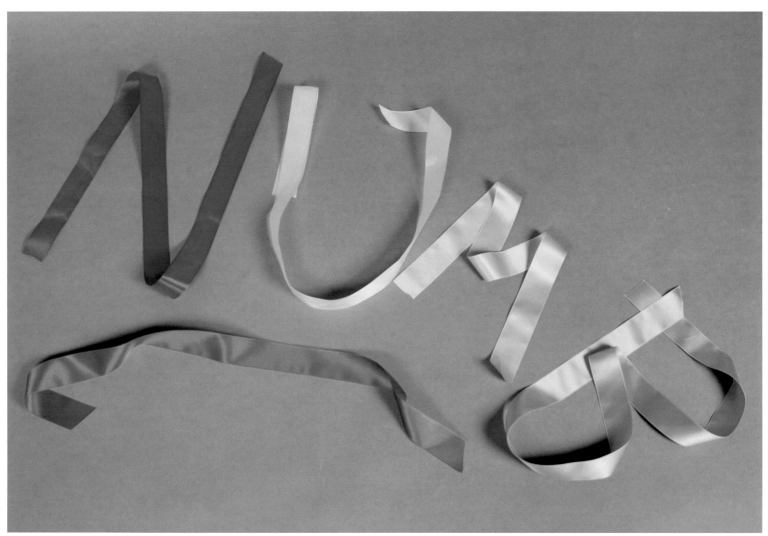

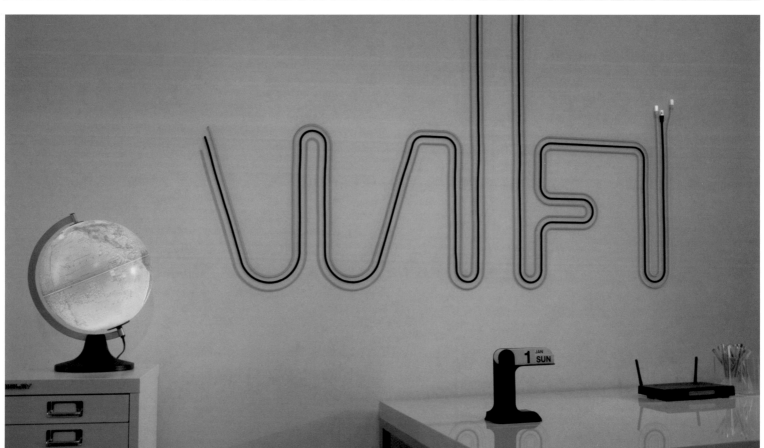

154

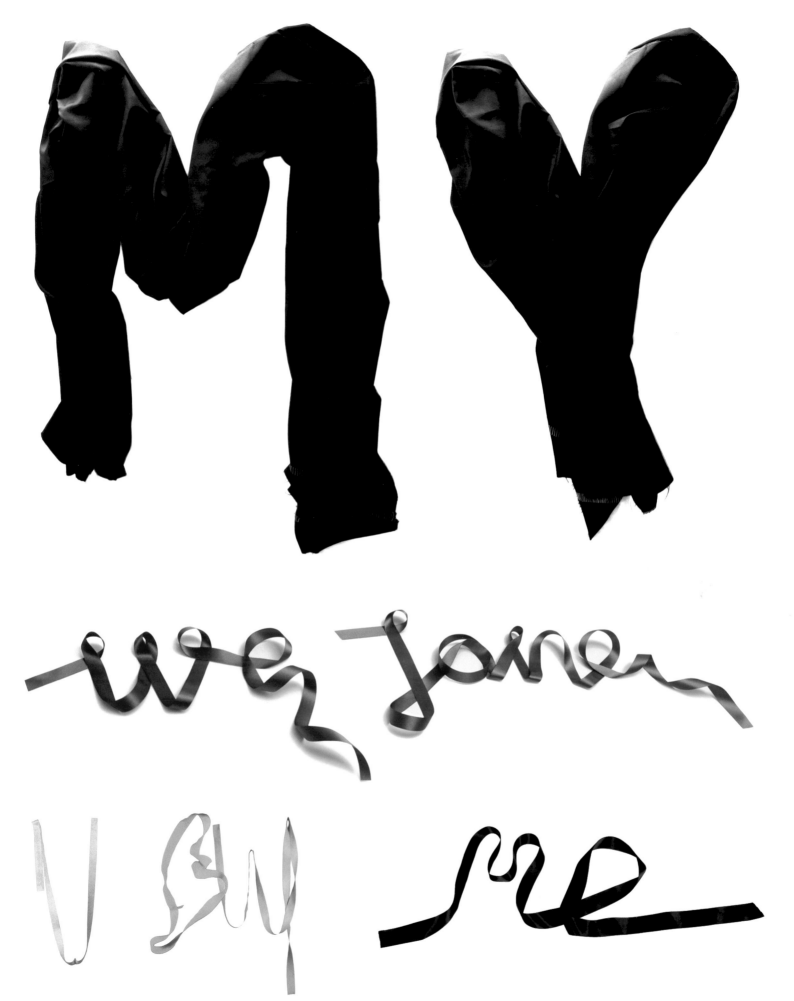

Helena Dietrich (top & bottom), MEstudio (centre)

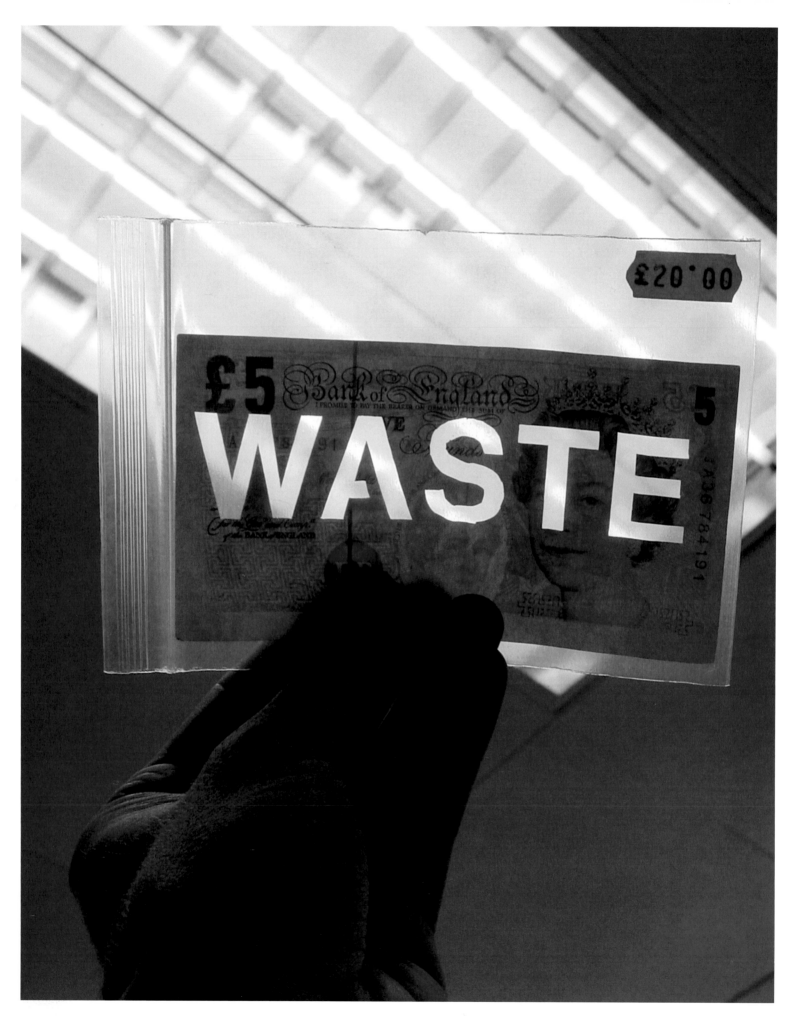

PETER CAREY
THE TAX INSPECTOR

PETER CAREY
COLLECTED STORIES

ILLYWHACKER
PETER CAREY

PETER CAREY
BLISS

MY LIFE AS A FAKE
PETER CAREY

PETER CAREY
THE UNUSUAL LIFE OF TRISTAN SMITH

OSCAR AND LUCINDA
PETER CAREY

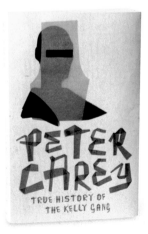

PETER CAREY
TRUE HISTORY OF THE KELLY GANG

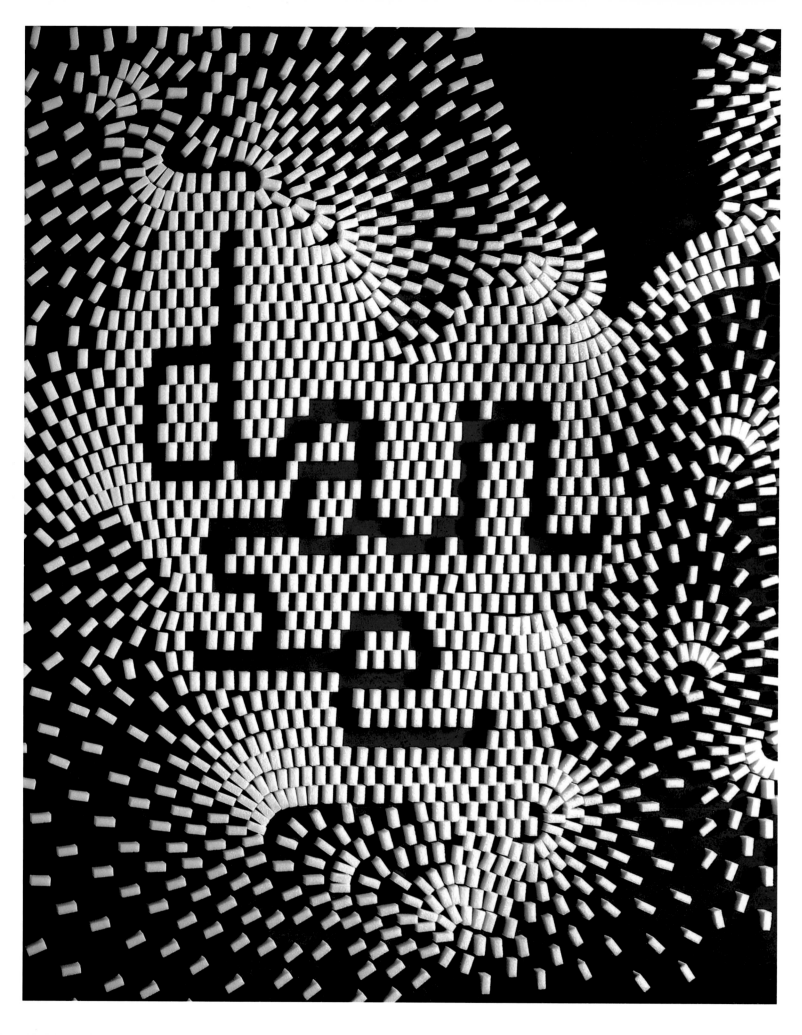

Akatre

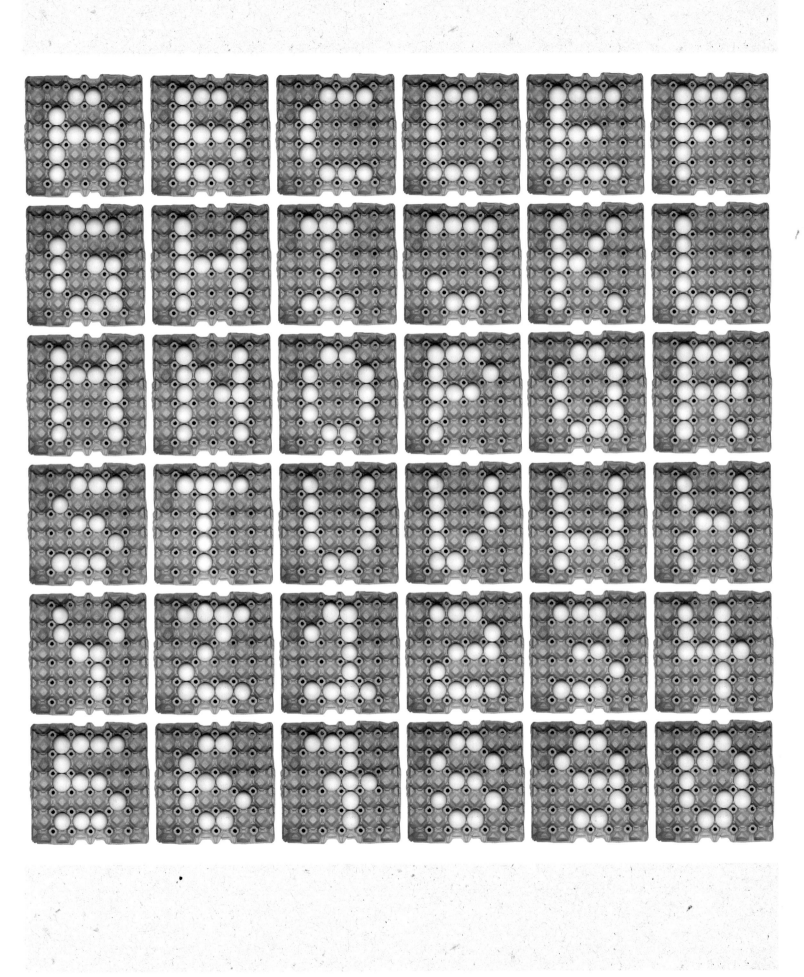

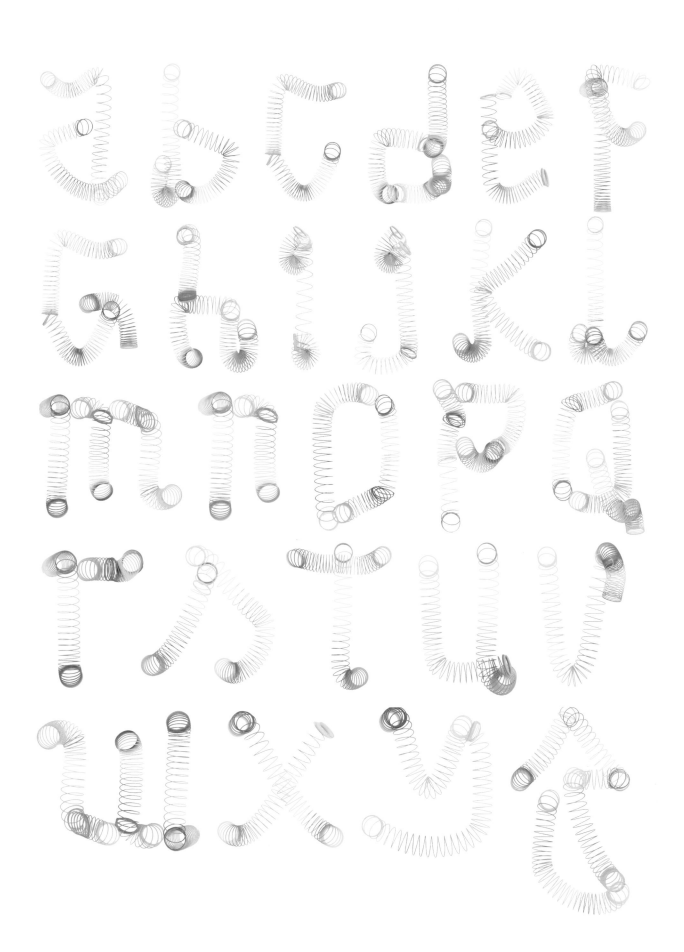

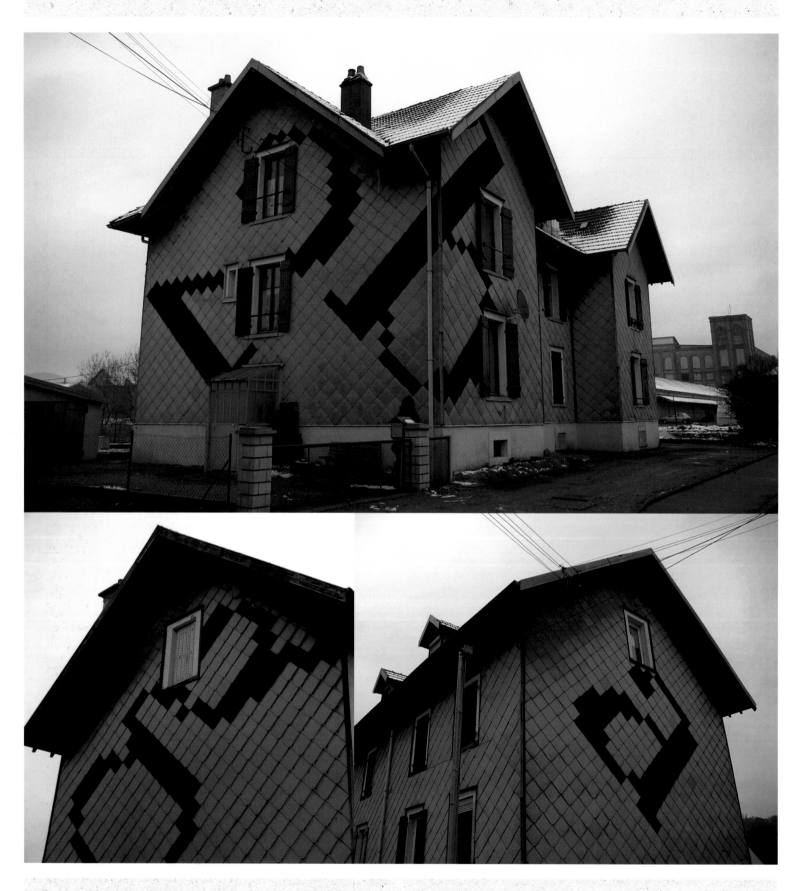

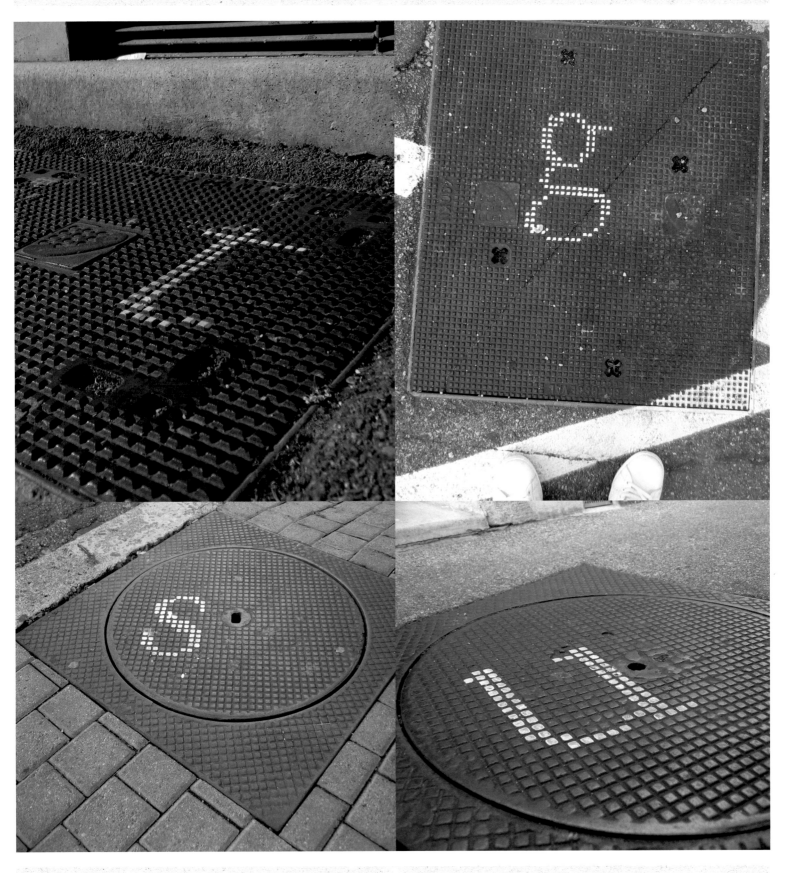

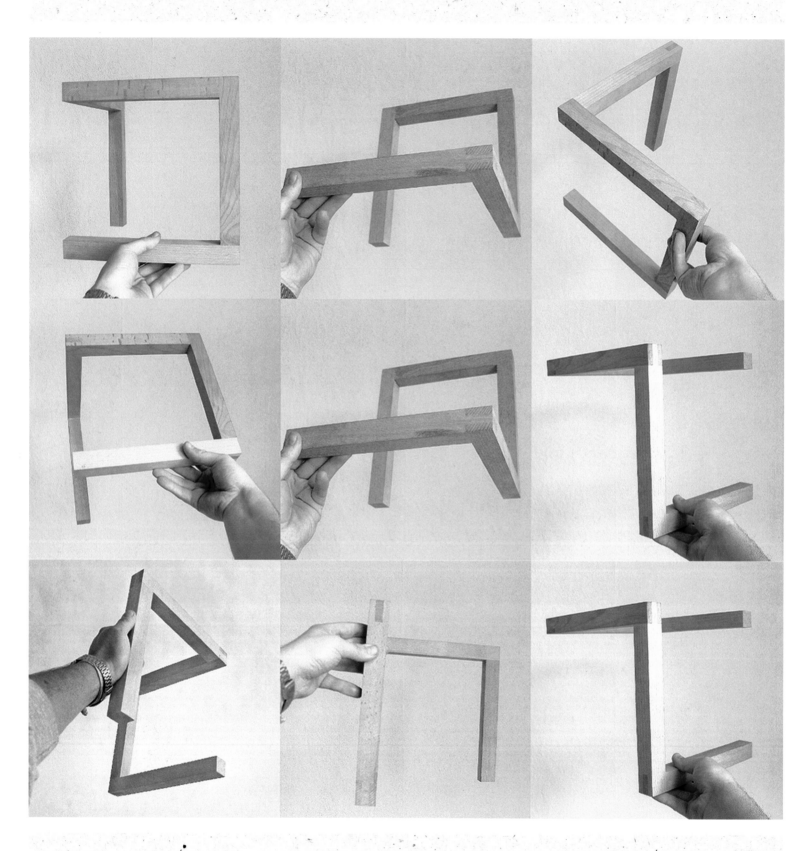

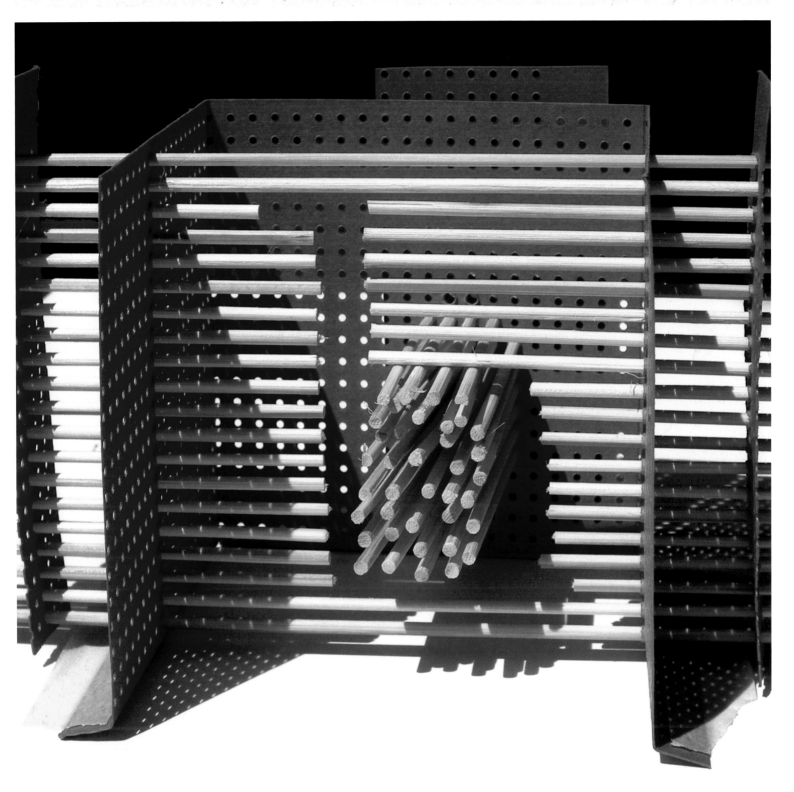

Karina Petersen

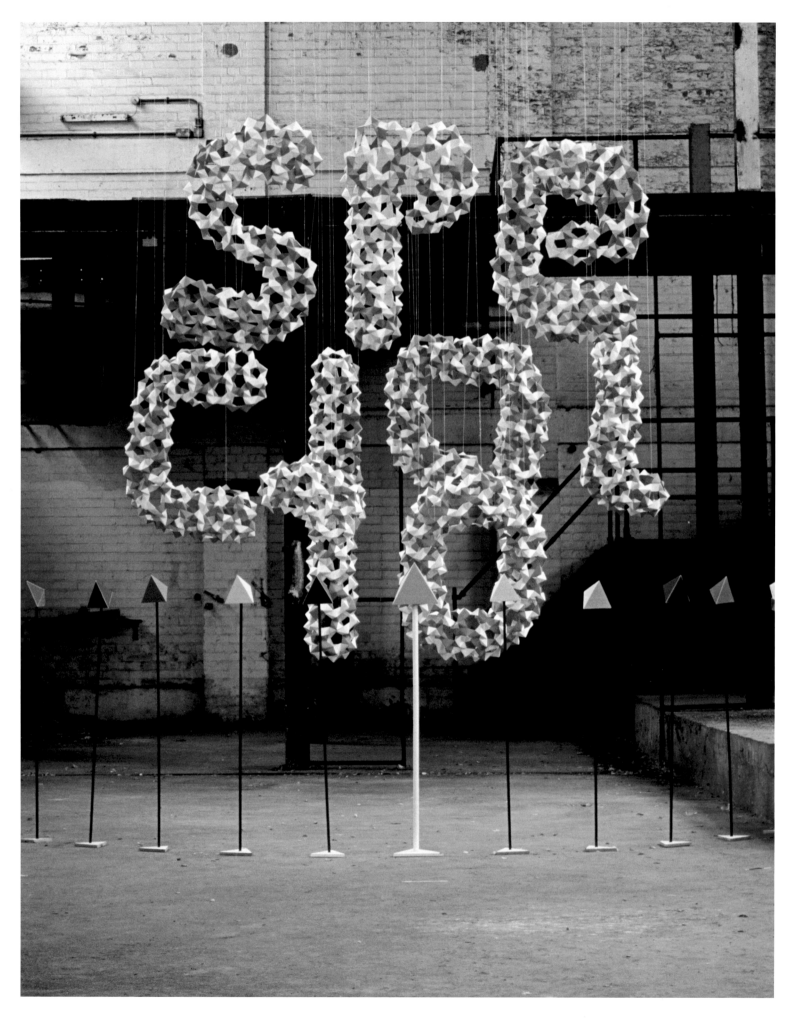

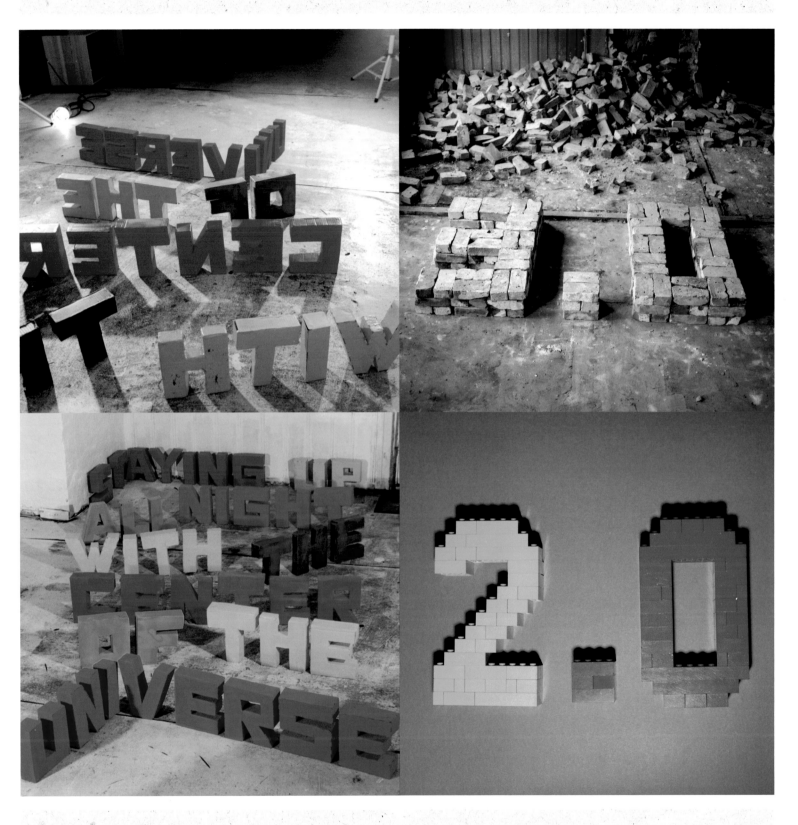

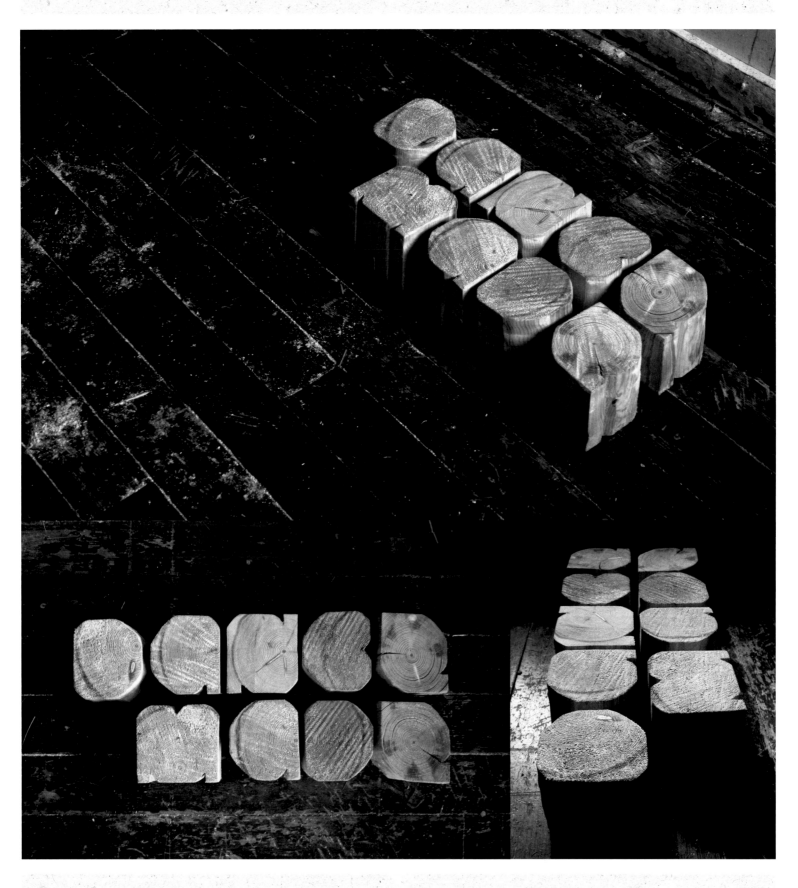

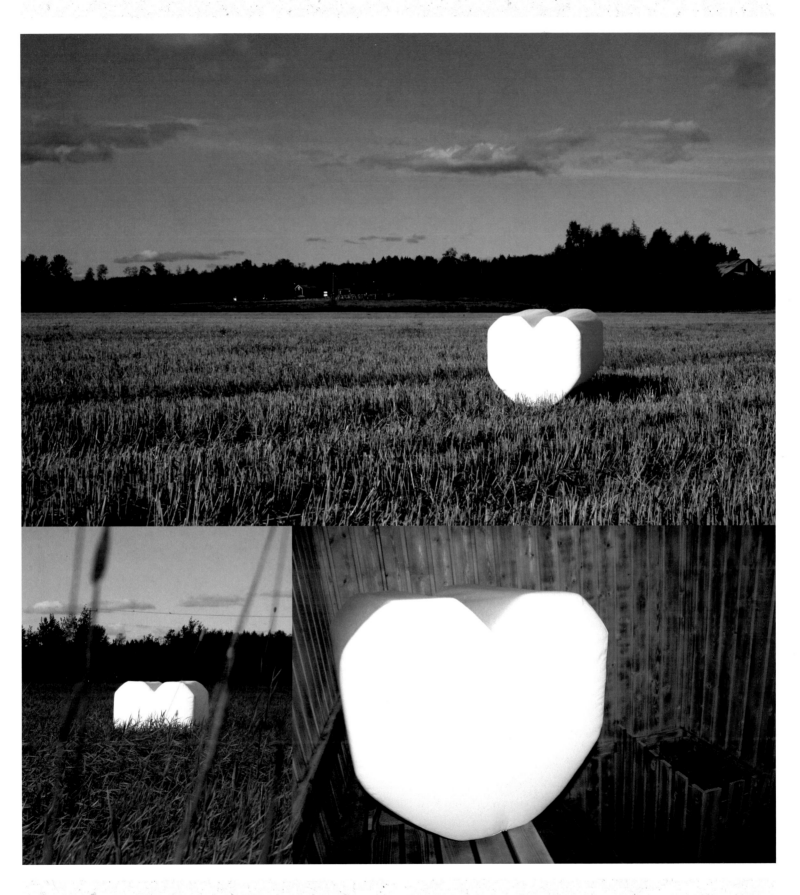

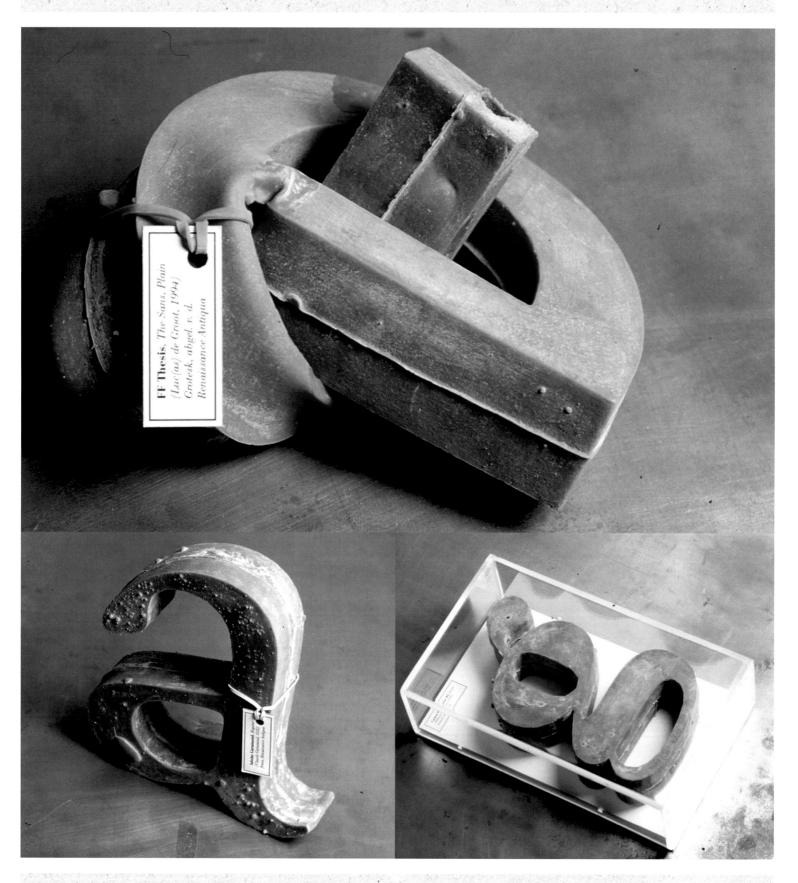

FF **Thesis**, *The Sans, Plain
(Luc(as) de Groot, 1994)
Grotesk, abgel. v. d.
Renaissance Antiqua*

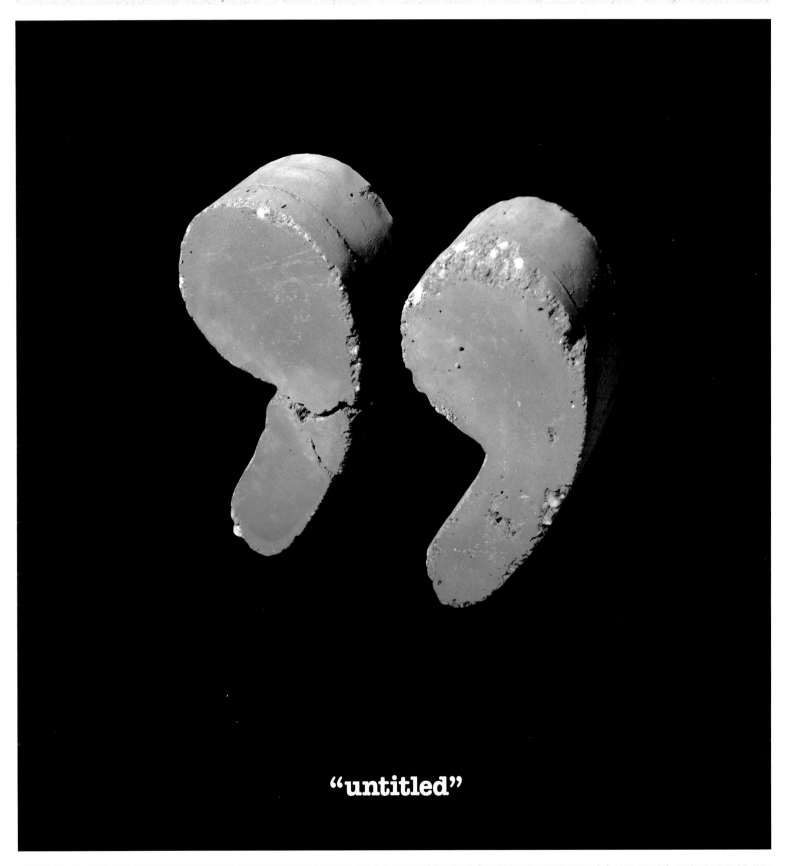

"untitled"

CUT 'N' glue

CRAFTING TYPOGRAPHIC GEMS

Paper, scissor, stone-casting;
paint, potato, concrete and rubber-mould.

Get your idea straight, find the means to realise it and select the materials of choice to start the act of crafting, cutting, bending and shaping until a final piece stands strong in its environment. Welcome to the cut and glue section of Playful Type!

Here is where we encounter various kinds of typographic installations. Again, it is material that plays a vital role in the outcome of the works, but this time the material is made to match, shaped and modified to realise a certain idea, to fulfil a certain typographic goal. Almost all works are design solutions composed with the context of space in mind.

Some of these works are clearly documentary photographs of a completed piece, which allow the viewer to imagine its space and grasp the tactile three-dimensional gestalt of the work. The piece by Kate Lyons (Bouquet of Parentheses), for example, is a simple play with light and shadow evolving around a group of words cut out of cardboard. The work is reminiscent of a 1965 ad for Olivetti typewriters, although the conceptual difference is striking. While the Olivetti ad showed an alphabet created in the very same way, their aim was to make the process (cardboard letters casting a shadow) as invisible as possible while focusing on the gentle, regular shadows of the objects. In the case of

the contemporary piece found here, however, the process and the material play a vital role in the final outcome of the work. Even the creator's hands are still visible in this composition.

The more elaborate and complex works in this chapter show letters intelligently set into scene, which function as spatial gatherers. Various angles of these typographic pieces are exposed to allow the viewer to grasp its full dimension. While these works can have a clear readability from one perspective, observed from a different point of view they literally decompose, collapse into abstract shapes lost in space. This is particularly visible when looking at the works of Karina Petersen.

Helena Dietrich's work titled "Tiefschwarz" – meaning "pitch black" – is that of a conceptual story. Letters are custom tailored, carved and piled up to a typographic sculpture in white on white. Then, black colour is gradually added and tossed over these very letters to result in a puddle of dripping pitch-black typographic matter. The combination of paint with this typographic sculpture is what added weight and a true visual and conceptual experience to the words chosen.

At the core of the works in this fourth chapter, is the construction of ideas with material that is not easily available, but that is instead carefully selected to define the look, texture and overall experience of the typographic pieces. It is not the material alone that interests, but the idea behind it, which acts as the driving force. Materials then get chosen and customised to fulfil their purpose.

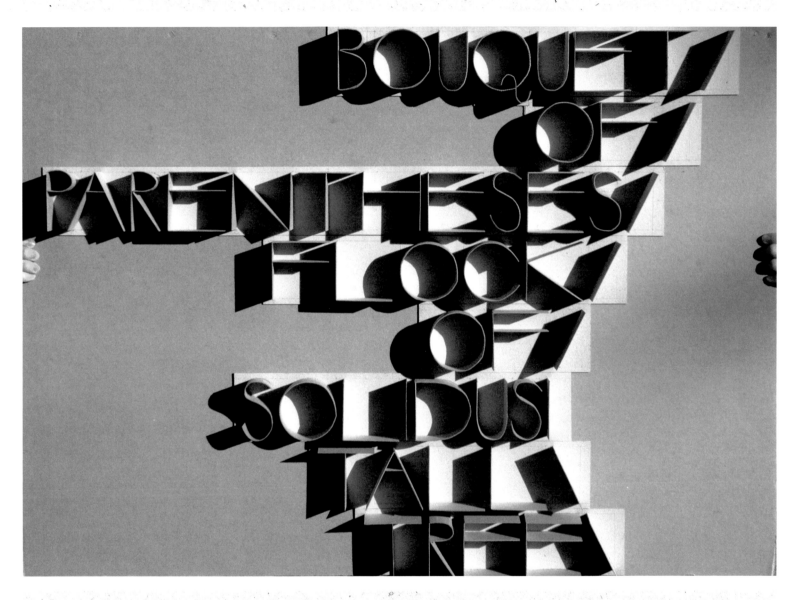

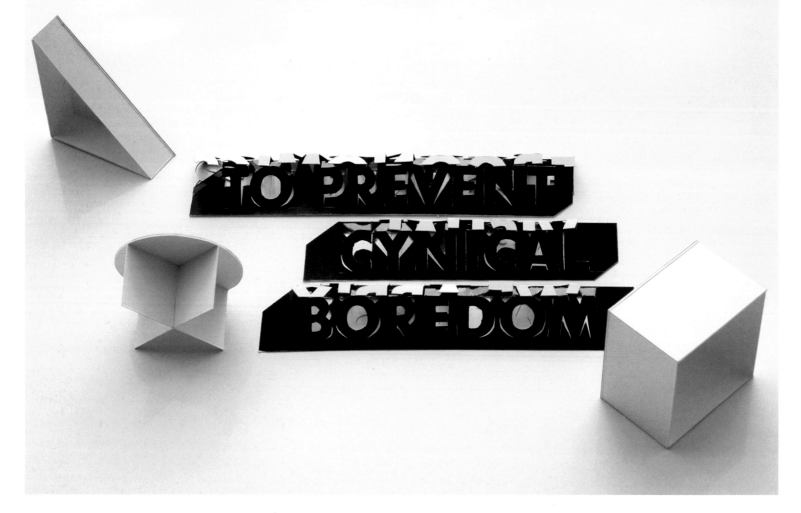

EXPOSITIE:

SENSES

BEELD & GELUID UIT DE BRONNEN VAN DE TAAL.

36 kunstenaars / 5 steden!

3-5 februari – Eindhoven
TAC (Temporary Art Centre)

10-12 maart – Breda
Lokaal 01

21-23 april – Helmond
De Nederlandsche Cacaofabriek

26-28 mei – Den Bosch
Artots in het Kruithuis

16-18 juni – Tilburg
VanMarenhuis

GO. Eric de Haas!

sponsoren & subsidiënten:

gemeente Eindhoven

accu breda

gemeente Helmond

's-Hertogenbosch

TILBURG

N B K S

LiBra

TAC LOKAAL 01 DENEDERLANDSCHECACAOFABRIEK

STOK® Stichting Van Marenhuis

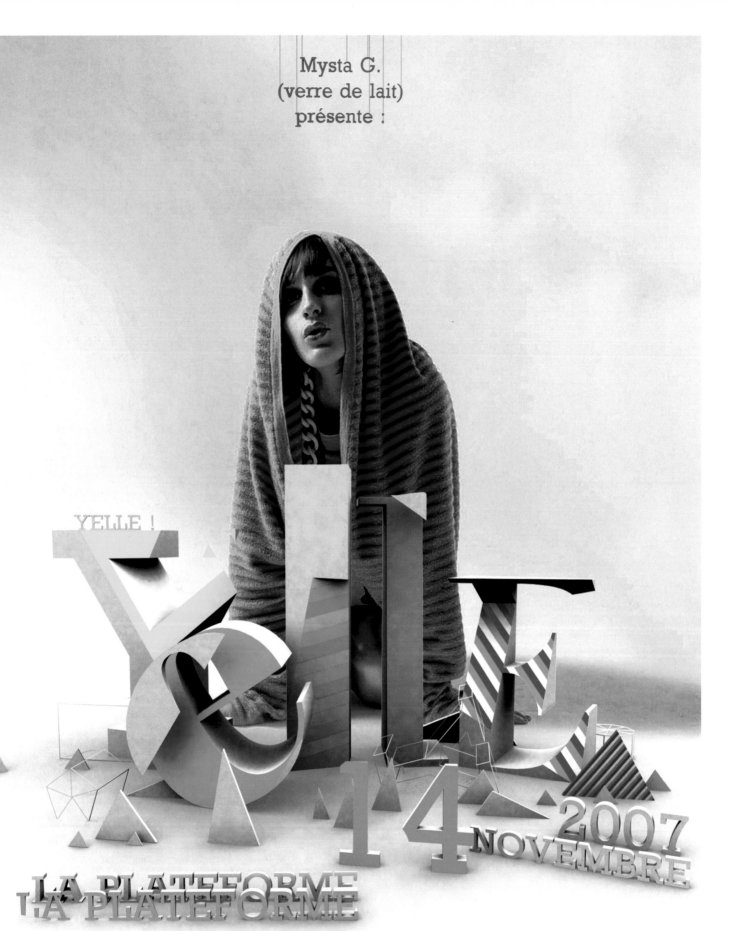

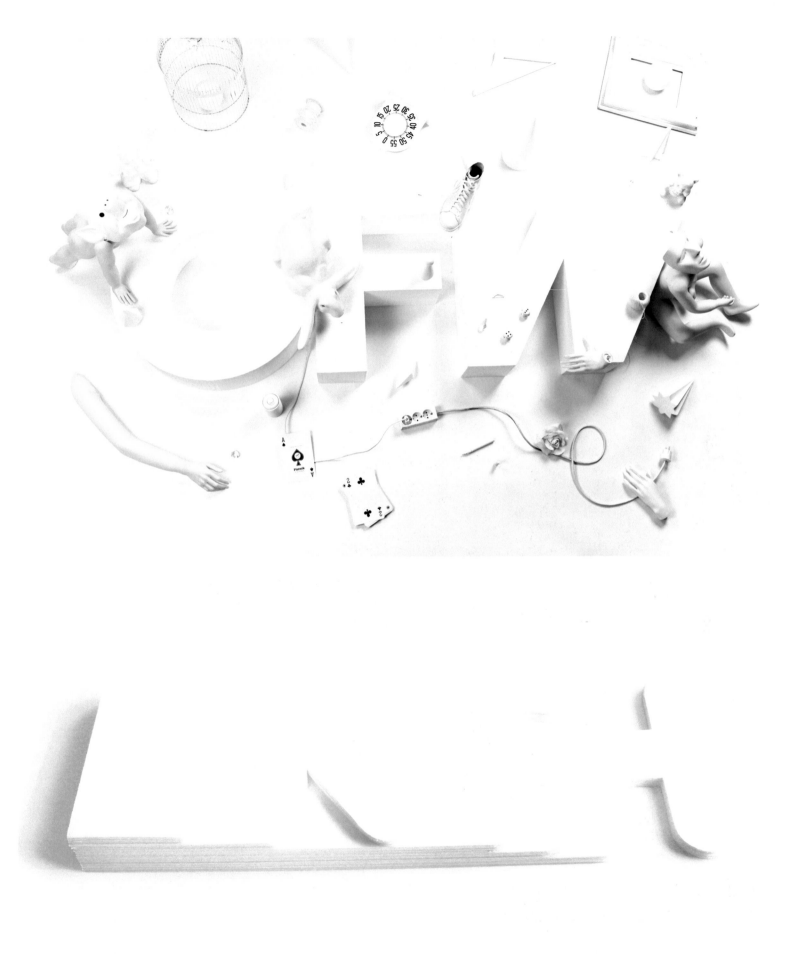

St. Paulus Creative Force (top), TNOP Design (bottom)

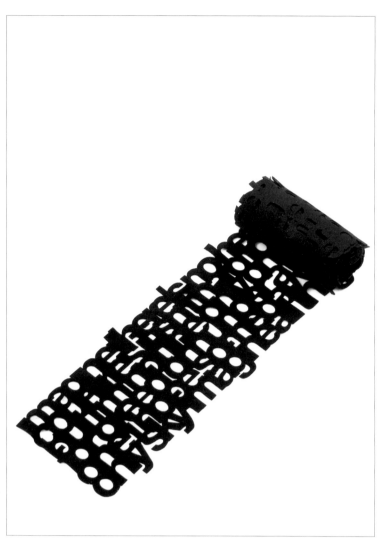

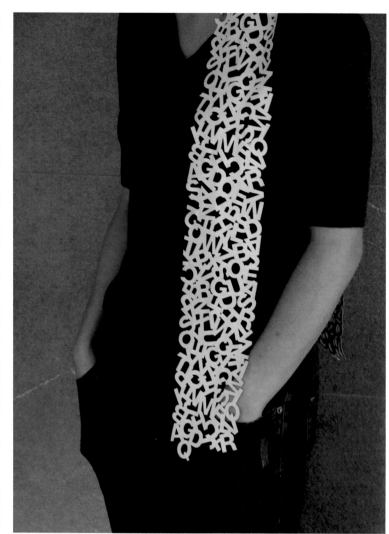

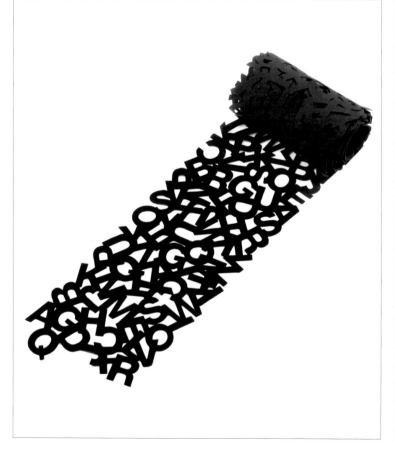

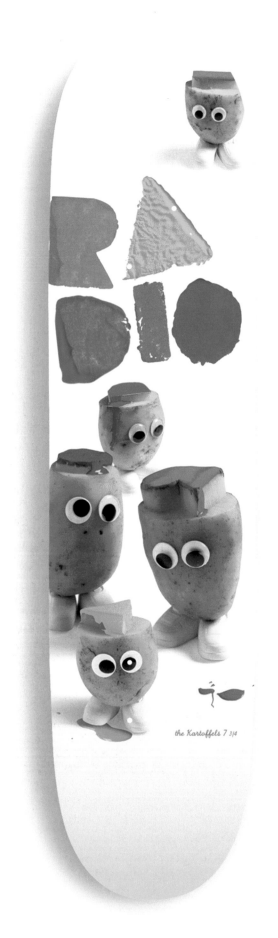
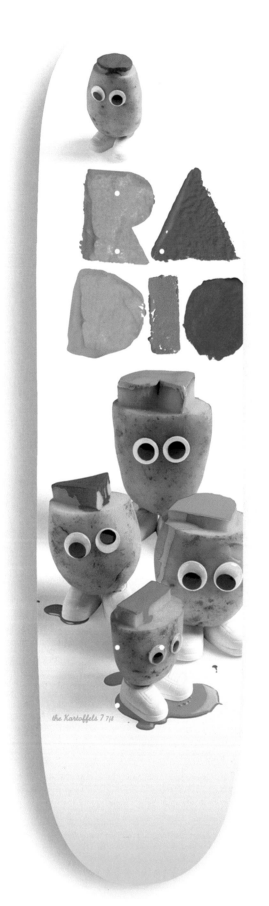

PLAY

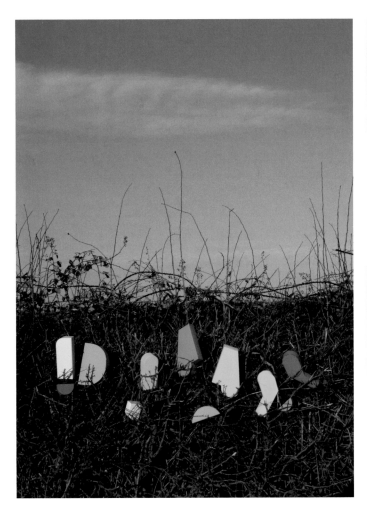

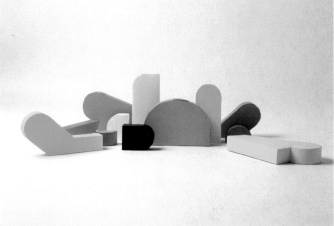

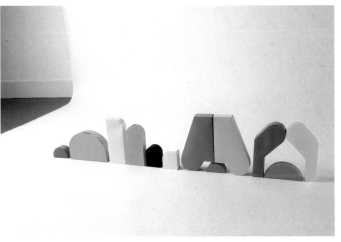

MAKE TIME FOR PLAY!

奇妙で、同等です。

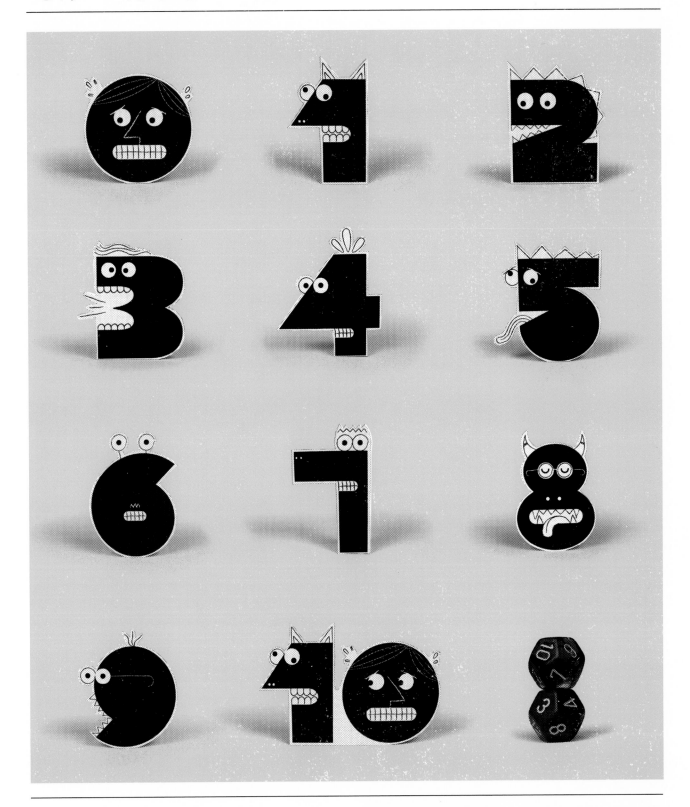

Steven Harrington

捨て札をセットすることで多少の基本的な心の数学が助けます。手を半端な番号を付けられていえさしたタイルに分けてください。10の倍数で、そのような数の法律はそれを私たちに話します。=（均衡がとれて、均衡がとれて、+均衡がとれる） 10（奇妙であることと+奇妙であることと+同等であること）の同等の可能な倍数＝10同等の可能な倍数か（半端で、+半端である、+半端な）= 奇妙である あるいは （同等で、+同等で、+奇妙で）=奇妙である。もし手が5枚の半端な番号を付けられたタイルを持っていれば、あなたは捨てることができません。もしあなたの手が4枚の半端な番号を付けられたタイルを持っていれば、それらとの捨て札と同等のタイルから始めることによって捨て札を捜して、他の2つをそれに加えてください。もしあなたの手が3枚の半端な番号を付けられたタイルを持っていれば、（半端で、+半端である、+同等の）組み合わせの捨て札を捜してください。もしあなたの手が2枚の半端な番号を付けられたタイルを持っていれば、3枚の同等の番号を付けられたタイルへの一覧あなたの手が1枚の半端な番号を付けられたタイルを持っている そしてそれをひっくり返るように変えて、捨て札を捜す 残りの4.で、あなたの手が半端な番号を付けられたタイルを持っていない そして残りの5枚のタイルの捨て札を捜す。

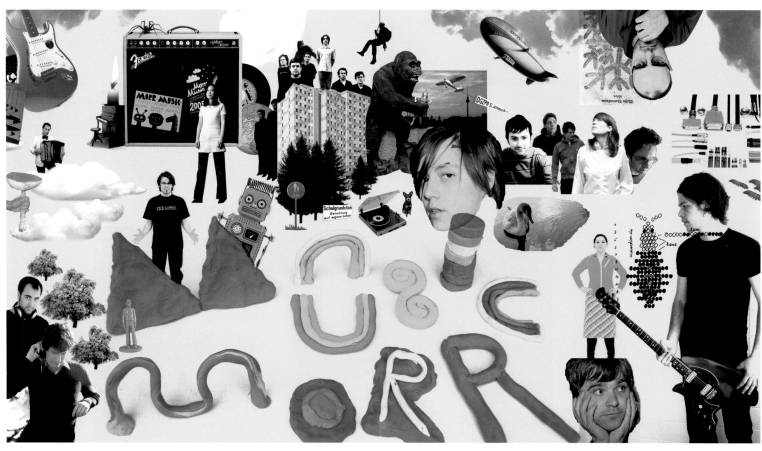

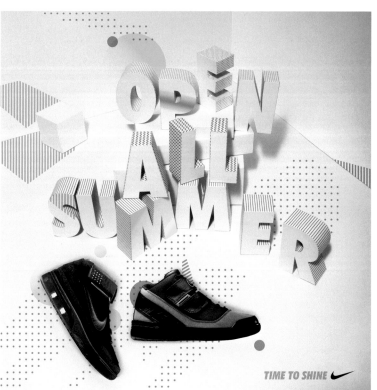

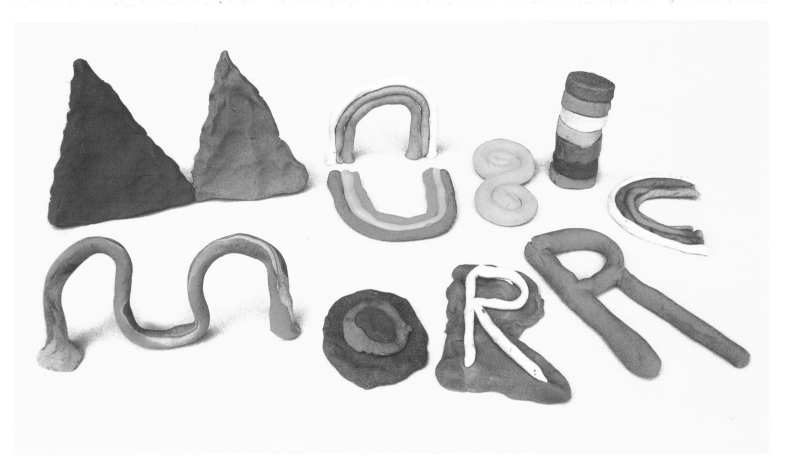

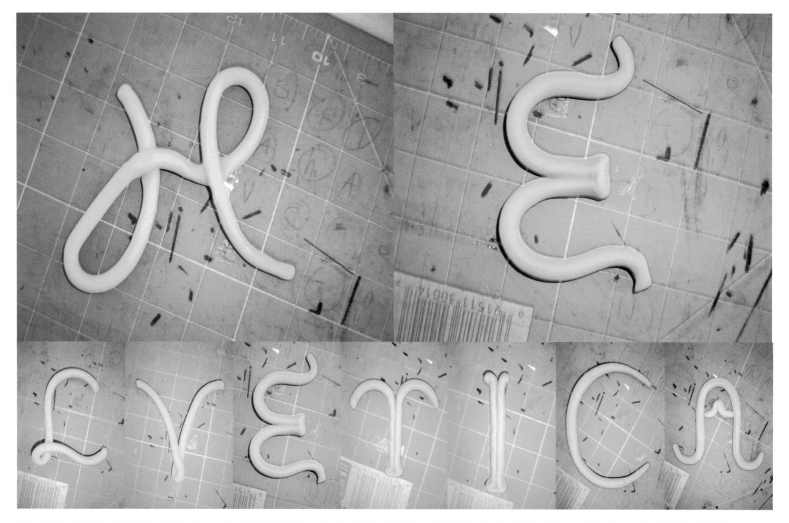

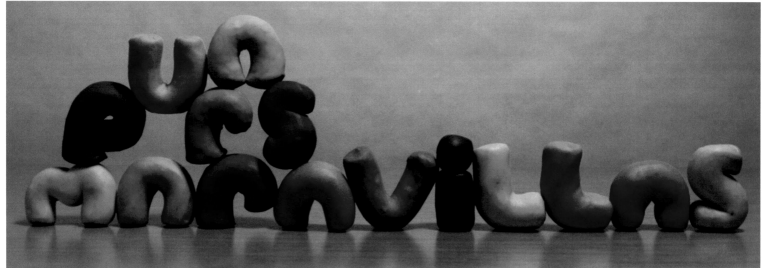

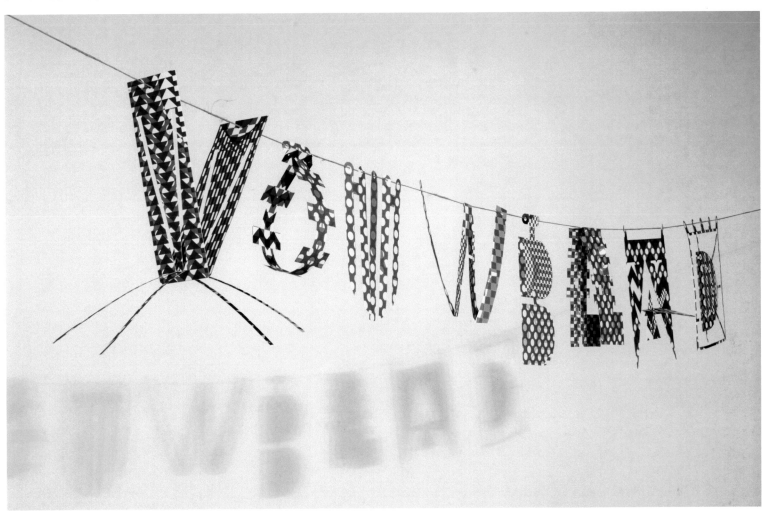

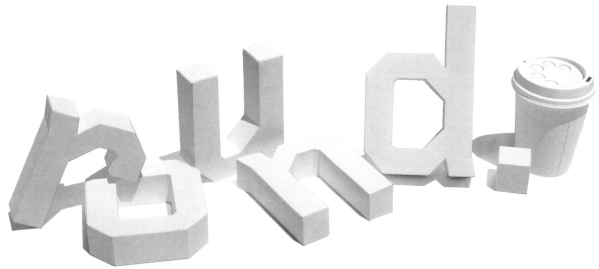

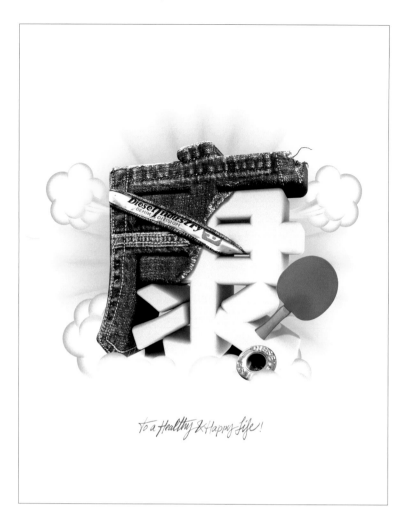

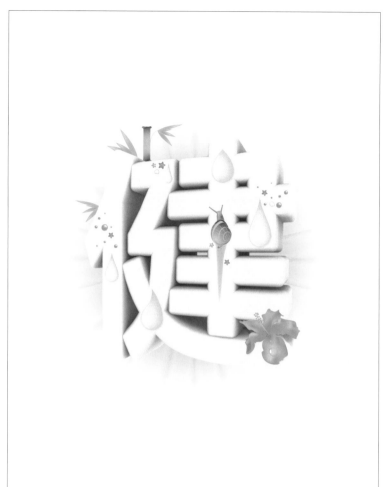

To a Healthy & Happy Life !

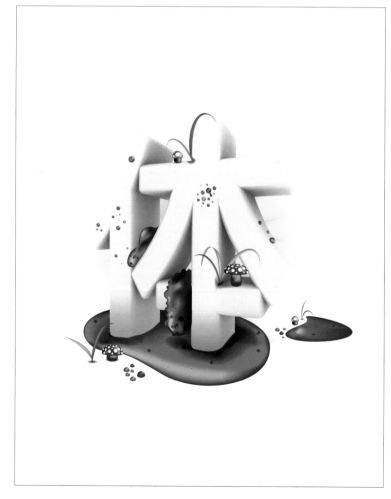

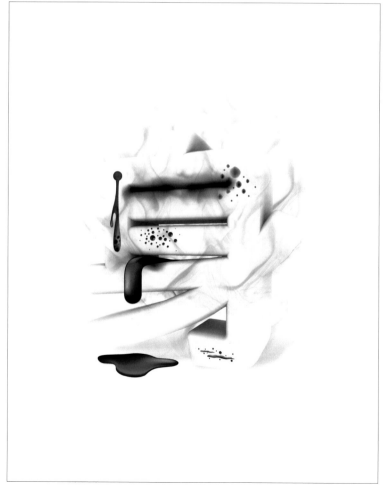

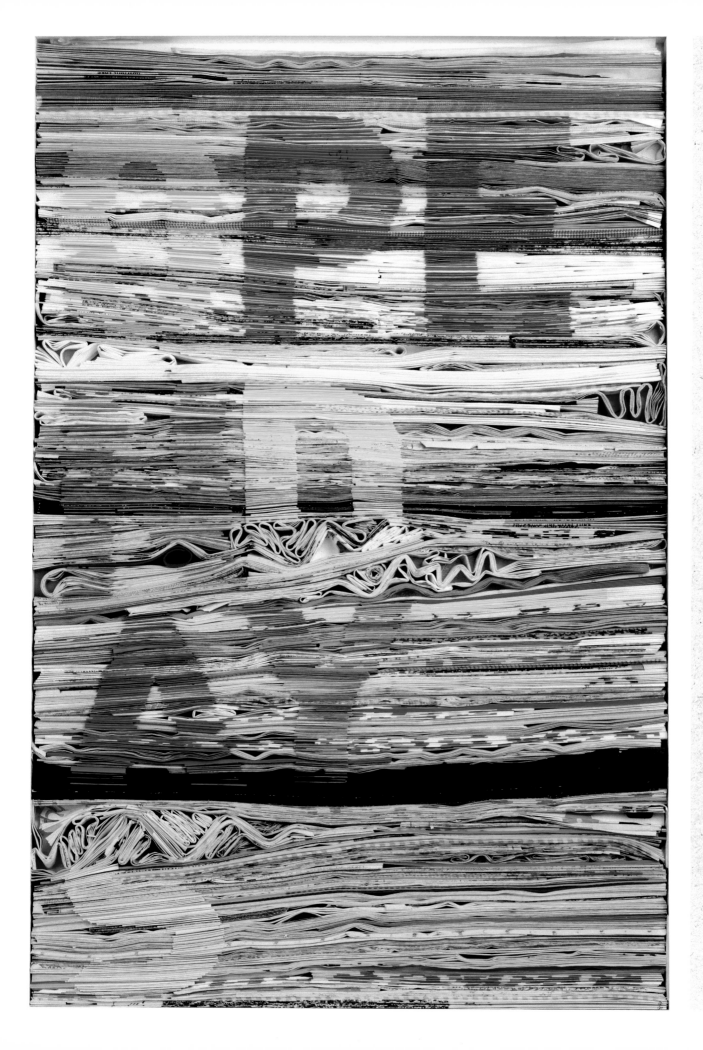

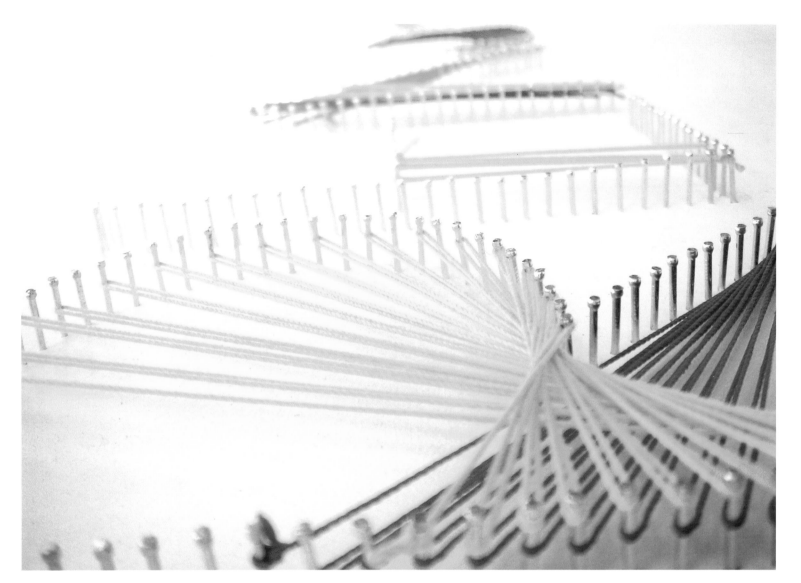

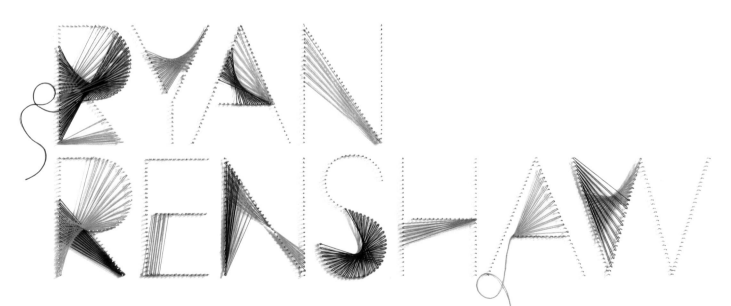

CONTEMPORARY AUSTRALIAN & INTERNATIONAL ART

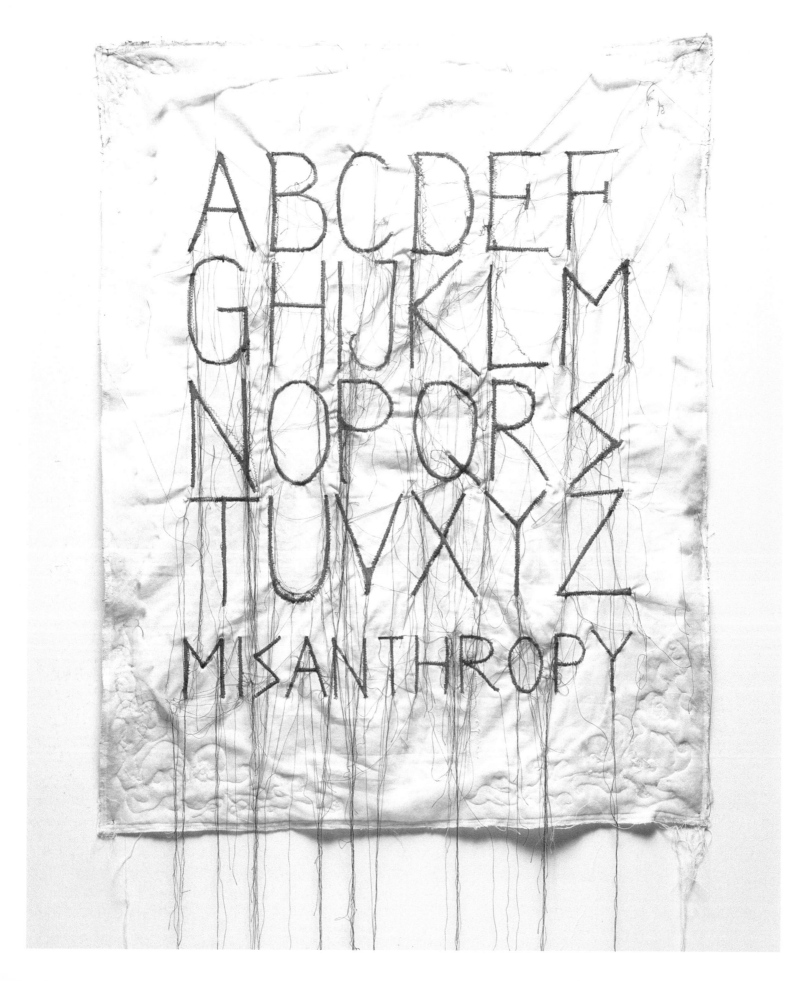

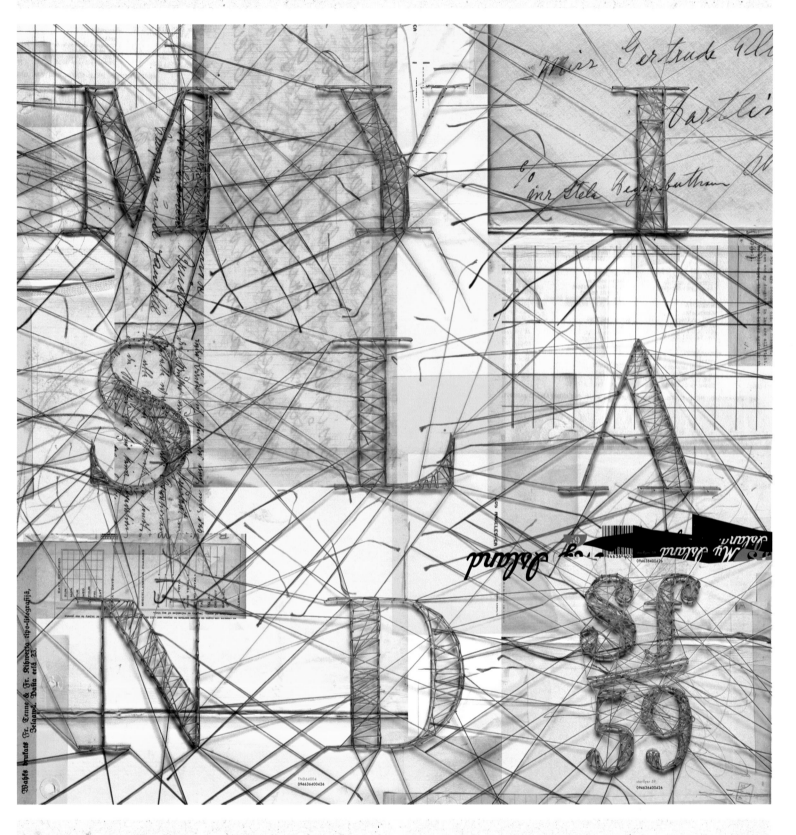

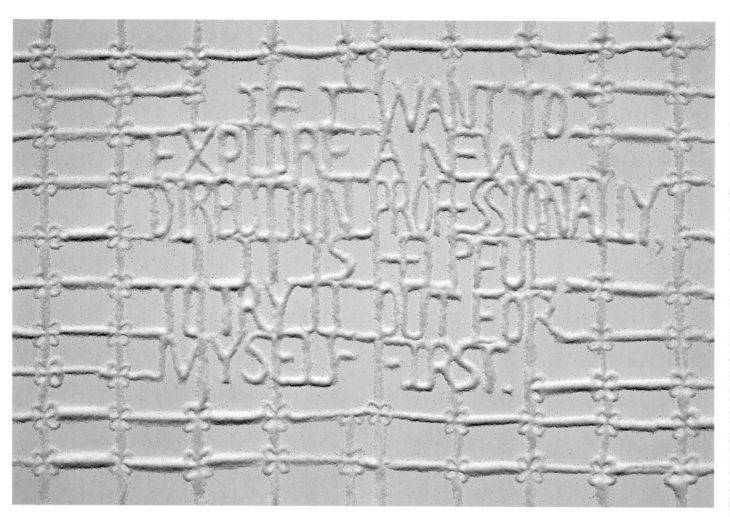

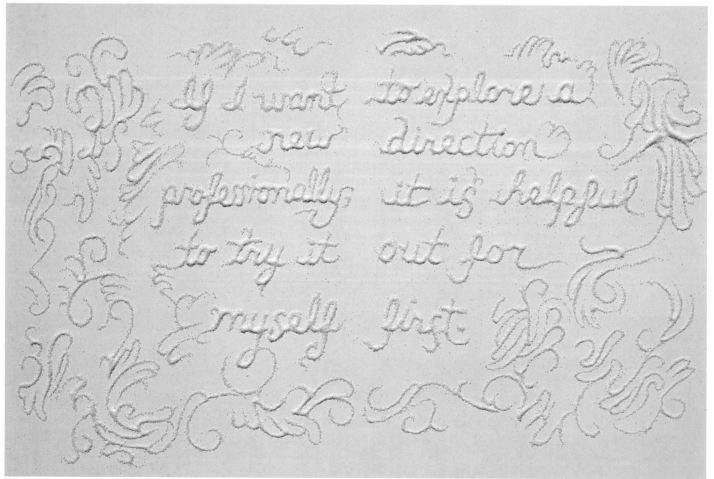

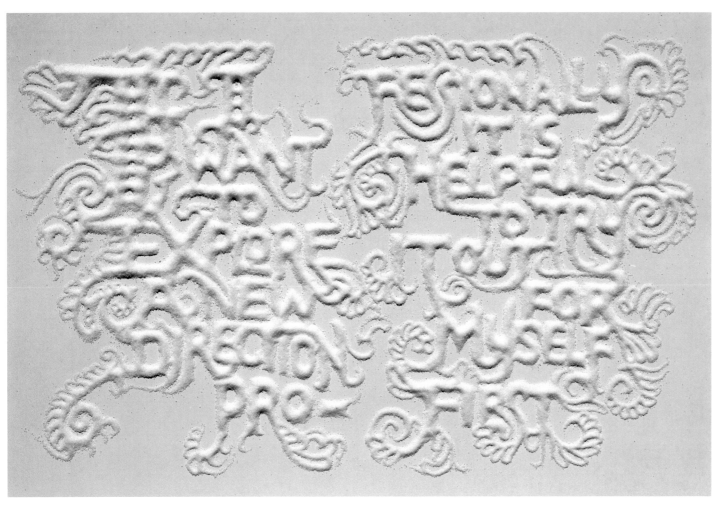

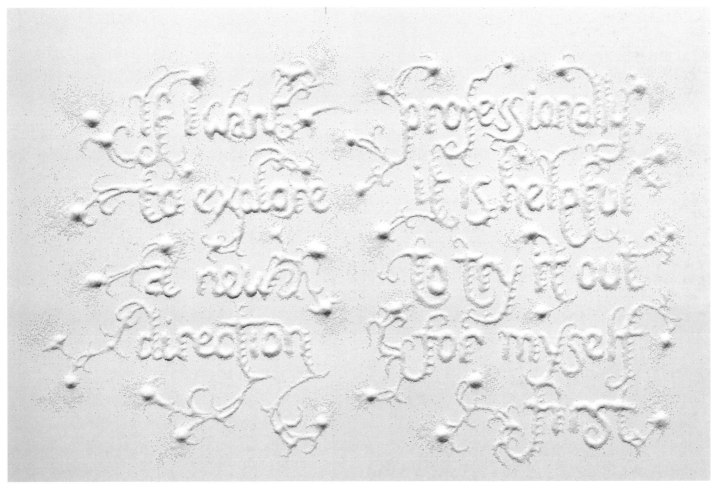

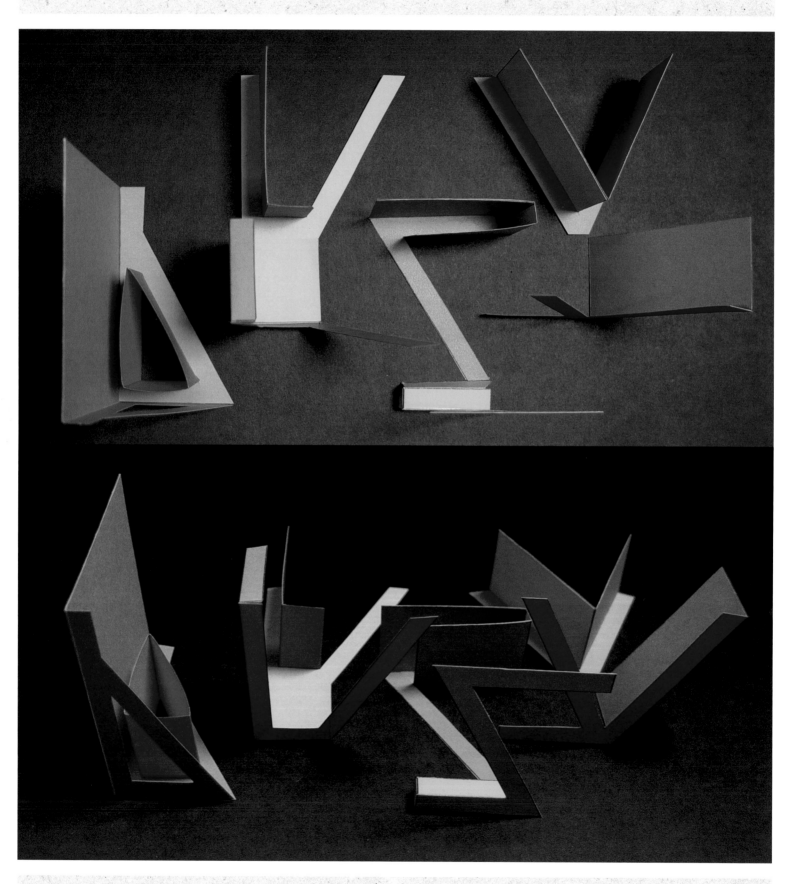

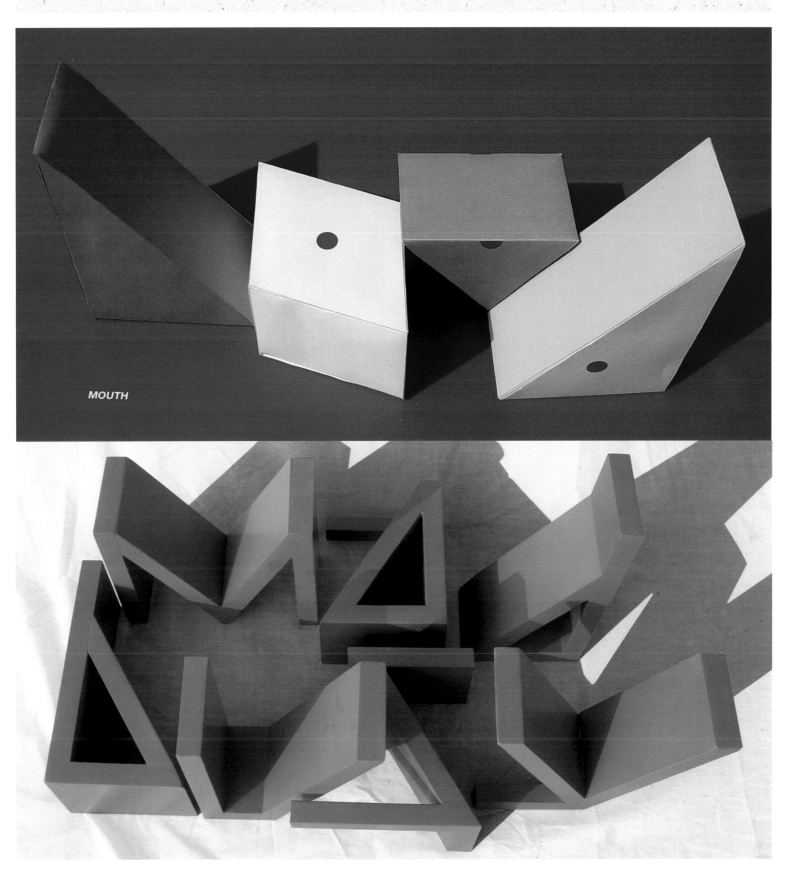

MOUTH

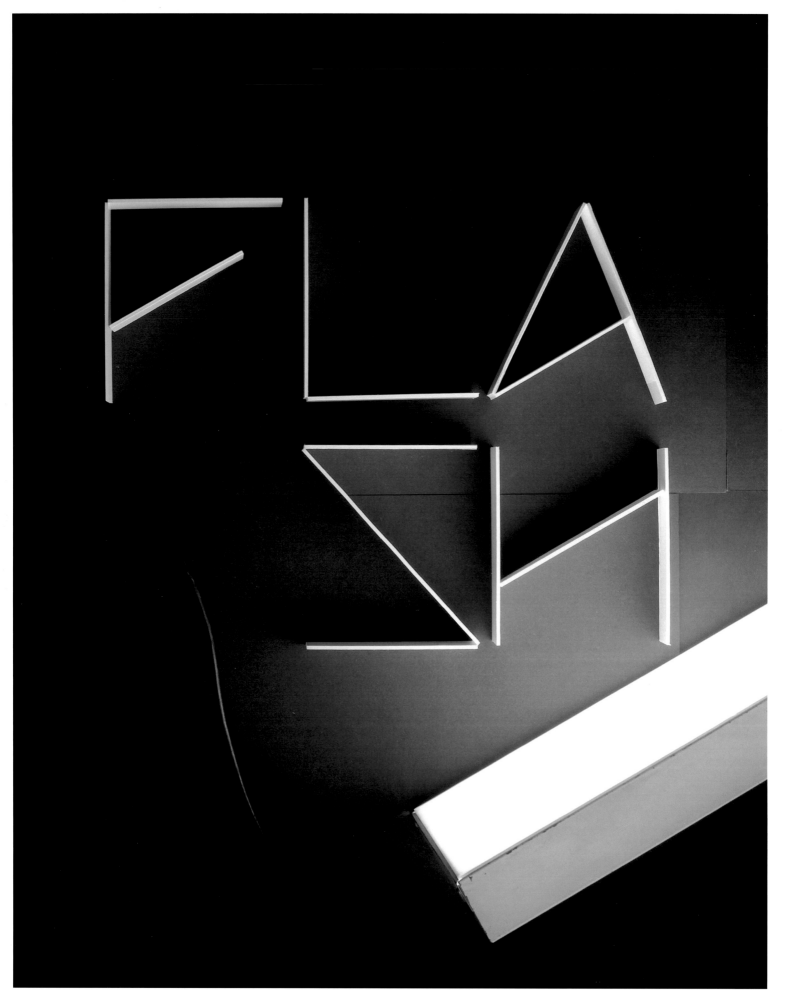

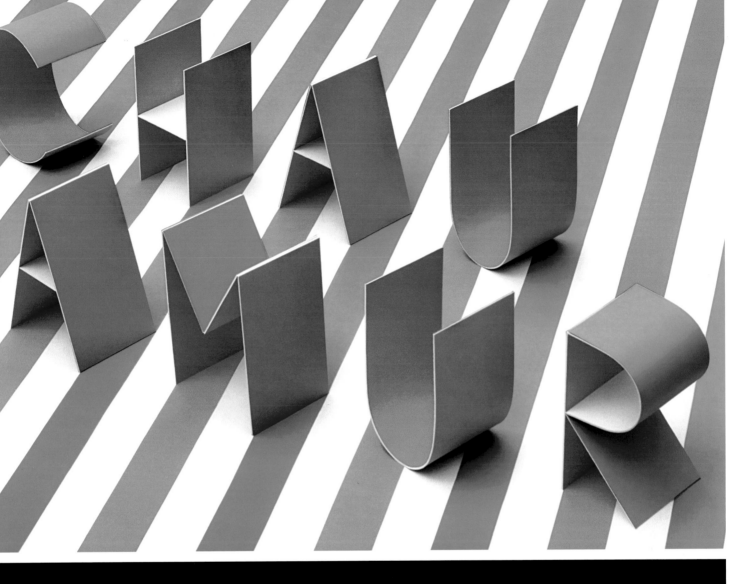

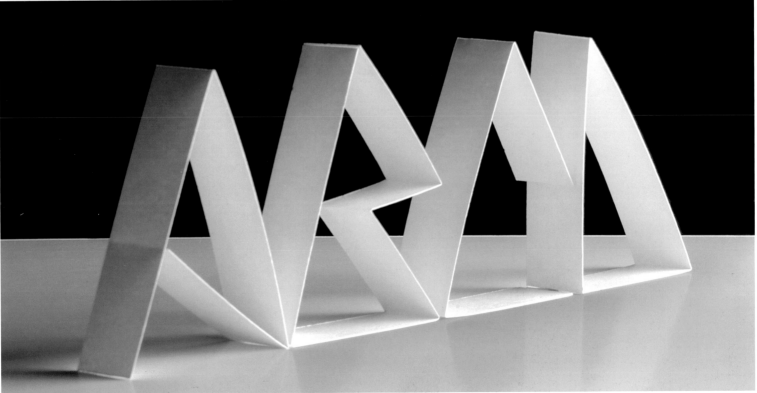

Theres Jörger & Susanne Stauss (top), Akatre (bottom)

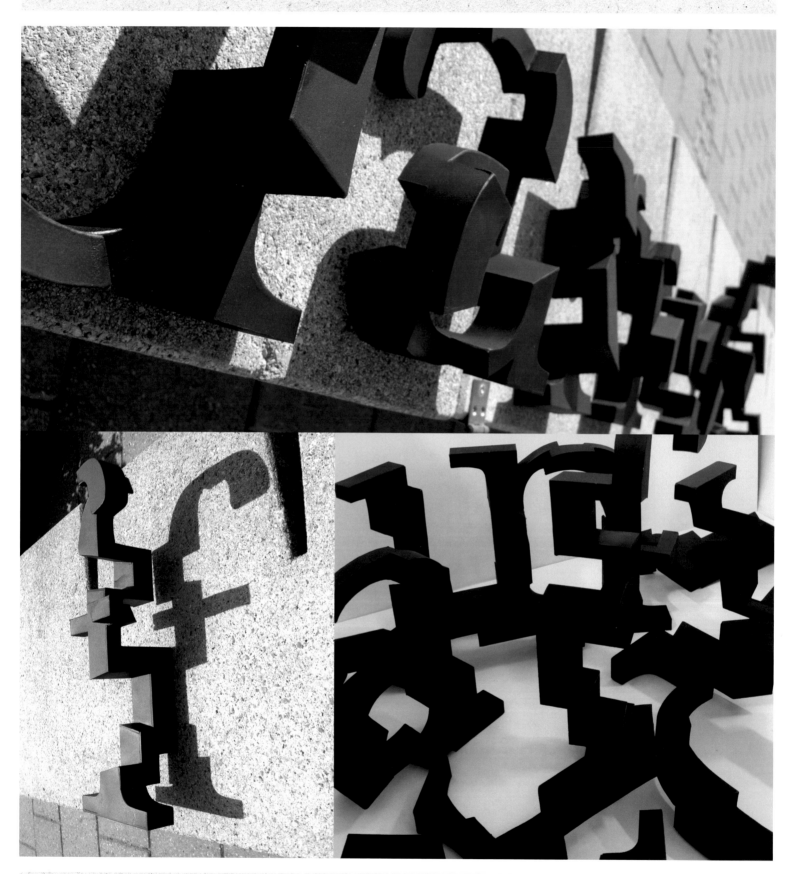

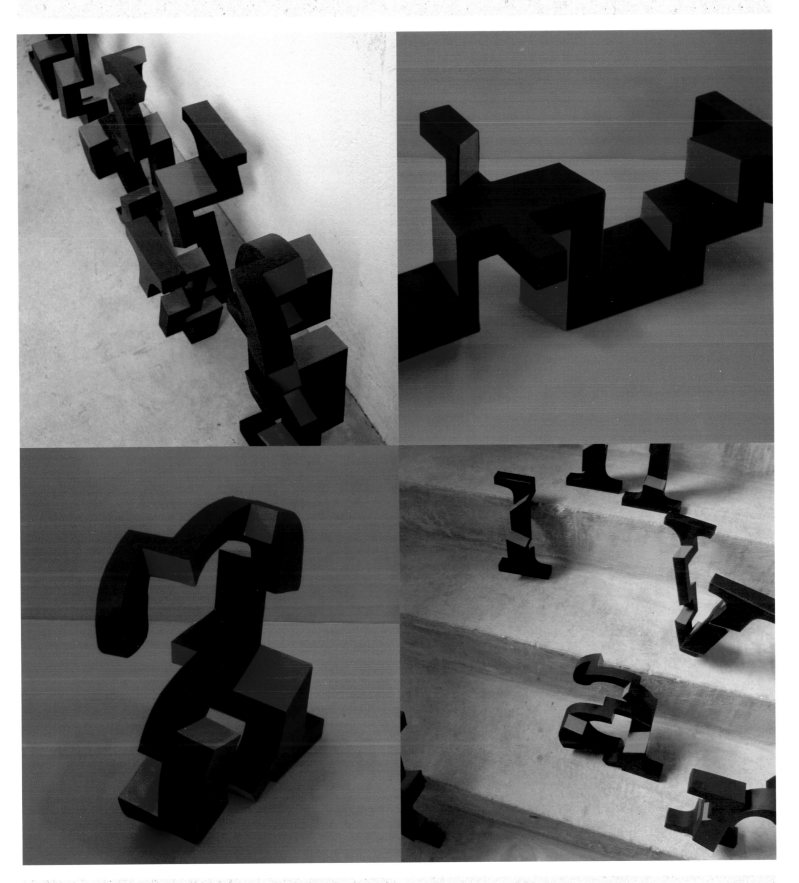

Karina Petersen

THOU SHALL NOT KILL TYPEFACES!

NAHT SANS

A B C D E F G H I J K L M N O P Q R S T U V W X Y Z
A B C D E F G H I J K L M N O P Q R S T U V W X Y Z

A B C D E F G H I J K L M N O P Q R S T U V W X Y Z

1 2 3 4 5 6 7 8 9 0 . , : ; ! ? ! { } + -

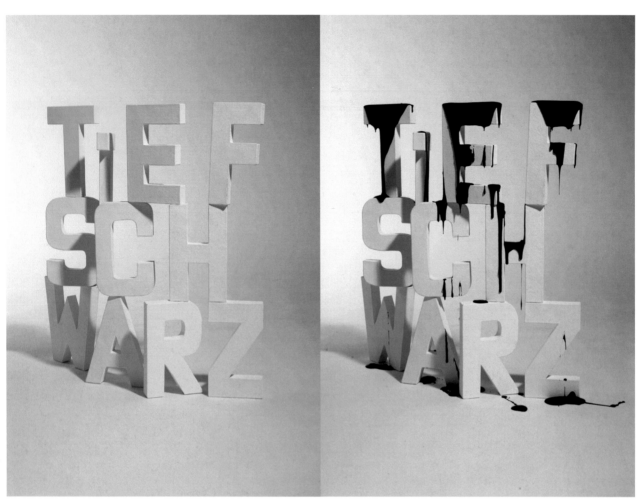

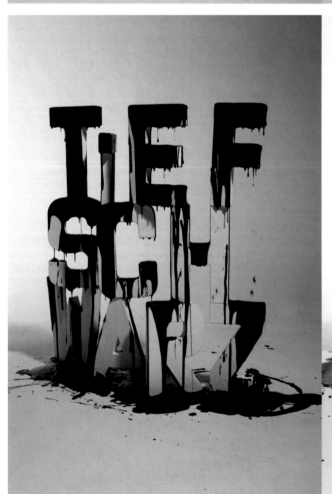

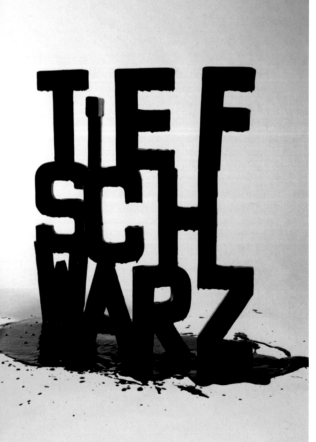

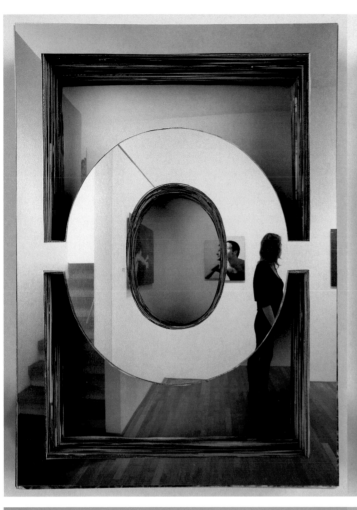
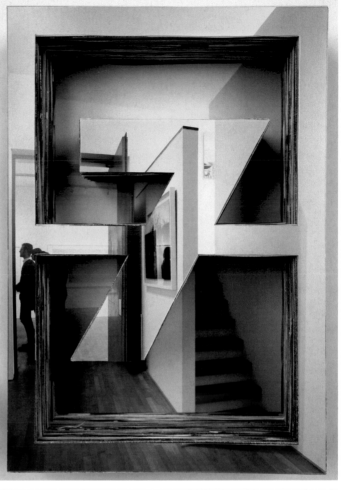
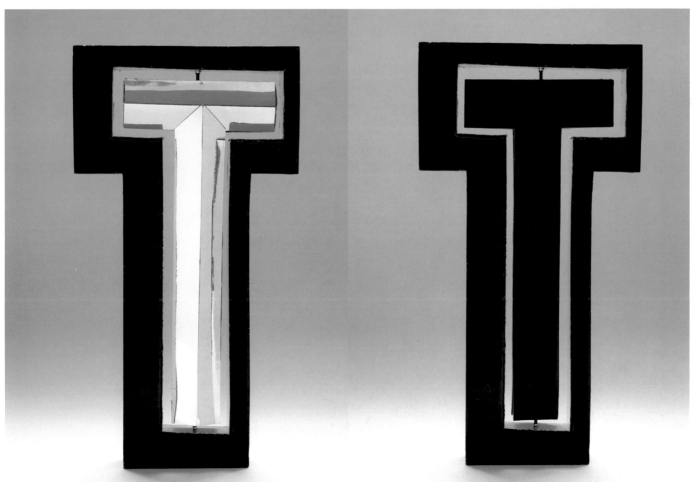

Thorbjørn Ankerstjerne (bottom), Corriette Schoenarts (top)

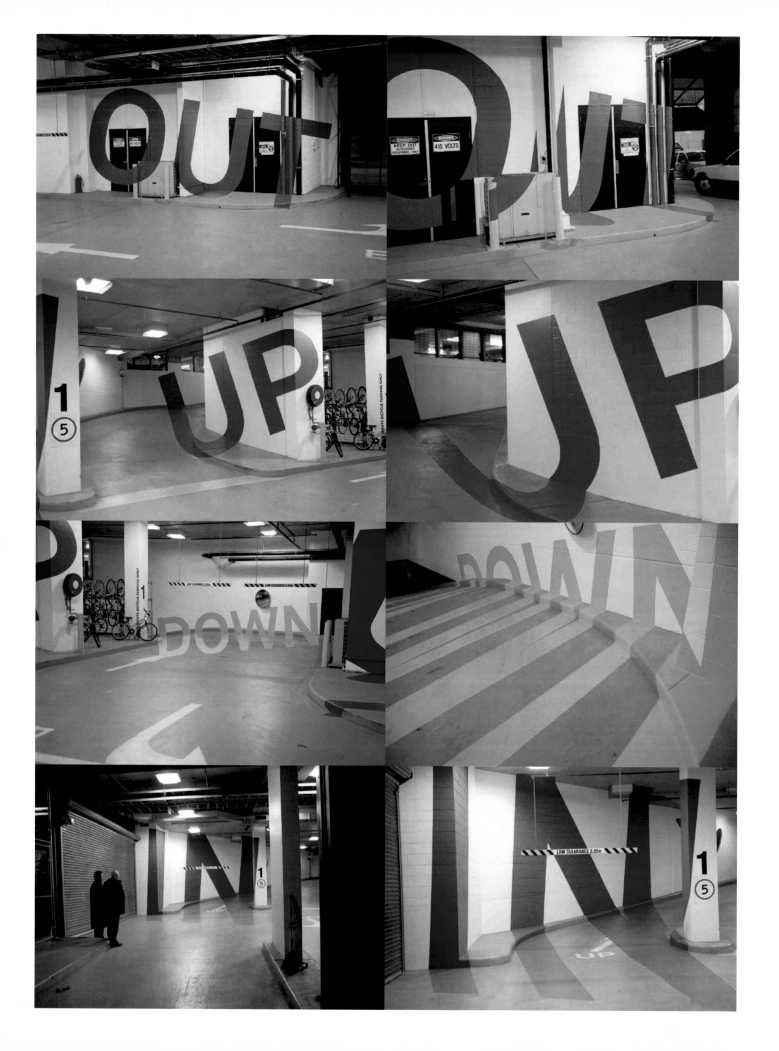

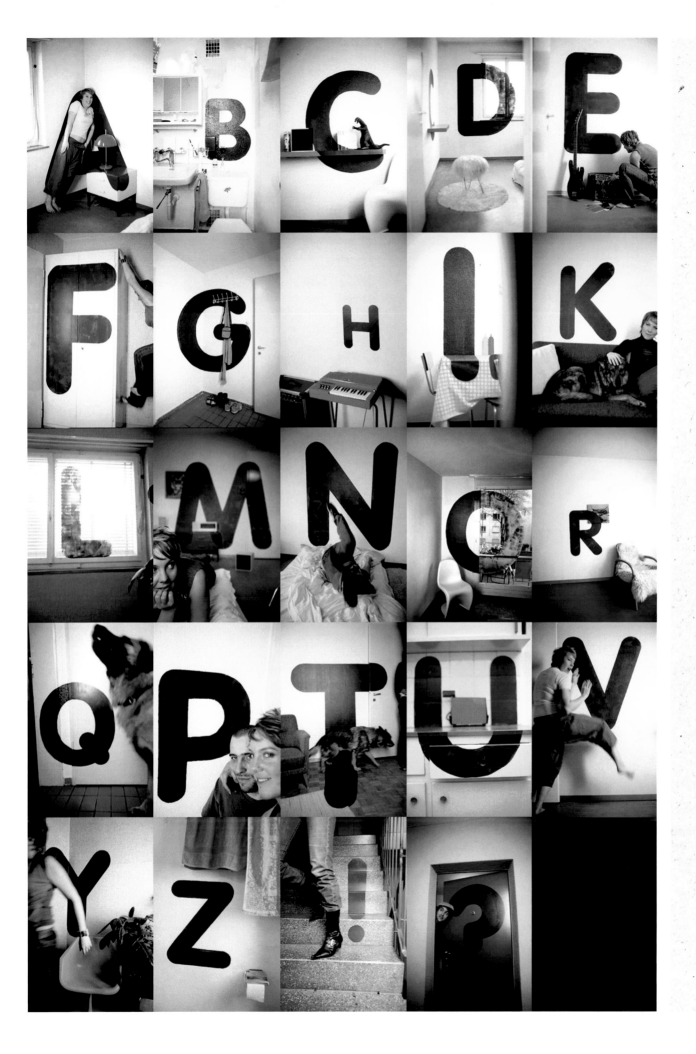

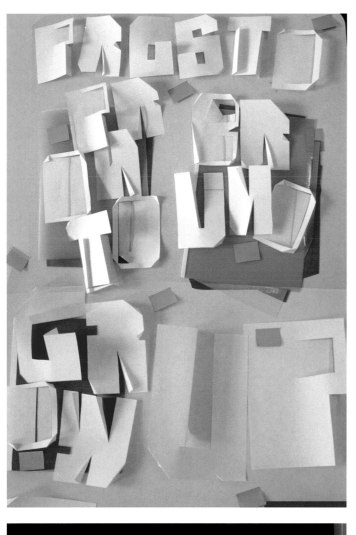

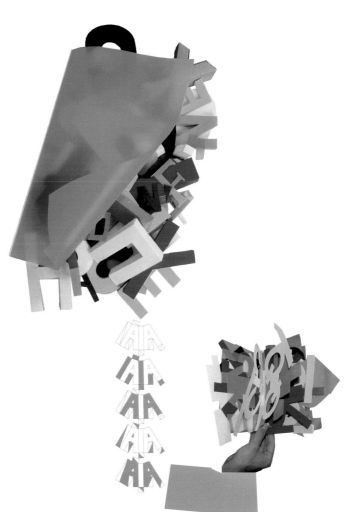

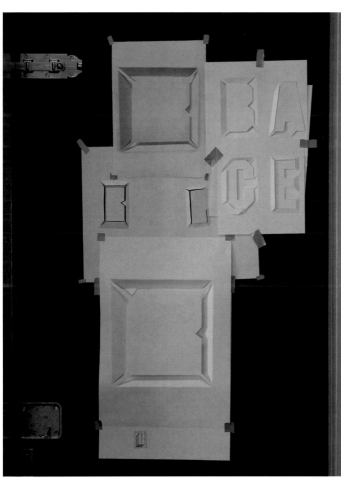

Camille Lebourges (top & bottom right), The Broken Headlines (bottom left)

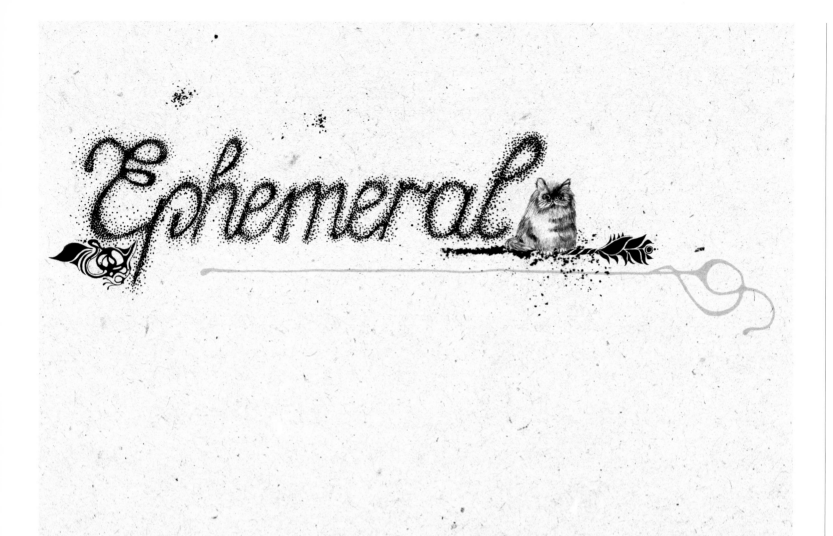

MOMENTS IN TYPE • • • • • • • • • •

„Ephemeral" – is a word that seems to be widely used today. It almost seems to represents a certain contemporary mindset. Due to the omnipresent ephemeral nature of the Internet and the fact that technology enables us to seemingly be everywhere at the same time, our lives appear fleeting. Information has never been so instantly available, having so much and so little impact at the same time due to its information overload. Today, everything around us seems to develop at an impossible speed, which often prevents us from grasping the simple truth of things. Everything appears complex; the world we live in seems momentary, perishable, in a constant stage of transition and change.

The works in this last chapter of Playful Type all emphasise their ephemeral existence. In fact, as typographic creations they don't last longer than a moment in most cases. Due to the changing nature of the materials chosen, the designer's attempt is not to make something that lasts, but rather to make something that deteriorates. Ice eventually melts, honey dribbles and soap bubbles dissolve. The visible letter is the conservation of a moment – a photo, that lets us imagine what was there before and after.

We are familiar with the fleeting nature of street art. Designs put up in the streets with a lot of care and energy – sometimes lasting merely a few minutes, while others endure for hours, days, their lifespans unknown. What is unique to these works is the celebration of the moment and the importance of the act of installing the work. This is similar to the ephemeral type solutions presented here.

Carving letters out of ice bit by bit and forming the pieces into a typographic sculpture is certainly a momentary thing to do, but what is essential here is that both the act and result of creation get captured in the form of a photograph. In this regard, the photograph is perhaps the opposite of "ephemeral", because it catches this moment in time. The intention was never really for those works to be ephemeral, but to relate to their ephemeral nature.

Birth, peak of life and decay – a simple but deeply rooted truth of life known to us all and therefore relevant to us. The works speak to us because we feel that we were present during the short period of time where the work is at its peak. It is the shared impression of something real, something easy and simple to grasp, especially because the materials chosen are so familiar. The simple photograph of these fleeting works proves a certain authenticity due to their unpretentious simplicity. By presenting ephemeral works with the medium photography, the designer speaks directly to the viewer and simultaneously breaks the loop of ephemeral fleeting design solutions by presenting the bare rawness of the moment itself. It incorporates all: sharing the process of creating, indulging in playfulness, the beauty of natural light and the surprise of recognising something familiar in these odd settings: type.

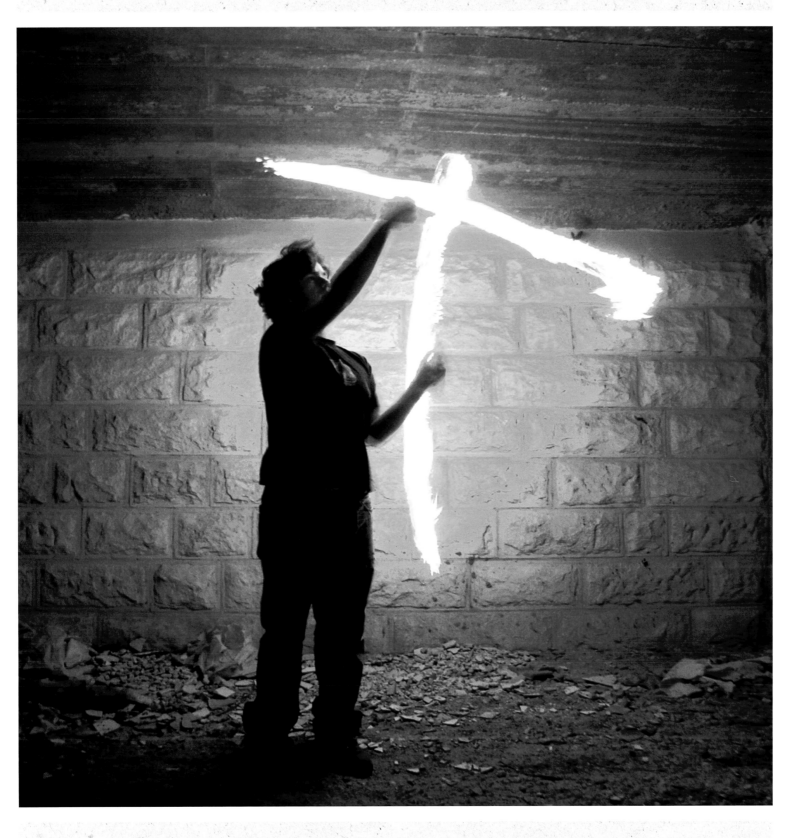

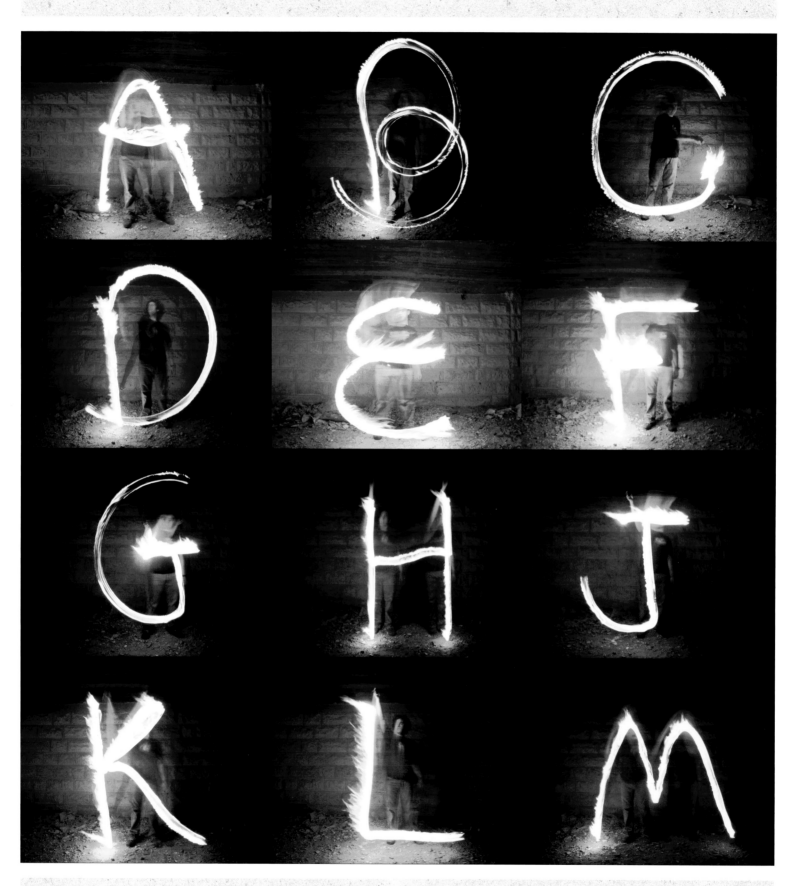

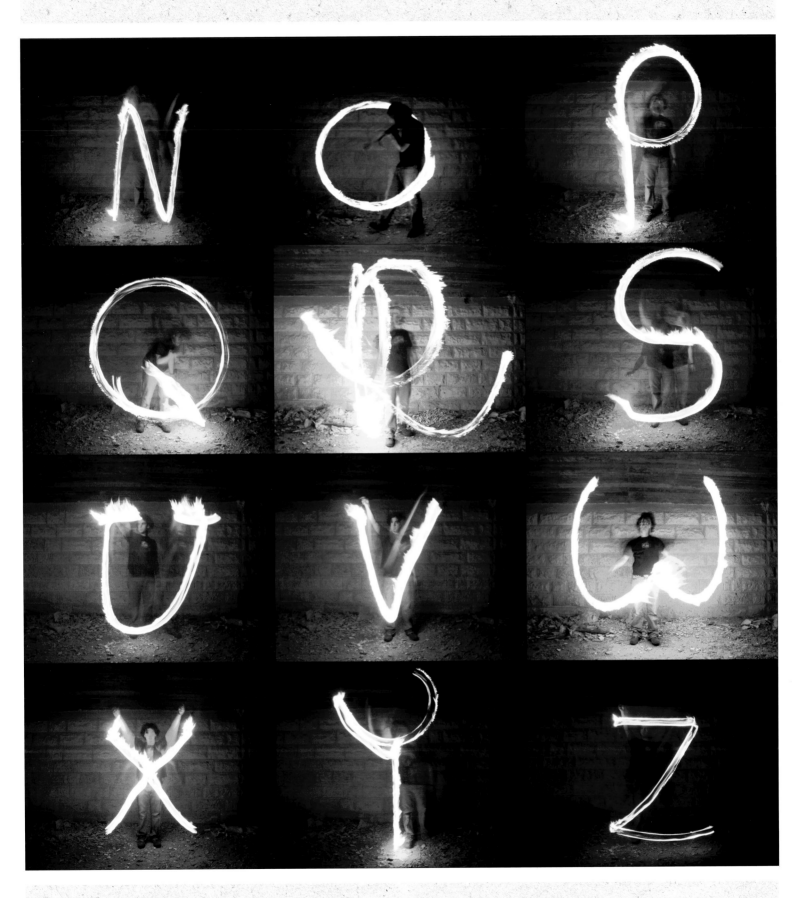

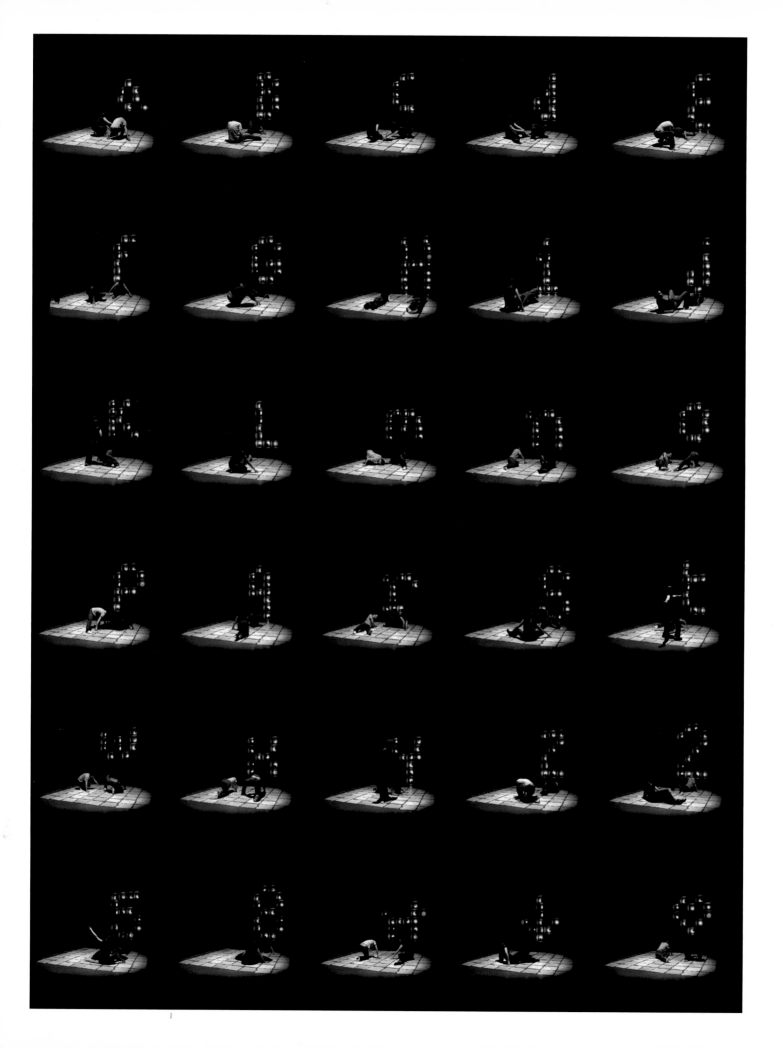

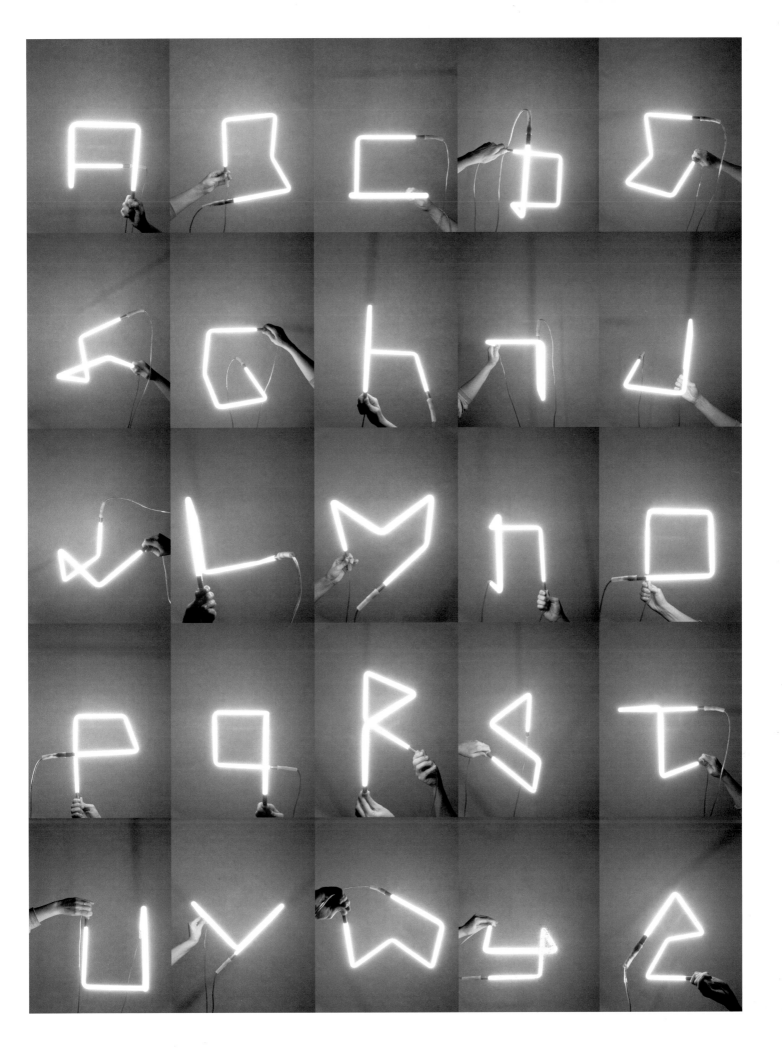

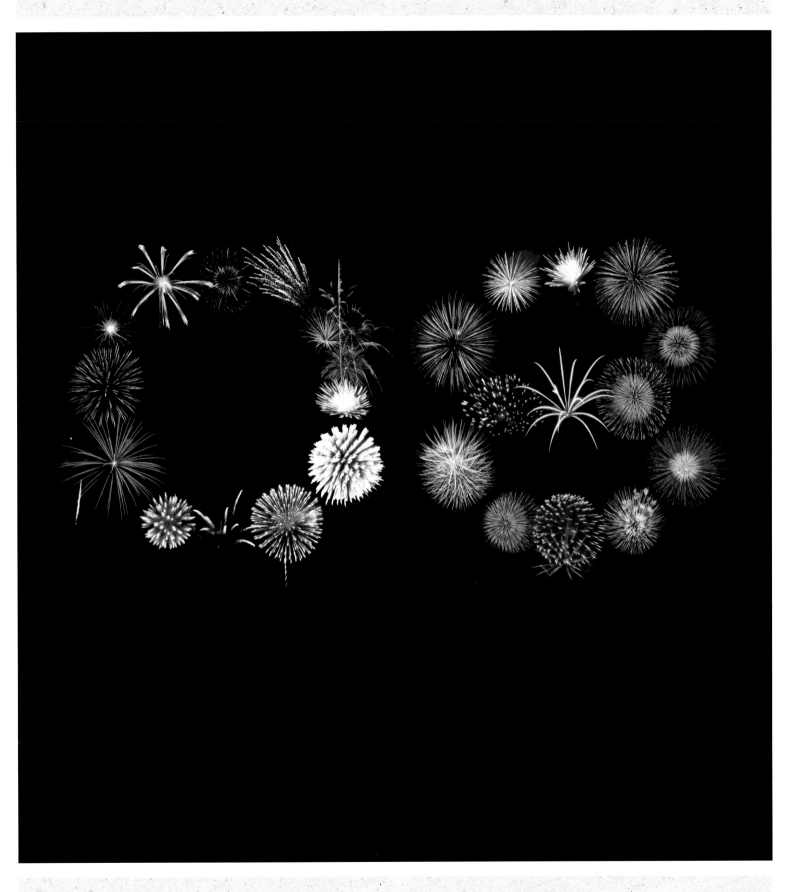

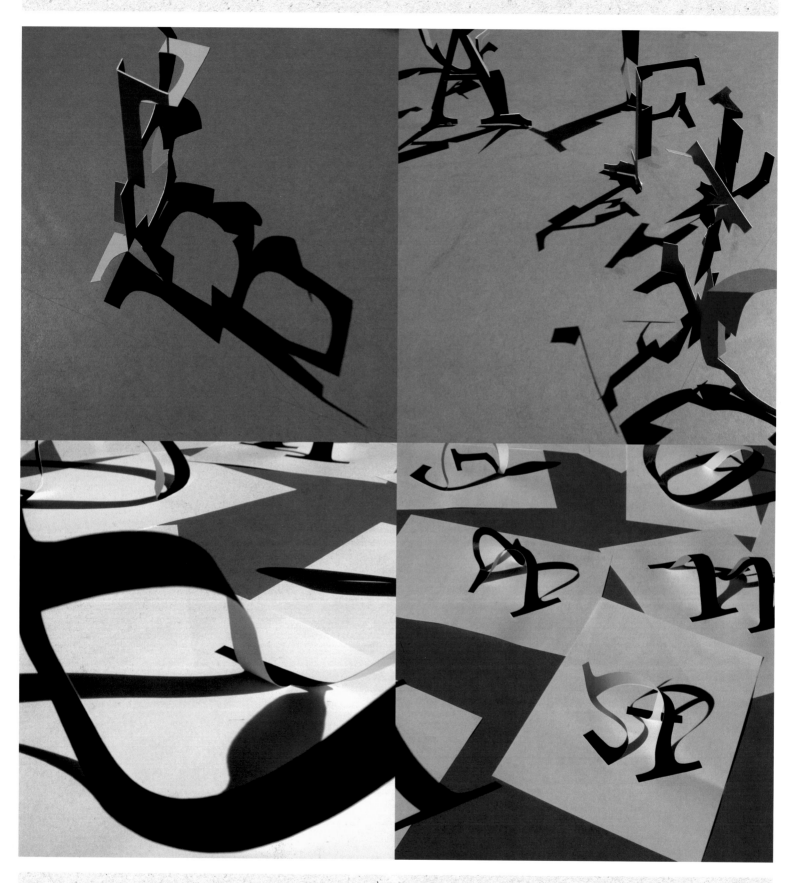

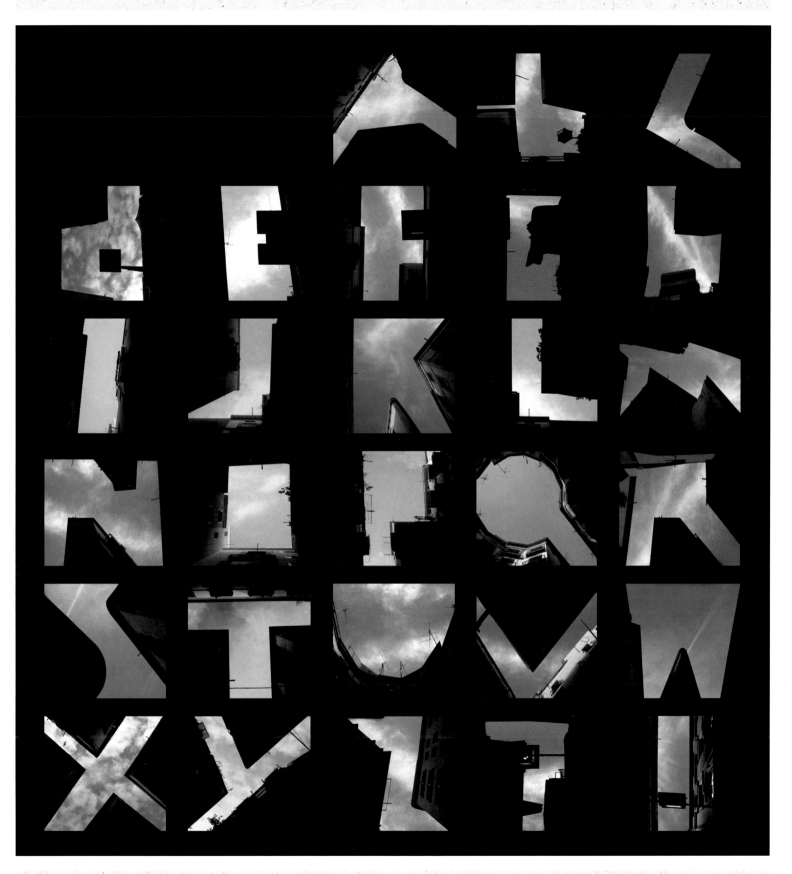

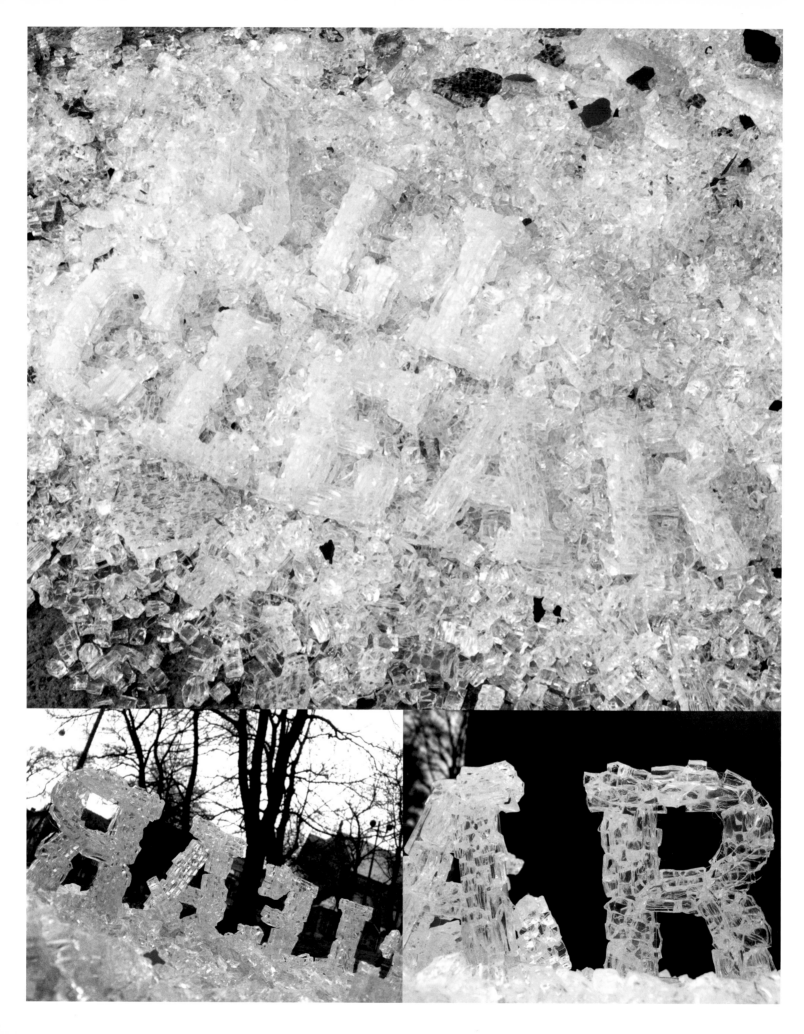

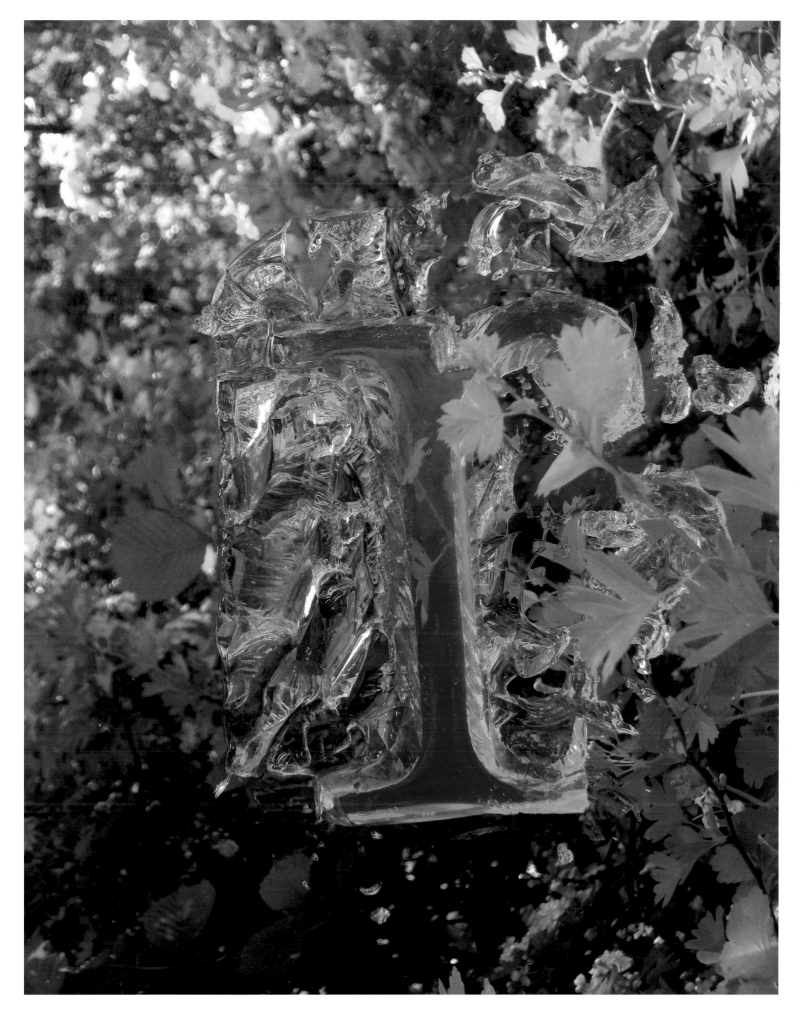

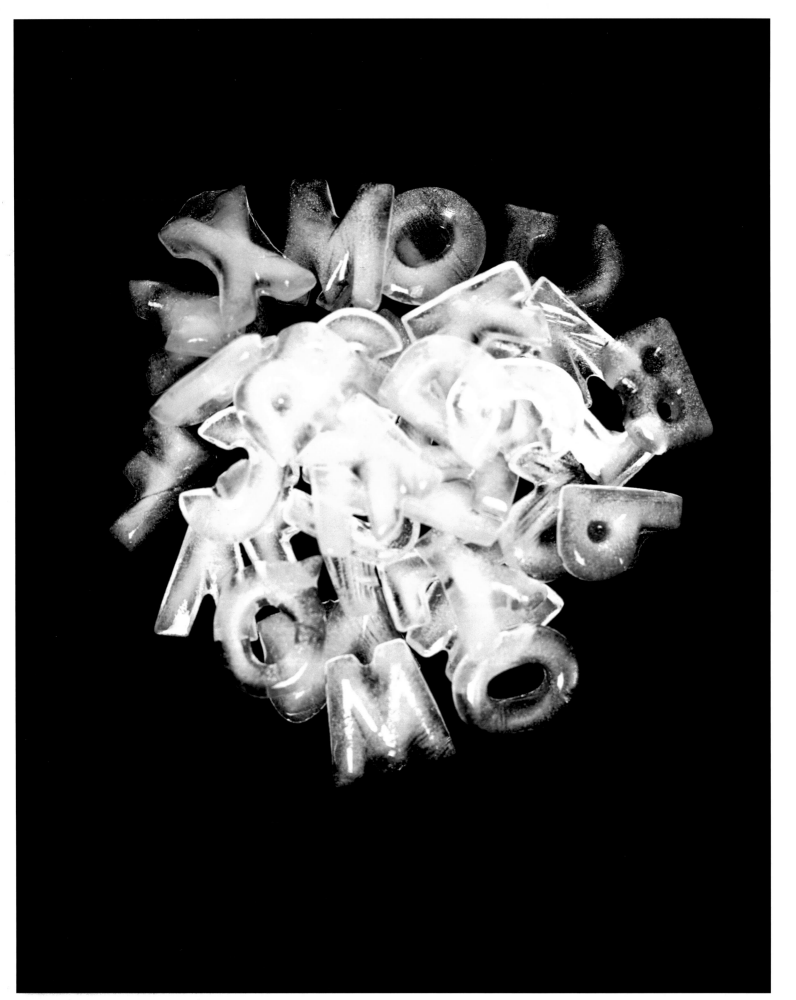

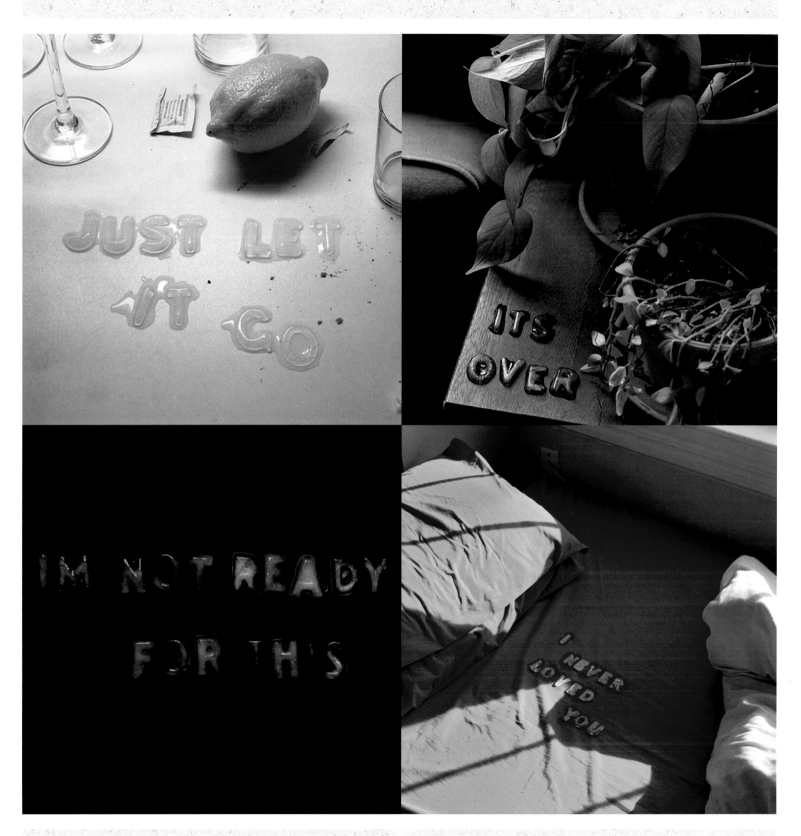

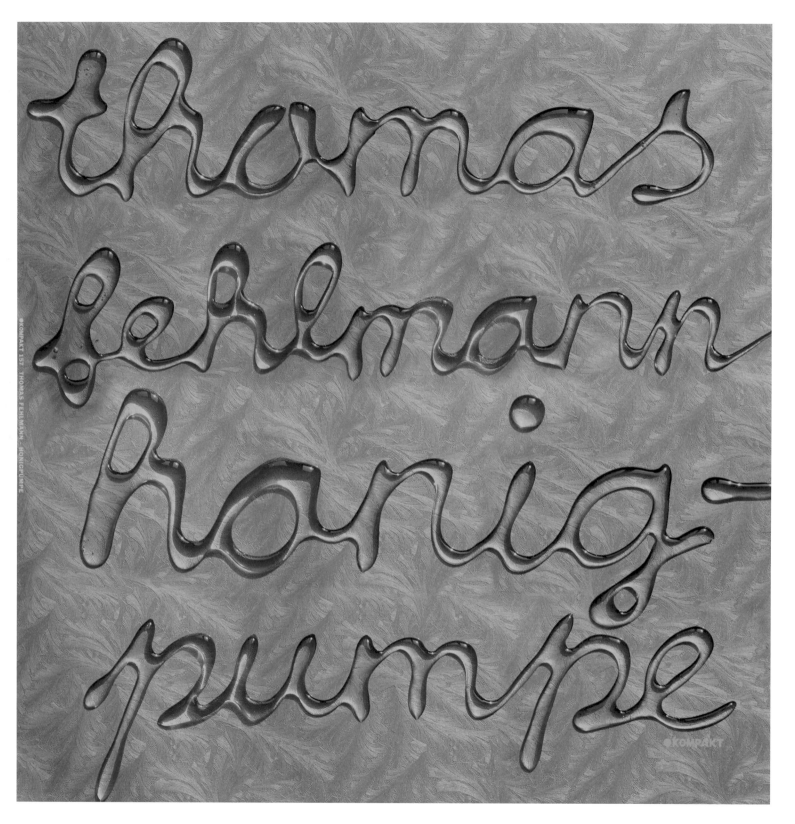

Bianca Strauch

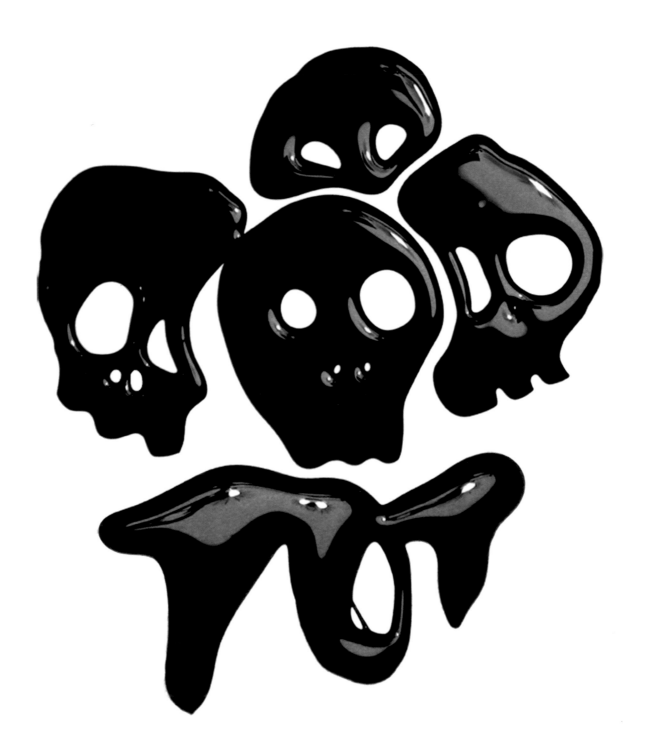

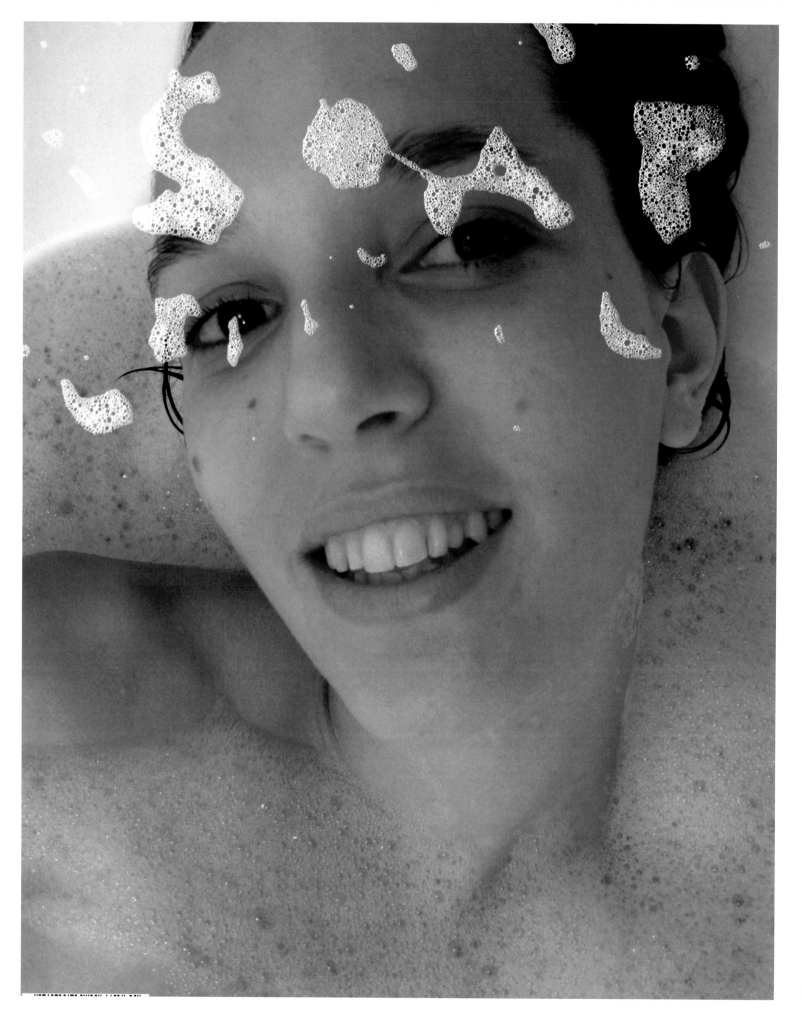

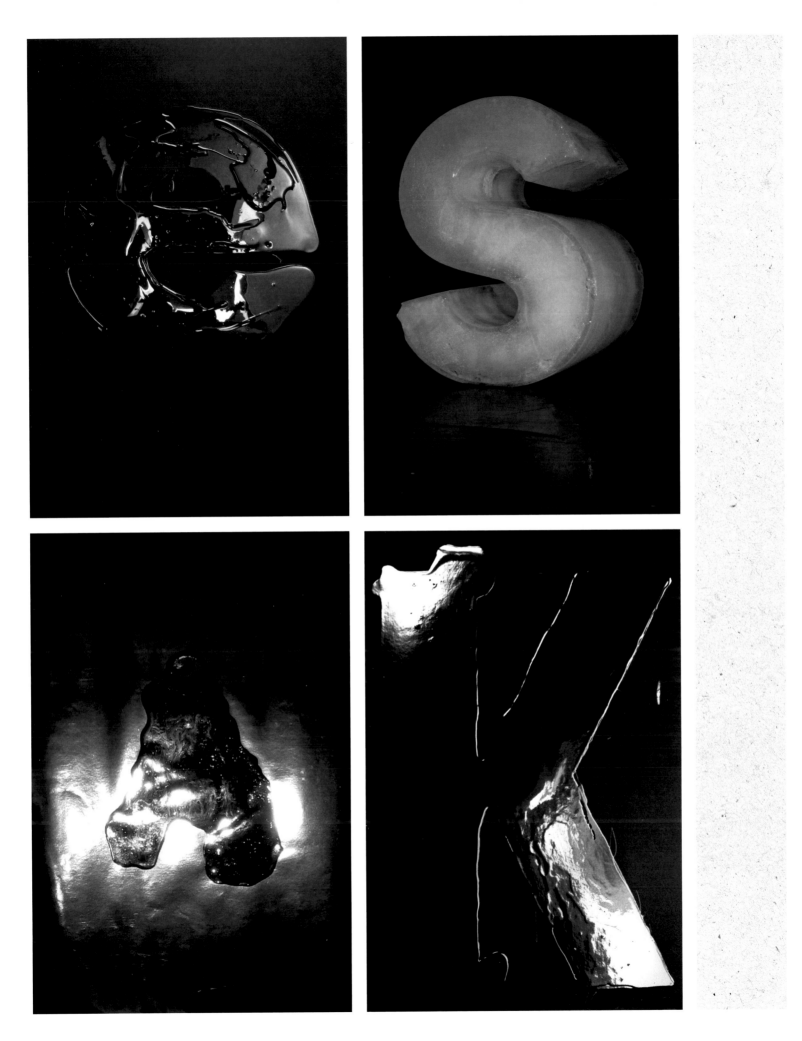

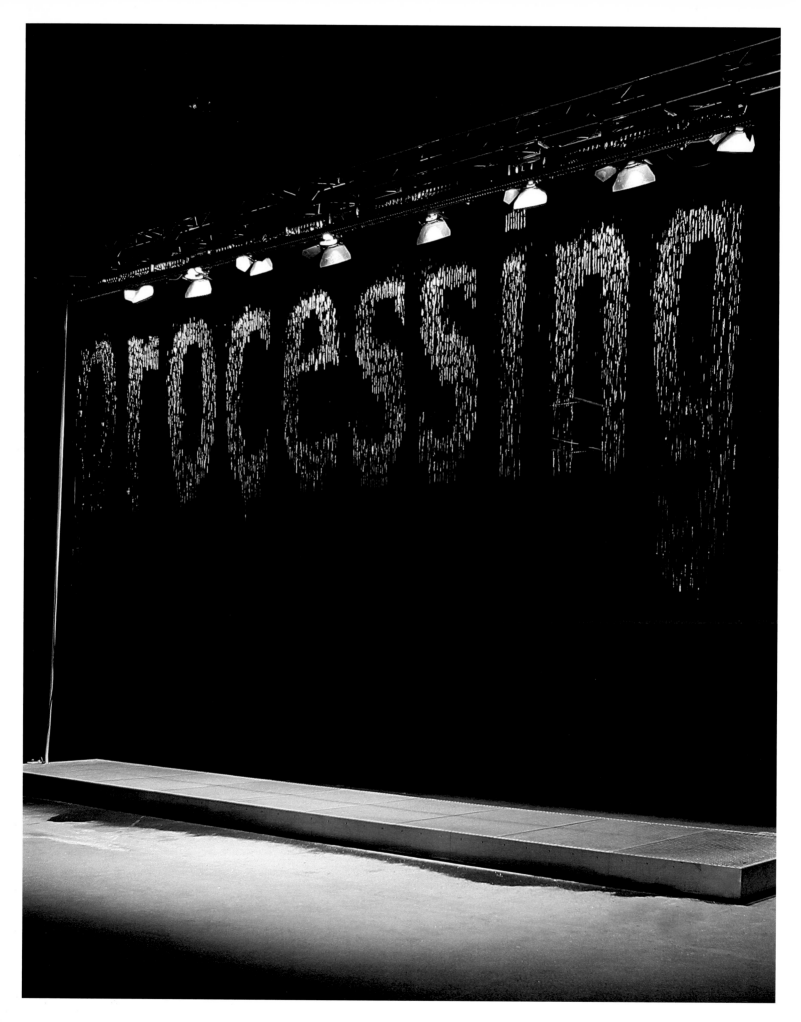

Julius Popp

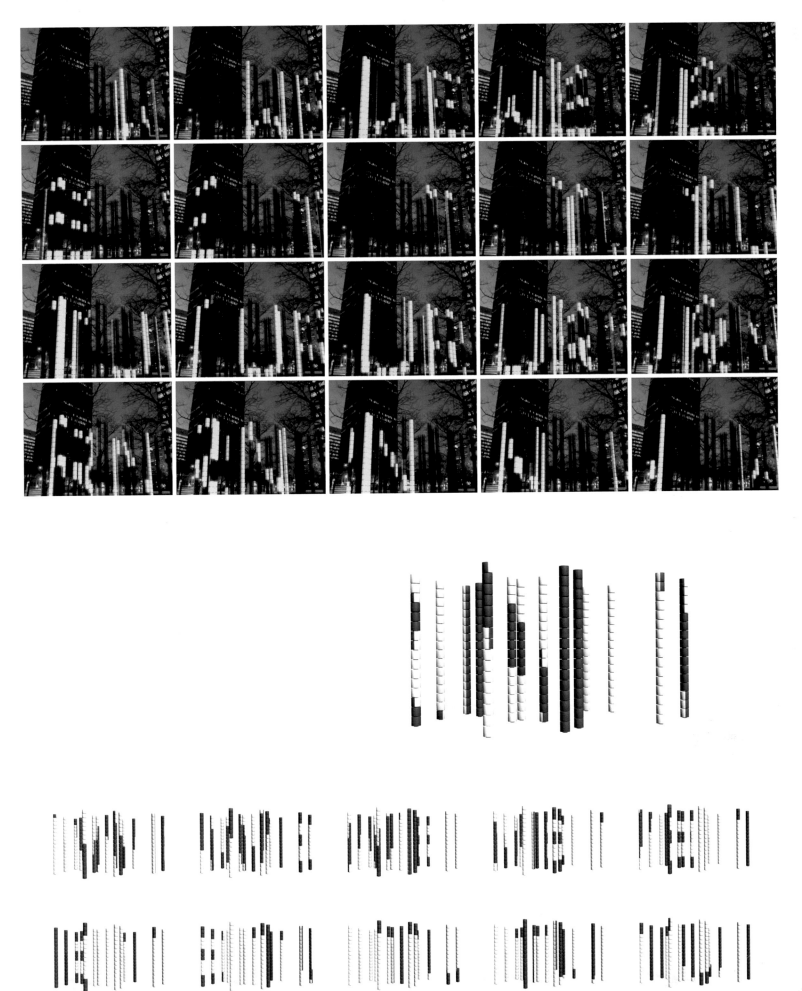

21bis
Netherlands
www.21bis.nl
frank@21bis.nl
Page 13 – Nowhere Amsterdam,
2008 – Flyer and register form for kids
workshops like drawing letters.
Page 143 – Graduation project 360°, 2007
Page 145, 147 – Personal, 2007

44 flavours
Germany
www.44flavours.de
hello@44flavours.de
Page 16 – Zoo York, 2005 –
Designer: Julio Rölle • Artdirection:
Kimou Meyer
Page 20, 21 – Topdollar, 2007/2008
Page 23 – Personal, 2006
Page 41 – The Tape vs. Rom "Public
Transport" album

Adam Hayes
United Kingdom
www.mrahayes.co.uk
adam@mrahayes.co.uk
Page 36, 37 – Personal, 2007 – Taken
from a on-going series of self produced
posters.

**Advancedesign | Petr Bosak + Robert
Jansa**
Czech Republic
www.advancedesign.org
info@advancedesign.org
Page 102 – Sperm Festival, 2007

Akatre
France
www.akatre.com
akatre@akatre.com
Page 158 – Mains Déduvres, 2007/2008
Page 200 – Grafik magazine, 2008
Page 201 – Personal, 2008

Alex Robbins
United Kingdom
www.alexrobbins.co.uk
alex@alexrobbins.co.uk
Page 106 – Sprawl, 2006
Page 156 – Personal, 2007
Page 221 – AIGA Denver, 2007

Alina Günter
Switzerland
www.alinaguenter.ch
hello@alinaguenter.ch
Page 31-35 – Personal, 2008

Angela Lorenz
Germany
www.alorenz.net
info@alorenz.net
Page 147 – Kitty-Yo, 2005

Annemarie van den Berg
Netherlands
www.v-annemarie.nl
annemarievandenberg@gmail.com
Page 134, 135, 142 – Personal, 2005-2007

Apirat Infahsaeng
USA
www.syntheticautomatic.com
email@syntheticautomatic.com
Page 104 - Logo for Beautiful/Decay
T-shirt, 2007

Axel Peemöller
Germany
www.de-war.de
axel@de-war.de
Page 210, 231, 233 – Personal, 2008

Backyard 10
Germany
www.backyard10.com
landgraf@backyard10.com
Page 95, 109 – USP, 2007

Bank
Germany
www.bankassociates.de
tellme@bankassociates.de
Page 153 – Personal, 2007 – Pneuma
typeface
Page 164 – Personal, 2007 –
Adam Slowik @ Bank
Page 219 – Personal, 2008 –
Adam Slowik @ Bank
Page 232 – Personal, 2008

Benjamin Mermaid
Iceland
www.benjaminmermaid.com
office@benjaminmermaid.com
Page 105 – Self promo, 2007
Page 105 – Not Gene Simmons, 2007

Bianca Strauch
Germany
www.biancastrauch.de
bianca@biancastrauch.de
Page 230 – Record cover, 2006

Blackjune
Germany
www.blackjune.com
info@blackjune.com
Page 69 – Skateboard label, 2006
Page 171 – Personal, 2008
Page 180 – Radio Skateboards, 2006

Boy 81
Switzerland
www.boy81.ch
mail@boy81.ch
Page 52 – Wasserwerk Club Bern, 2008
Page 52 – Tune Kid Records, 2007
Page 52 – Schurken Bern, 2006

C100 Studio
Germany
www.c100studio.com
hello@c100studio.com
Page 109 – Lovem, 2007

Camille Lebourges
France
camillesupercool@gmail.com
Page 130, 131 – Un sourire de toi et
j'quitte ma mère, 2008
Page 161 – Crazy Ondamania, 2008
Page 212, 213 – Personal, 2007/2008
Page 212 – C. Lebourges/G. Baujard,
Paris Musées, Greeting Card for 2008.

Christoph Zielke
Germany
www.miketypeson.com
christoph@miketypeson.com
Page 109 – The Architecture Foundation/
D&AD, 2007

Coboi
Switzerland
www.coboi.li – katharina@coboi.li
Page 113 – Hochschule der Künste Bern
HKB, 2006
Page 206, 207 – Hochschule der Künste
Bern HKB, Typoclub, 2007 –
Designer: Katharina Reidy & Krispin Heé

Corriette Schoenaerts
Netherlands
www.corrietteschoenaerts.com
corrietteschoenaerts@mac.com
Page 129, 132, 133 – 178 Aardige
Ontwerpers for HKU, 2007
Page 209 – Vandejong for Foam, 2008

Deanne Cheuk
USA
www.deannecheuk.com
neomuworld@aol.com
Page 43 – Nylon Magazine/
Urban Oufitters, 2008

Damien Vignaux | Elroy
France
www.elroy.fr
damien.vignaux@9online.fr
Page 12 – Private projects, 2007/2008
Page 12 – PLAY collective, 2007
Page 80 – LeEdition populaire, 2008
Page 176 – Arty Farty, 2007

Dancemade
Sweden
www.dancemade.com
dancemade@gmail.com
Page 168, 169 – Personal, 2006

Dani Klauser
Switzerland
www.dkgd.ch
hello@dkgd.ch
Page Page 103 – Personal, 2008

Daryl Tanghe
USA
www.dtanghe.com
dtanghe@gmail.com
Page 151 – Personal, 2007 – Bloom/Gloom,
Typography IV, College for Creative
Studies, Detroit, MI

DTAM
United Kingdom
www.dtam.co.uk
info@dtam.co.uk
Page 107 – Steve Swindells –
Wrexham Arts Centre, 2008

Dynamo
Dynamo | Thibaud Tissot
www.dynamo.li ||| dynamo@dynamo.li
Page 48, 49 – Personal, 2007

Emil Kozak
Spain
www.emilkozak.com
info@emilkozak.com
Page 87 – Vasava, 2008

Faith
Canada
www.faith.ca
info@faith.ca
Page 141 – The Juggernaut, 2007

Falko Ohlmer
Germany
www.falko-ohlmer.com
hello@falko-ohlmer.com
Page 85 – Lisbon, 2008

Fiodor Sumkin
Netherlands
www.opera78.com
opera78@gmail.com
Agency: Unit C.M.A. – www.unit.nl
Page 58, 59 – Aeroflot Airlines, 2008
Page 60 – Mr.Hyde, 2008
Page 61 – Men's Health Magazine, 2008
Page 63 – Esquire Magazine, 2008
Page 63 – Personal, 2008

Gray 318
www.gray318.com
Page 68 – Extremly Loud, Incredibly Close, book cover
Page 69 – Everything Is Illuminated, book cover
Page 69 – Fortress of Solitude, book cover
Page 179 – Fascination, book cover

Gustavo deLacerda
Brazil
www.substantivo.net
gustavo@substantivo.net
Page 138 – Personal, 2007
Page 138 – Random, 2007
Page 160 – Post St. Joost, 2006

GVA Studio
Switzerland
www.gvastudio.com
info@gvastudio.com
Page 107 – Salomon, 2007

Helena Dietrich
Germany
www.workwithhelena.com
helena@workwithhelena.com
Page 154 – Personal, 2007 – Designer: Helena Dietrich, Denise Amann
Page 155 – Exhibiton at the werkform gallery, Bozen, 2007
Page 208 – Tiefschwarz, 2007 – Photography David Späth

Hello Von
UK
www.hellovon.com
say@hellovon.com
Page 70 – Personal, 2008

Hjaerta Smaerta
Sweden
www.hjartasmarta.se
info@hjartasmarta.se
Page 148, 149 – Personal, 2007
Page 220 – ñ, 2008

Hort
Germany
www.hort.org.uk
contact@hort.org.uk
Page 109 – Get Physical Music / Kindisch, 2006
Page 184 – Get Physical Music / K7! Records, 2007
Page 196, 197 – Wallpaper*, 2008

Human Empire
Germany
www.humanempire.com
post@humanempire.com
Page 88, 89, 151, 184, 185 – Morr Music, 2006 / 2007

Invisible Creature
USA
www.invisiblecreature.com
info@invisiblecreature
Page 193 – Record cover, 2006

Jack Featherstone
UK
www.jackfeatherstone.co.uk
feathersflys@gmail.com
Page 181 – Personal, 2007

Jarrik Muller
Netherlands
www.getbusyfoklazy.nl
Page 86 – Mark and the Spies, 2007
Page 198, 199 – Personal, 2007
Page 205 – Loud Mouth

Jayne Helliwell
United Kingdom
www.jaynehelliwell.com
jaynehelliwell@hotmail.com
Page 29 – Personal, 2008
Page 29 – Lark, 2006

Jenny Grigg
Australia
www.jennygrigg.com
jenny@jennygrigg.com
Page 157 – Booktitle "Bliss"

Jonathan Calugi
Italy
www.happyloverstown.eu
hello@happyloverstown.eu
Page 37
Page 84

Jonathan Prêteux
France
www.jonathanpreteux.eu
jonathanpreteux@gmail.com
Page 78, 79, 90, 121, 132, 133 – Save project, 2006

Julius Popp
Germany
www.sphericalrobots.org
info@sphericalrobots.org
Page 234, 235 – Personal, 2007

Karina Petersen
Denmark
www.karinapetersen.com
petersen_karina@hotmail.com
Page 165, 202, 203, 222, 223, 224, 227 – Personal, 2007

Karoly Kirafalgi
Hungary
www.extraverage.net
drez@extraverage.net
Page 85 – Lisbon, 2008

Kate Lyons
UK
www.iamkatelyons.co.uk
iamkatelyons@hotmail.com
Page 173 – Personal, 2007

Keith Scharwath
USA
www.scharwath.com
keith@scharwath.com
Page 9 – Sidetrack Films, 2008

Koi
Switzerland
www.koi.li – info@koi.li
Page 206/207 – Hochschule der Künste Bern HKB, Typoclub, 2007 –
Designer: Krispin Heé & Katharina Reidy

Klon2
Sweden
www.klon2.dk
hello@klon2.dk
Page 121 – Personal, 2008

Kollega
Denmark
www.kollegaworks.com
kollega@kollegaworks.com
Page 226 – Personal, 2007

Kotama Bouabane
Canada
www.kotamabouabane.com
k@kotamabouabane.com
Page 228, 229 – Personal, 2007

Lapin Studio
Spain
www.lapinstudio.com
jorge@lapinstudio.com
Page 137, 140 – Personal, 2007

Laundry
USA
www.laundrymat.tv
pj@laundrymat.tv
Page 91 – Personal skate decks, 2004
Page 116 – urb magazine, 2008
Page 116 – mtv suburban virgin, 2006
Page 117 – Joanna music video, 2004
Page 117 – the royal magazine, 2007

Linda Sweenie
United Kingdom
www.lindasweenie.com
Page 112, 113, 123 – Personal, 2007
Page 124 – Personal, 2007 – Designer: Linda Sweenie, Anette Kirkeby & Sissel Johannessen

Linzie Hunter
United Kingdom
www.linziehunter.co.uk
linzie@linziehunter.co.uk
Page 5 – Revista Colectiva, 2008 – Supermarket Issue
Page 6, 7 – Personal, 2007 / 2008 – From „Secret Weapon: 30 Hand-painted spam postcards" Chronicle Books, 2008
Page 8 – Patapri, 2008 – Typography for a Tea Towel Design
Page 18, 19 – Personal, 2008
Page 182 – Personal, 2007

Lisa Rienermann
Germany
www.lisarienermann.com
yeah@lisarienermann.com
Page 225 – Personal, 2007

Little Factory
Hong Kong
littlefactory.com
hello@the-item.com
Page 178 – Items, 2008

Lorenzo Geiger
Switzerland
www.lorenzogeiger.ch
hello@lorenzogeiger.ch
Page 96, 97, 144 – Dachstock
Reitschule Bern, 2006
Page 159 – Personal, 2007

Lowman
Netherlands
www.hellowman.nl
mail@hellowman.nl
Page 142, 186 – Personal, 2008

Luca Forlani
Italy
www.agentespeciale.com
indastria@agentespeciale.com
Page 141 – Paper Experience
Magazine, 2005

Magnetofonica
Venezuela
www.magnetofonica.net
lorette@magnetofonica.net
Page 186 – Puras Maravillas, 2008

Malcolm Buick
USA
malcolmbuick.com
malcolm@malcolmbuick.com
Page 94 – NIKE SB, 2008

Marcus Walters
United Kingdom
www.marcuswalters.com
mail@marcuswalters.com
Page 14, 15 – Coca-Cola, Mother London

Marian Bantjes
Page 38, 39 – Pentagram / Saks Fifth
Avenue - Art Direction: Michael
Bierut / Terron Shaefer -
Implementation: Saks Fifth Avenue
creative team under Terron Shaefer, 2007
Page 98 – G2 (The Guardian) -
Art Director: Richard Turley, 2007
Page 99 – "Restraint", Font by Marian
Bantjes & Ross Mills - Released by Tiro
Typeworks (www.tiro.com), 2007
Page 100 – Print Magazine -
Art Direction: Kristina DiMatteo, 2006
Page 110 – G2 (The Guardian) -
Art Director: Richard Turley, 2007
Page 111 – Stefan Sagmeister - Photos:
Kunsthaus Bregenz, 2006
Page 150 – Society of Graphic
Designers of Canada (GDC), 2005
Page 194, 195 – Stefan Sagmeister,
2007 - Medium: Sugar

Mario Hugo | Loveworn
USA
www.loveworn.com
hello@loveworn.com
Page 24 – La Surprise, 2008
Page 25 – Personal Project / Vallery
Exhibition, 2007
Page 30 – Channel 4 / Spin, 2007
Page 105 – G.U., 2006
Page 126, 127 – Daniel Ciardi, 2007
Page 127 – Beck / Interscope
Records, 2008 – Unused concept artwork
for Beck's "Modern Guilt" album.

Marion Mayr
United Kingdom
www.marionmayr.net
info@marionmayr.net
Page 170 – Book cover "The Origin of
Letters by Means of Human Selection"

Masato Yamaguchi
Japan
www.ideasketch.jp
yamaguchi@ideasketch.jp
Page 140 – Weave, 2005

Maskara
Switzerland
www.maskara.ch
sandrine@maskara.ch
Page 196 – Personal, 2007

Mathilde Nivet
France
mathildenivet@gmail.com
Page 88, 146 – Personal, 2004

Matt W. Moore
USA
http://mwmgraphics.com
matt@mwmgraphics.com
Page 40 – Personal, 2006 - Alphafont 1.0
Page 93 – Personal, 2008 - Alphafont 2.0

Mediaone unltd.
Portugal
www.cpluv.com/mediaoneunltd
mediaoneunltd@gmail.com
Page 85 – Lisbon, 2008

Memo-Random
UK
www.memo-random.com
michelle@memo-random.com
Page 190 – University of Brighton, 2008

MEstudio
Netherlands
www.mestudio.info
look@mestudio.info
Page 155 – We Jane, 2008

Michael Gillette
USA
www.michaelgillette.com
m.gillette@sbcglobal.net
Page 74, 75 – Penguin books /
Jon Grey, 2007 / 2008

Michael Genovese
USA
www.genovesestudios.com
info@genovesestudios.com
Page 28 – Personal, 2008

Niessen & de Vries
Netherlands
www.niessendevries.nl
richard@niessendevries.nl
Page 187 – Personal, 2007

Nigel Peake
Ireland
www.secondstreet.co.uk
nigel@secondstreet.co.uk
Page 53 – Personal, 2005
Page 56, 57 – Personal, 2007

Nikki Farquharson
United Kingdom
www.kinkinerd.com
nikki@kinkinerd.com
Page 17 – Apparatus Inc., 2006

Niklas-H / Nicklas Hultman
Sweden
www.nicklas-h.se
info@nicklas-h.se
Page 107 – Zeigeist, 2007

Nir Tober
Israel
www.nirtober.com
Page 215, 216, 217 – Personal, 2006

Ohiogirl
USA
www.thequietlife.com
info@ohiogirl.com
Page 15 – Personal, 2007

Oliver Hydes
www.oliverhydes.com
Page 22 – Artists Open Houses
Exhibition, 2007
Page 50, 51 – Observer Magazine, 2007

Overture
USA
www.operture.org
overture.image@gmail.com
Page 46, 47 – Kasino A4, 2007

Phenomenal | MacGregor Harp
USA
www.pnmnl.com - mac@pnmnl.com
Page 103 – Personal, 2006

Pleaseletmedesign
Belgium
www.pleaseletmedesign.com
oh@pleaseletmedesign.com
Page 152 – Personal, 2007

Raffinerie
Switzerland
www.raffinerie.com
team@raffinerie.com
Page 211 – Personal, 2006

Raphael Bastide
France
www.raphaelbastide.com
bonjour@raphaelbastide.com
Page 135 – Personal, 2007